Complete Guide to
PORTRAIT
PAINTING

Complete Guide to
PORTRAIT PAINTING
By Furman J. Finck

WATSON-GUPTILL PUBLICATIONS NEW YORK

PITMAN PUBLISHING LONDON

To Hans Obst, Patron of the Arts

Paperback Edition
First printing, 1977
Second printing, 1977

Published 1970 in New York by Watson-Guptill Publications,
a division of Billboard Publications, Inc.,
1515 Broadway, New York, N.Y. 10036

Published 1974 in England by Pitman Publishing, Ltd.,
39 Parker Street, London WC2B 5PB
ISBN 0-273-00875-7

Library of Congress Cataloging in Publication Data
Finck, Furman J., 1900-
 Complete guide to portrait painting.
 1. Portrait painting. I. Title. II. Title: Portrait painting.
ND 1302.F5 757 73-117073
ISBN 0-8230-0825-8 ISBN 0-8230-0826-6pbk.

Manufactured in Japan

Acknowledgments

My thanks and appreciation to Professor Alexander Abels for his valuable technical assistance; to Mr. Donald Holden, Mr. Allen Koss and Mr. Russell O. Woody for checking and editing the chapter on polymer colors (acrylics); to Miss Rosamond Harley and Mr. Karl-Heinz Escher for their help in locating works of English and German portraitists; to Miss Susan Meyer as editor; to Noel Llinos for assistance with the original text; and to the artists and collectors who made portraits available for this book.

Photographic credits to: American Photo Service, Inc.; Brenwasser Studio; Peter A. Juley and Son; Martin/Arnold Color Systems; Morecraft/Oliwa Photographers; Becker Laboratories; Nishan Yardumian.

List of Paintings

Contents

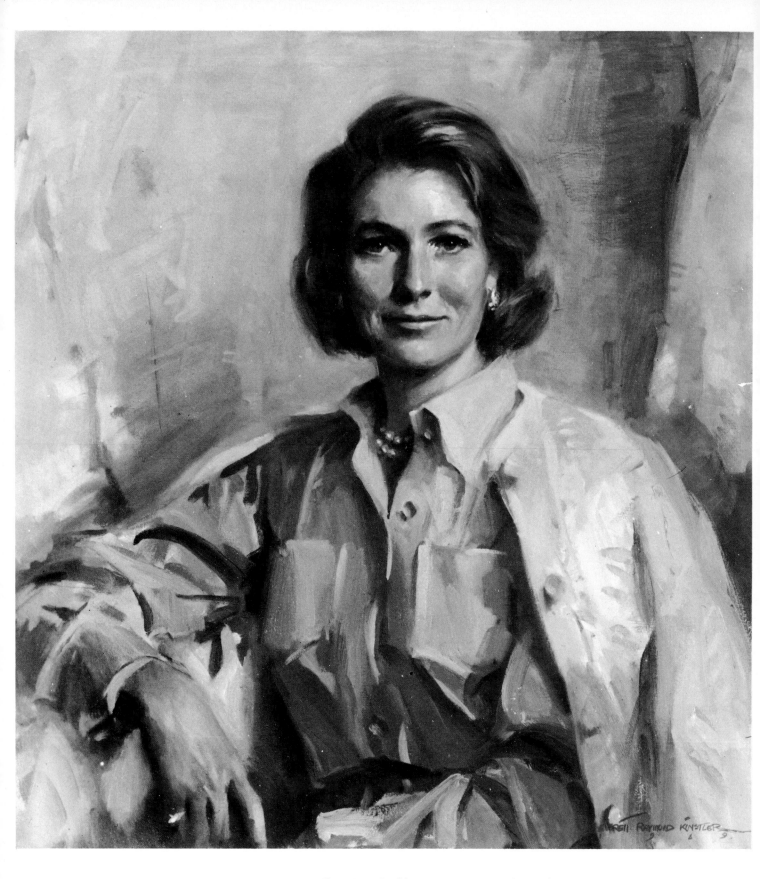

Mrs. J. Hamilton Crawford by Everett Raymond Kinstler.

Oil on canvas. This was painted on Winsor & Newton linen canvas ("Winton"), using Winsor & Newton bristle filbert brushes. The palette contained yellow light, raw sienna, cadmium red light, alizarin, cerulean and ultramarine blues, raw umber, and green oxide. The medium was turpentine with a few drops of cobalt drier. Retouch varnish was used. Courtesy, Mrs. J. Hamilton Crawford.

It is important to work with the best grade of art supplies. Good brushes will outlast and perform better than less expensive brushes, as will good canvas and good colors—those guaranteed not to change their strength or their hue with age. A responsible color manufacturer provides information about permanence in his catalog.

Paint Box and Colors

Buy a sturdy paint box and fill it with your own choice of colors, brushes, and other accessories. I recommend any of the following boxes:

Winsor & Newton, Inc.: "Wealdstone" (12″ x 16″) with or without aluminum tray.
F. Weber Co.: No. 3311 "Tizian" (12″ x 16″) or No. 3317 or 3318 "Hudson" (12″ x 16″)
Permanent Pigments: No. 30 (12″ x 16″) natural oak with hardwood palette.
M. Grumbacher, Inc.: No. 281 "Venetian" (12″ x 16″) or No. 291 "Gainsborough" (12″ x 16″)

The traditional artist's palette is natural wood and most paint boxes come with a palette which is included in the price and fits into grooves in the box. The natural wood is absorbent and many artists rub the palette with linseed oil before it is put to use, in order to prevent the paint from soaking into the fibers.

Do not buy a ready-made "artist's set" of materials, the contents of which have already been assembled for all-purpose needs; rather, select each item individually so that it fits your own personal requirements.

In Chapter 2, I discuss colors in detail. Unless otherwise indicated, they refer to oil colors. Initially, you should purchase these minimum colors:

(1) Cremnitz or flake white (Tube No. 40, one pound, or Tube No. 20, one half pound)
In No. 14 "studio size" tubes, add the following colors:
(2) Ivory black
(3) Burnt sienna
(4) Cobalt blue
(5) Oxide of chromium—transparent (viridian)
(6) Yellow ochre
(7) Cadmium yellow light

1
Materials and tools

Grumbacher "Venetian" paint box.

Winsor & Newton "Wealdstone" paint box.

Permanent Pigments No. 30 paint box.

Weber "Tizian" paint box.

(8) Cadmium red light

(9) Alizarin crimson

You may add to this minimal list, selecting other colors from those described in Chapter 2.

Mediums and Cups

You will want to mix liquid painting medium with your tube colors to make them more luminous, fluid, easier to mix and to brush. This medium is a combination of oil and varnish which the artist mixes from ingredients bought separately. I will suggest a combination of cold-pressed linseed oil (the first pressing of the flax seed) and dammar varnish. Mix these vehicles in the proportion of one part of oil to three parts of varnish; store this mixture in a new bottle of dark glass which you will carry in your box.

You will need *two* palette cups to hold the medium. These cups should be two separate, single cups, not a unit of two cups welded to one clamp. This twin cup unit can cause you to be wasteful; when the medium in one cup becomes soiled while the other is clean, both cups must be emptied in order to dispose of the soiled medium. If you employ two individual cups, you can use them independently or together.

Brushes and Palette Knife

As you select your brushes, give attention to their shape and proportion and consider how you will use them. Here is a selection of brushes which has been most serviceable to me. In the Winsor & Newton list I have used the listing published in their own catalog, even though the nomenclature tends to be British, rather than American.

Winsor & Newton, Inc.

Series CL bristle no. 9 short filbert (hog hair)
Series AO bristle no. 6 long filbert (hog hair)
Series 27 bristle no. 2 extra long filbert
 (hog hair)
Series 54 red sable no. 00 pointed rigger
Series 57 red sable no. 1 long round
Series 807 red sable no. 12 and no. 20 bright
Series 810 red sable nos. 1, 2, 4, 5, 6, 7, 10, and
 16 long flat

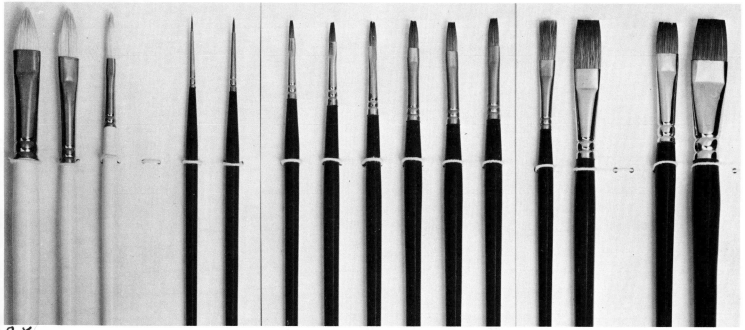

Winsor & Newton brushes, (l. to r.): three hog hair filberts—series CL no. 9 short, series AO no. 6 long, series 27 no. 2 extra long; red sable—series 54 no. 00 pointed rigger, series 57 no. 1 long round, series 810 nos. 1, 2, 4, 5, 6, 7, 10 & 16 long flat, & series 807 nos. 12 & 20 bright.

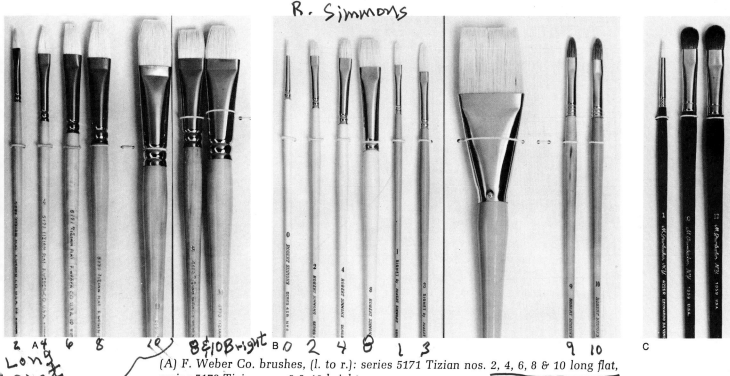

(A) F. Weber Co. brushes, (l. to r.): series 5171 Tizian nos. 2, 4, 6, 8 & 10 long flat, series 5173 Tizian nos. 8 & 10 bright.

(B) Robert Simmons Inc. brushes, (l. to r.): series 41R no. 0 round, series 41B nos. 2, 4 & 8 bright, series 42 nos. 1 & 3 filbert, series 40 "Broad" no. 20 bright, series 67 red sable nos. 9 & 10 filbert.

(C) Grumbacher Inc. brushes, (l. to r.): series 4226R Leonardo Da Vinci no. 1 round, series 1859 red sable nos. 10 & 12 filbert.

F. Weber Co.

Series 5171 Tizian bristle nos. 2, 4, 6, 8, and
 10 long flat

Series 5173 Tizian bristle nos. 8 and 10 bright

Robert Simmons Inc.

Series 41R bristle no. 0 round

Series 41B bristle nos. 2, 4, and 8 bright

Series 42 bristle no. 1 and no. 3 filbert

Series 40 and 41 "broad" bristle no. 20 or
 24 bright

Series 67 red sable nos. 9 and 10 filbert

M. Grumbacher Inc.

Series 4226R bristle Leonardo Da Vinci
 no. 1 round

Series 1859 red sable nos. 10 and 12 filbert type

Using this list as a guide, make your own selection. Do not settle for cheap brushes; they are your mainstay and must perform well.

After each day's painting, rinse your brushes in Xylene, then clean them with soap and warm water. Lather the palm of your hand, push the brush into the lather, and repeat this procedure until the lather contains no more color. Then rinse the brushes in warm water, dissolving both soap and Xylene. Finally, pinch the tip of the brush to dry, to shape it.

In addition to brushes, you will need a palette knife. Buy a long palette knife, with a good, flexible steel blade. This instrument may be used as a tool for painting on the canvas as well as for cleaning the palette.

Your complete painting set should contain a paint box with palette; a minimum of eight colors (plus white); a bottle of cold-pressed linseed oil; a bottle of dammar varnish; a new, empty bottle of dark glass for mixing and storing your painting medium; two palette cups; a palette knife; and an assortment of at least ten brushes. Add to this a piece of clean cloth, used as a paint rag for keeping brushes dry and clean while you work; for cleaning the mixing area on the palette; and for wiping your hands.

Canvas

Many artists prefer to work on a canvas because they like to feel its spring and rebound to the touch of the brush. A good grade of canvas is generally acceptable for most painting. Linen is recommended. Linen is strong and not subject to great expansion and shrinkage caused by atmospheric change.

For small to medium size canvases, a good grade of cotton duck (sail cloth) is somewhat less expensive than linen and will prove satisfactory. Since it is more subject to atmospheric change, however, cotton is not recommended for large sizes, as it may tend to wrinkle and sag.

Your canvas should be made either of pure linen or pure cotton. Some fabrics are mixed, containing a combination of linen and cotton. Some materials are woven with a double thread warp (double threads running lengthwise) and a single thread woof (single threads running perpendicular to the warp). These variations in weave create an uneven tension, and are an unstable foundation. For your purpose, canvas should be made all of one material and should contain an equal number of threads running each way to insure a uniform distribution of tension in the fabric. A fabric with a tight and even weave is necessary to provide a strong, solid backing and a responsive painting surface.

Artists' canvas must first be sized and primed. You *can* perform this process yourself, but it is simpler to buy artists' prepared—already primed—canvas by the yard or in a stock roll from your art materials supplier.

Panels and Canvas Panels

For a smooth surface and a rigid backing, a panel may be used for painting. A panel of solid hardwood is preferable, but a laminated panel with a lumber core—on which a finish of hard or semi-hard wood has been mounted with a waterproof adhesive—will also serve your purpose. When the panel is sized, it will have a hard, durable surface.

Some artists, who desire the woven surface of a canvas but prefer the rigidity of the panel, will be attracted to the canvas panel. This is simply a panel which has been covered with canvas. Both panels and canvas panels are available at your art materials supplier.

Although I do not use it myself, the most widely used panel material today is not wood,

but Masonite. This material comes in thicknesses of $1/8''$ and $1/4''$ (the latter is more rigid) and is made of compressed wood fibers. Be sure to buy the type called _untempered_, rather than the tempered variety, which contains an oily substance that threatens the adhesion of your paint. Masonite is generally rough on one side, smooth on the other. Most artists prefer the smooth side because the rough side has a rather unpleasant, mechanical texture. Before sizing, the smooth side should be lightly roughened with sandpaper and then prepared as you would a canvas or wood panel.

Charcoal and Kneaded Eraser

Artists' vine charcoal no. 2 (a soft, thin stick of charcoal) is useful for drawing your preliminary sketches on paper and your compositions on the canvas. Examine this charcoal for its softness and thinness: it must produce a black line easily, but must not scratch the surface. I use a Permanent Pigments product, vine no. 2, which comes in boxes of six sticks.

The kneaded eraser is a square of gum specially manufactured. Before using the eraser, work it between your thumb and finger to extract any excess oil and to make it more malleable. Then you can flatten it or point it to facilitate refined erasing, for establishing highlights, for crosshatching light into dark, and for picking off excess charcoal.

Fixative

Fixative is a liquid spray of selected pale gums or plastic resins, used to cover and protect the completed drawing, so that the drawing will not smear or pick up on the brush when paint is applied over it. If you use fixative in a spray can, read the directions and employ it with caution. Fixative is also available in a screw top bottle and it is sprayed manually with a fixative atomizer. Since dammar varnish (in the thin form called retouch varnish) is quick drying, it can be applied effectively as a fixing agent through the atomizer.

When fixing a drawing, do not spray too close to the canvas. A distance of two or three feet will insure a more complete coverage.

Easel

You should own a folding easel so that you can carry it about from place to place and you will have no trouble storing it. There are a number of good folding easels on the market; examine them for their design and workmanship. For an all-purpose easel, I recommend the folding easel, which has served me for more than twenty-five years, designed by Captain Oscar Anderson of Gloucester, Massachusetts, and known as the Gloucester Easel. This easel is constructed according to basic principles of leverage, one point locking with another to gain strength and flexibility in a simple, functional design.

Having completed your initial purchases, open the easel, set the canvas or panel on it, and take your charcoal or brush and go to work.

If you wish more extensive information concerning materials, I suggest that you purchase a copy of _Art Materials Buyer's Guide,_ published by _American Artist,_ 1515 Broadway, New York, N.Y. 10036.

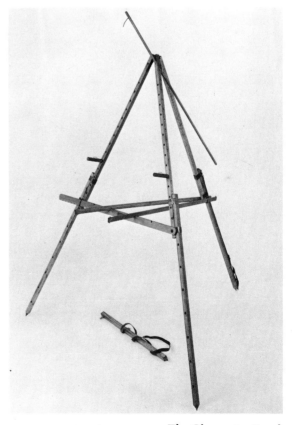

The Gloucester Easel.

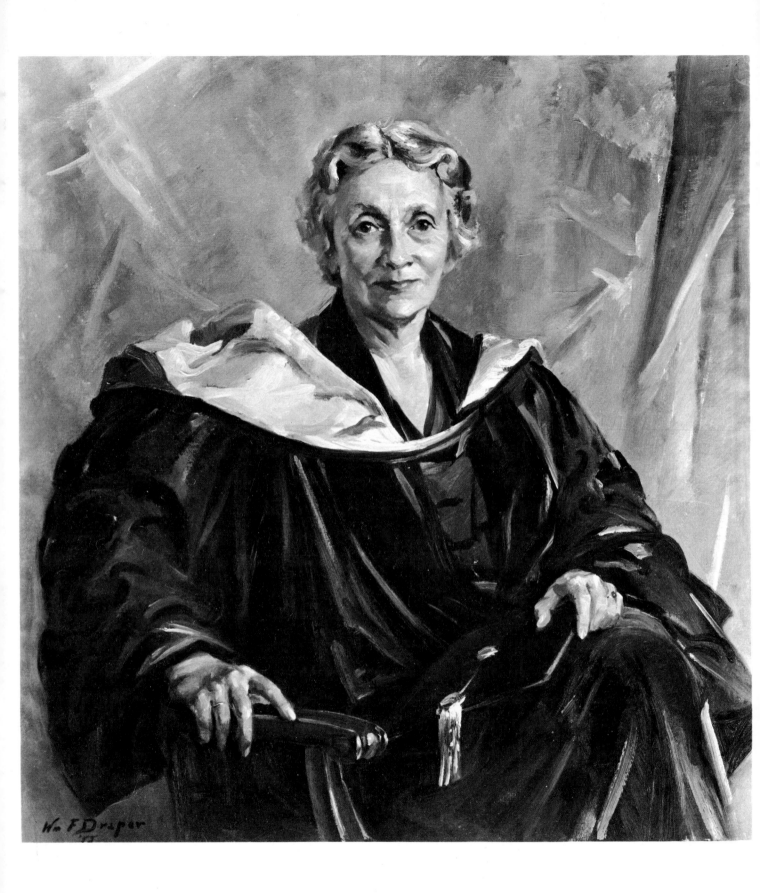

Sarah Gibson Blanding, *Former president of Vassar College,* by William F. Draper.

Oil on canvas. Even within a simple color scheme, the richest hues are possible with an imaginative palette. Collection, Vassar College, Poughkeepsie, New York.

2
Setting up the palette

Setting up the palette is a matter of individual preference, but I recommend that you establish a formal pattern, arranging the colors on your palette in a basic order. By using a simple color selection, you will learn to develop a wide range of color tints.

Basic Color List

White is your major pigment, the one you will be using most frequently. Nearly every shade you mix will contain a base of white. You will, in fact, use ten times as much white as any other color. Place the colors around the periphery of the palette, with the white in the middle where it will be most accessible. To the left of the white, leaving an inch of space between colors, set the following colors:

Oxide of chromium transparent (viridian)

Cobalt blue

Burnt sienna

Ivory black

To the right of the white, place these colors:

Yellow ochre

Cadmium yellow light

Cadmium red light

Alizarin crimson

If you add to this list, keep each additional color adjacent to others of its kind: reds with reds, yellows with yellows, etc.

Now fit your oil cups to the outside right corner of your palette. As you place your thumb in the thumb hole of the palette, the colors should lie away from you so that your arm is in no danger of touching any of the paints as you hold the palette.

Some Notes About Colors

Artists' colors are obtained from animal and vegetable sources, coal tar derivatives, clays from the earth, oxides, and various metallic elements. They divide into two chemical classifications: organic colors—from animal and vegetable sources and coal tar derivations; and inorganic colors—from earth clays and metal oxides. For example, animal bones are burned to make ivory black; the root of a madder plant is ground to produce the dye for

rose madder; alizarin and the phthalocyanine colors are by-products obtained from the distillation of bituminous coal. Clays originally produced umbers, siennas, ochres, and other earth colors (some of which are now produced chemically), while the cadmiums, blues, and whites are metal derivatives.

Some artists who prepare their own colors buy pigments in powder form. From the powder, these colors are ground in a liquid medium known as the binder. They become oil color, watercolor, tempera color, or polymer color, depending on which vehicle is used as the binder. Prepared paints are stored in tubes so that they can be easily handled.

At the outset, I suggest you buy your paints in tubes. Be sure the pigments are permanent. As stated in Chapter 1, leading artists' materials manufacturers actually rate the permanency of each color they make; this rating appears in the manufacturer's catalog. Permanent colors will not fade or change color on exposure to light or air. An oil color is considered permanent if, when mixed with oil, it does not dissolve or change color; nor should it alter when dry.

When you purchase oil paints, you may be tempted by some of the more beautiful shades prepared by the manufacturer. Do not purchase any of these special blends unless the manufacturer lists them as permanent. Using a basic palette, you may easily mix these blends yourself—knowing the ingredients are permanent.

Let us consider a list of some well known pigments which are recommended for their permanency and range of color. The accompanying notations will suggest some of their useful purposes for the portrait painter. The colors are discussed in the order in which they appear on your palette. For a more complete listing, the United States Department of Commerce has published information on Commercial Standards of Artists' Oil Paints which is available to you in Document CS 98-62, United States Government Printing Office, Washington, D.C., 20541.

Viridian Green

Oxide of chromium transparent (viridian) is a deep, cool green, brilliant and transparent.

This color is used to advantage when glazing (the method of applying a transparent color over a previously painted form). Viridian is permanent and blends readily with all permanent colors. Mixed with white, viridian readily produces luminous shades of green from pale to deep. Blended with alizarin crimson and white, viridian gives a cool, transparent gray; blended with cadmium red light and white, a warm transparent gray, both excellent tones for darkening skin areas. Viridian can be blended with cobalt blue and white to produce a warm, light blue and, by adding a small quantity of ivory black, you will obtain beautiful atmospheric tints. Viridian will satisfy most of your requirements for a green. Oxide of chromium transparent is recommended for your initial palette.

Another form of viridian is called oxide of chromium mat (or dull), which is viridian that has been burned (heated). It is permanent and opaque. This warm, olive shade is very useful: it mixes well with the other colors and has considerable tinting strength. Mixed with white, oxide of chromium mat will produce a light ochre-green hue. Add a touch of red and some black or blue, and you will obtain warm to cool grays of considerable variety, useful for tinting skin. These two greens have many uses for the portrait painter and are recommended.

Green Earth

Green earth, a natural earth color, is a permanent, warm color resembling green leaves. Green earth has very little strength or covering power. It is especially suited for tinting, producing optical grays (translucent grays like the subdued tones of the flesh). Some portrait painters hatch the shadowed areas of the portrait in green earth and into this wet color place other colors, wet-into-wet. Because of its weakness, this green does not interfere with the overpainting, wet-into-wet, and will only penetrate the new surface painted over it when allowed to do so by the artist.

Cobalt Blue

Cobalt blue, in light and dark shades, is a cool, permanent blue. Cobalt blue is of medium intensity, a pure blue, combining all the valued

properties of the color. Cobalt blue mixes well with white. It produces beautiful, clear and useful values, remarkable for their freshness. As a color of moderate intensity, cobalt will readily cool or neutralize a flesh tone without saturating the tone with blue. In small quantities, it will give you airy tones around the subject, allowing the painted form to exist well against the background, creating the illusion of space and a third dimension in a quiet way, not obvious to the observer.

Mixed with white and alizarin crimson, cobalt blue makes a cool purple, of gray tone; with cadmium red, a warm purple to gray. Cobalt blue will modify the character of yellow ochre, viridian, burnt sienna, or black, without overcoming the colors. Cobalt blue is a color of prime importance and is required in your initial palette.

Cerulean Blue

Cerulean blue, in light and dark shades, is often called sky blue. This is a permanent color of intense, light blue with a greenish cast. In its purest form, cerulean is a beautiful blue and when combined with white can give hues of great variety and usefulness for painting the blue of the sky or the haze of the atmosphere. It is valuable for outdoor backgrounds. Cerulean blue usually works well as the color for a blouse or a dress, and it will frame and compliment the head when it is used in a background.

Ultramarine Blue

Ultramarine blue, in light and dark shades, has a rich, dark cast with an overtone of violet. It is permanent, and although a glaze color (relatively transparent), it has covering power and is capable of strongly influencing other colors. It mixes well and will produce strong tones when blended.

Mixed with white, a brilliant, cool blue will result; mixed with alizarin crimson, a bright, deep purple. If you blend ultramarine with black and white, a vibrant, cool gray will result; if you add a touch of yellow ochre, you will make the gray warmer. These grays tend to recede in the painted areas and are very good used as a background. Ultramarine blue,

mixed with burnt sienna, gives a brilliant, intense, and powerful dark tone.

Burnt Sienna

Burnt sienna is a fiery, reddish brown, one of the most permanent and intense colors. It mixes well with all of your paints and will vitalize almost any color blend. Burnt sienna is a warm, dark color which can easily overpower other colors unless it is used sparingly. Employ it with discretion in flesh values, in hair tints, and the like. Occasionally, if you want richness of color—when you paint dark velvet or silk, for example—burnt sienna, added to the mix, will lend the desirable intensity to the color.

Mix any of your colors, especially the dark ones, with burnt sienna and note the results. Black, blue, alizarin crimson, or viridian, either singly or in combination, will blend with burnt sienna, to give a rich, warm, dark tone.

Ivory Black

Ivory black, a form of carbon, is the purest and deepest of the black pigments. When used to darken another color, it will also dull that color, reducing its chromatic strength, thus making it less brilliant. If blue is used to darken a red, a purple results, and the chromatic power of the red is not reduced; but if black is used to darken the same red, a dull red results. Therefore, employ ivory black profitably to mute or quiet a color area, or to subdue a flesh tint. In each case, the black should be used with restraint.

Ivory black will sometimes crack when used in its pure state, applied over a painted surface. It is best used when mixed and is compatible with any other color. Ivory black is permanent and very serviceable, and it is recommended for your initial stock of colors.

The Whites

You will use more white than all of your other colors combined, so it is necessary for the white to be of good grade. White must have brilliance and good covering power; it must be permanent and flexible.

Artists' white paint is obtained chiefly from

basic lead carbonate, oxide of zinc, and dioxide of titanium. Pure basic carbonate of lead is commonly known to the trade as either Cremnitz or flake white. The familiar flake white and less familiar silver white sometimes contain zinc as well as lead. Oxide of zinc is called zinc white. Dioxide of titanium is known as titanium white or by trade names such as Permalba, Superba, etc. Some titanium whites also contain a small percentage of zinc in addition to titanium. These names, carrying the manufacturer's guarantee for permanency, purity and workability, may indicate a difference of consistency or formula of manufacture. What are the differences between them?

Cremnitz white (so named because it was originally made at Kremnitz in Czechoslovakia), is generally considered the best grade of white lead, is permanent, and should be your first choice in whites. It is dense and has great covering power; it is pliable, and is a good drier. Cremnitz white will mix with any color, causing the slow-drying ones to equalize with the more rapid-drying ones into a strong, durable paint surface.

This is a very important consideration, especially if you intend to establish the basic structure of a portrait in an underpainting. Working with a lead white, you may feel free to proceed slowly, without any concern for drying or setting of the layers of paint. Bear in mind that your underpainting will be covered by a new layer of paint; the underpainting covered by fresh paint will be slowed in its drying, while the second layer, exposed to the light and air, will dry more rapidly. The two layers of paint, drying at different speeds, may create uneven tensions within the surfaces. Lead white forms a flexible paint film and is able to incorporate these tensions without giving way under the strain. If you use a paint that tends to be brittle—such as zinc white—cracks may appear on the surface whenever that color is used in quantity.

Flake white, another lead white, is a satisfactory substitute if Cremnitz is not available. Flake white is a basic lead carbonate in some cases; in other cases, it is a basic lead carbonate with an addition of zinc oxide. Its base is lead, and when it is pure it has all the features of a lead white; when it is mixed with zinc, it combines the best features of both. Like Cremnitz, flake white blends well with all of the other colors, producing a durable surface. Flake white is a trade name for lead white and for whites in which the lead component dominates. These whites are sometimes cut with a cheaper filling material, such as barite or chalk, which reduces the color's effectiveness for artistic use. Purchase only a top grade flake white made by a reputable manufacturer.

Lead white is the oldest white in use. Though it cannot be used in water base paint, it has been time tested as an oil paint. There is some evidence that lead white in oil darkens very slightly, though not seriously, with age; varnishing the painting, which should occur periodically, will offset this darkening.

Lead colors are poisonous; take precautions when using them; wash your hands after working, and keep brush handles away from your mouth at all times.

Zinc white, oxide of zinc, is a brilliant white pigment which was first employed by artists in 1840. It is non-poisonous, blends readily with all the other colors, is permanent, and does not yellow. Zinc white is slow-drying, does not cover as well as lead white, and has a tendency to be brittle, which can cause the painting surface to crack. To avoid a situation which may give rise to cracking, direct painting (alla prima) is recommended, in which the paint is worked wet-into-wet and finished in one sitting. (See Chapter 14.)

Titanium white is a non-poisonous white with good covering power and resists light and fumes. Although titanium white was discovered in 1780, its preparation in the form of white for artists' use is only recent, and is being continually improved. It is a slow drier, and permanent, but lacks the rich, buttery consistency of lead white.

To summarize: lead white is the most useful and practical oil white for artists. Lead is a good drier, has covering power, develops a pliable paint film, and will not crack. As it ages, it tends to darken and yellow slightly. Zinc is the whitest of the whites mentioned here, dries slowly, is brittle, and has a tendency to crack. Titanium has the best covering power, is whiter than lead, but has the least appealing consistency. You have my recommendations

for a good white, and some information about the others, but the final choice is up to you.

Yellow Ochre

Yellow ochre is a permanent yellow of the color of earth with good covering power, which can be readily mixed with all of the other colors. When mixed with white, yellow ochre can be used as a base for all flesh tints. It is an opaque, soft yellow, with overtones of brown and green. Yellow ochre is not as brilliant as the cadmium yellows, but contains the yellow of skin tone, as you will discover when you use it.

Mixed with viridian, yellow ochre produces a soft, warm green; with black, a warm gray; with blue, a neutral to warm gray; with red, a soft orange. Yellow ochre affects the other colors in the same way as the other yellows, except that this yellow mutes the colors, reducing their brilliance. It is a color for which you will find wide usage in portrait painting and I recommend it for your initial palette.

Gold Ochre

Gold ochre is a deep, semi-transparent, golden yellow color. It warms and enriches all tones with which it is mixed. A permanent color, gold ochre, blended with white, is good for all basic flesh mixtures, and can be safely blended with all of the other permanent colors. Since it is semi-transparent, this color is ideal for glazing.

Naples Yellow

Naples yellow, in light and dark shades, is a good, permanent yellow of excellent covering power, a color that dries well. Since it is a lead pigment color, Naples yellow is poisonous. It is a muted shade of warm yellow that mixes well with white and is useful for painting flesh. Mixed with alizarin crimson and white, Naples yellow will produce a cool flesh tone; mixed with cadmium red light and white, it will give a warmer tone. Naples yellow, used with the addition of a touch of yellow ochre, then viridian or black in minute quantity, will enable you to produce a variety of tones and to render practically every value and subtle change required for the development of your portrait.

Naples yellow is not as brilliant as the cadmium yellows, but it is entirely satisfactory to supply many of your needs for yellow.

Cadmium Yellow, Orange, and Red

The cadmiums are a group of bright, permanent colors, ranging from cadmium lemon, through cadmium orange, to the cadmium reds, from light to dark. Because they are opaque, they have excellent covering power. They are slow drying and are, therefore, better used when mixed with other pigments. Each cadmium is a useful color and will blend with any of your other colors, adding luster to the tone.

Cadmium yellows are listed by the manufacturer as cadmium lemon and cadmium yellow light, medium, and deep. Like the cadmium orange and cadmium reds, the cadmium yellows are brilliant and full-bodied. Cadmium yellow light is unique for its high brilliance and is the yellow I prefer. Cadmium lemon, the lightest yellow, is similar to cadmium yellow light, but contains a touch of green. These two yellows have much the same intensity and will produce tones that are slightly cooler, but no less strong, than those of the deeper yellows. Mixed with white and cadmium red light, either of these light yellows will produce a warm flesh tone of great delicacy. Mixed with white and alizarin crimson, these light yellows will create a cooler flesh tone of similar beauty.

Cadmium yellow medium is perhaps the nearest of the cadmium yellows to a pure yellow. Like cadmium lemon and cadmium yellow light, cadmium yellow medium, when mixed with white, forms a base for the lighted flesh areas. This mix can then be blended with each of the other flesh tones to create dependable hues for designating the lighted areas.

Cadmium yellow deep is a warm, rich yellow, tending toward orange. When mixed with white, this color will produce a warm, bright yellow-orange, excellent as a base for the strongest of the lighted flesh tones. This mix can be muted with yellow ochre, viridian, blue, or black, and will create strong, opaque flesh grays. The cadmium yellows will supply you with a considerable range of tones, all of which are useful for skin and flesh tints.

Cadmium orange cannot be surpassed for

warmth and strength. It has a variety of possibilities in oil painting, but it is chiefly valued by the portrait painter for tinting flesh tones. Mixed with white, cadmium orange gives a base for all lighted flesh tones. Mixed with white, yellow ochre, and black, it produces warm grays for blocking in shadows on the head, neck, or shoulders. Cadmium orange can be blended with white, alizarin crimson, and viridian to obtain neutral to cool shadows. Because of its strength, cadmium orange should be used in small quantities so that it does not dominate the mixed tone.

Cadmium red light, sometimes listed as cadmium red, the brightest of the cadmium reds, is perhaps the most useful. (I have already recommended it for your initial stock of colors.) This red, mixed with white, gives a luminous pink. This pink, combined with yellow ochre, cadmium yellow, or Naples yellow, will produce a powerful and luminous flesh tint. Mixed with white and viridian, cadmium red light will produce a warm gray; with white and blue, a cool gray; with burnt sienna, a fiery, intense red; with black, a luminous brown.

Although cadmium red medium is a strong shade, it represents the middle range of red color, not so rich as the deep, nor so brilliant as the light. It can be made to produce all of the same effects of the other two cadmium reds mentioned here, but in a more limited range. The medium red can be employed to produce blends of lesser strength. Cadmium red medium, when mixed with white, will give a red tending towards pink; when mixed with yellow, it will produce orange; with viridian, blue, yellow ochre, or black, it will create tones similar to those obtained with the light and deep cadmiums, but less intense. It can be used effectively with the other reds to modify a tone from light to dark or from dark to light. It is often preferable to darken or lighten one shade of red with another shade of red, as in the modeled parts of a mouth, nostril, or in the transparent areas of the ear, where a medium red is required. For such areas, cadmium red medium is the color needed.

Cadmium red deep will supply the red you need for a uniform or dress, or a note in the background. Its depth of color will force it to recede when it is contrasted with a lighter color. Using this dark color will identify the uniform, dress, or other note as secondary to the head and hands, without sacrificing the intensity of the red. Cadmium red deep can be mixed with white to make a warm, bright red; with cadmium or Naples yellow, to make a brilliant red-orange; with viridian, to produce a warm gray; with blue for a warm brown of purplish cast; with ochre for a red earth; with black for a vibrant black. It is a good, dark red.

The cadmiums, all strong, bright hues, are colors of first importance for the portrait painter. They are employed constantly to describe the tone and intensity of the major and secondary areas of the portrait. As you remember, your initial palette calls for cadmium red light and cadmium yellow light. You may find use for all the cadmiums, but not all are indispensable. Examine each color, then select the ones you prefer.

Alizarin Crimson

Alizarin crimson comes in varying degrees from dark to darker. It is a dark, cool, permanent red, a color without body, similar to a dye. This color is effective for tinting and glazing. If used thickly, alizarin has a tendency to crack. It is best used when mixed with other colors.

Blended with cadmium yellow light and white, alizarin gives a warm flesh tone; mixed with viridian and white, alizarin produces cool flesh grays; with ultramarine blue or cobalt blue and burnt sienna, alizarin provides a luminous substitute for black. Although a slow dryer, alizarin is a dependable color, one that you will use constantly. I recommend it for your initial palette.

Rose Madder

Rose madder, in light and dark shades, is a cool, transparent, dark red, similar to alizarin. Rose madder does not have much body, is slow drying, and shows a tendency to crack when applied in a thick application (impasto). Not a strong color, it is used mainly for glazing. This color produces a variety of luminous, delicate rose and pink tints most useful for ruddy flesh tones.

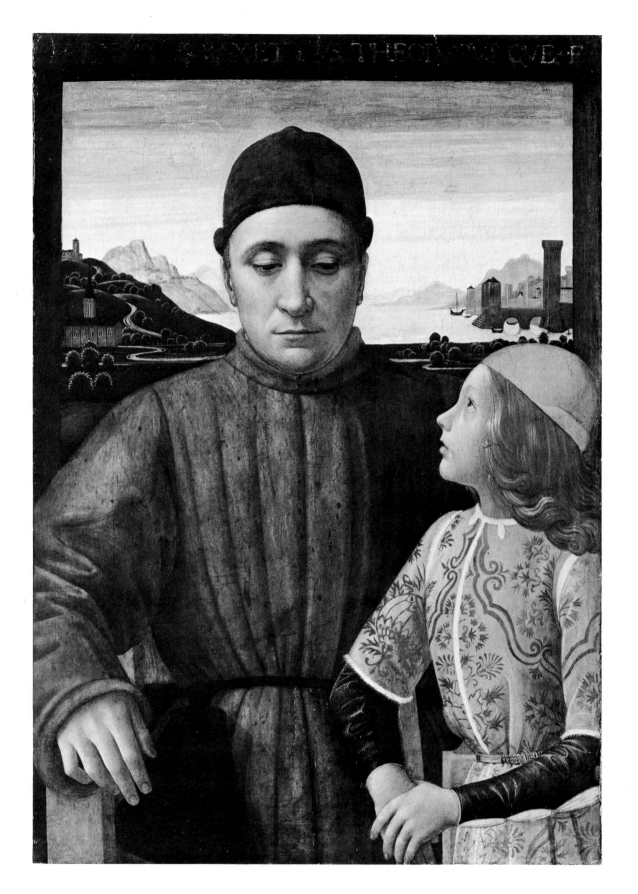

Francesco Sassetti and his Son Teodoro by Domenico Ghirlandaio.

Tempera on wood, 29¹/₂″ x 20¹/₂″. The profile represents the side, and the full front represents the frontal of the head seen on dead center. The conditions for these poses are fixed and the artist must work for his interest within their set limits. Collection, The Metropolitan Museum of Art, The Jules S. Bache Collection, 1949.

Head of a Woman by S. Edmund Oppenheim.

12″ x 16″. Imaginative use of the brush produced the soft, amorphic quality in this portrait. Courtesy, Grand Central Galleries.

In Chapter 1, I suggested a list of brushes that should be examined for inclusion in your painting set. In this chapter, I will discuss their use in more detail and later—in the demonstration chapters—you will see how these tools are applied to specific paintings.

Brushes

Brushes come in different shapes and sizes and are designed to contrast with one another, so that you may obtain greater technical variety in your work.

Brushes are made from a variety of hair. I suggest that you use brushes from two classifications: the bristle brush (made from the white bristles of the hog); and the sable brush (made from the hair of the sable, the marten, or the mink).

It is important that you work with good brushes, those designed to take advantage of the natural taper of the hair or bristle. The hair or bristle is set in the metal ferrule and each hair is turned so that it tapers inward to meet those on the opposite side of the ferrule. The natural taper of the hairs will, therefore, form a point or edge, and a brush made in this manner will always retain its point or edge.

The shape of the ferrule becomes the shape of the brush: brushes are flat or round, pointed or fanned. They are made out of long hair or long bristle, short hair or short bristle.

The longer hair or bristle is stronger and more flexible; the shorter hair or bristle is stiffer and more precise. A long flat brush will make a flat stroke and has greater spring and workability than the shorter one. The short flat brush, though less flexible in its range, is useful for flat brushwork where more exacting control and precision are desired.

Rounded brushes are for drawing and outlining: those with long hair will hold a greater amount of paint; those with shorter hair, though not holding much paint, will render a fine line.

Brushes are designed according to the following classifications: brights, flats, and rounds. The *bright* is a flat brush of short bristle, almost square in proportion, ranging in width from square to wide. The *flat,* of long bristle, ranges in proportion from long to longer. The *round* has a round ferrule and can

3
Using brushes and palette knives

Dr. Bela Schick by Joseph Margulies.

Oil on canvas, 24" x 30". By using a smooth consistency in the paint, the artist was able to achieve linear effects where he needed them. Collection, National Portrait Gallery, Smithsonian Institution, Washington, D.C.

be obtained in any size and length from small to large, short to long. Each of these designs is available in sable and bristle.

Bristle Brushes

As a rule, the bristle brush will serve to "block in" your first impressions. It will accept vigorous handling and will not lose its shape when used briskly for spreading and manipulating the heavy oil paint. For the foundation painting of a portrait approximately life size, a no. 9 bristle long flat is effective; or, for the same purpose, you might prefer a no. 9 bristle bright, of a shorter bristle.

For "laying in" facial areas, neck or hands, you might use a no. 2, 4, or 5 bristle long flat, or I suggest its equivalent in bristle bright.

A no. 1 bristle long round will have the proper spring and strength for placing nostrils, corners of lips, eyelids, and similar detail. The bristle, because of its strength, is recommended for initial "laying in" of all paint notes. It is useful for spreading the pigment and also for *lifting off* the excess color.

The filbert bristle brush is a long flat and comes to a rounded tip. When applied to canvas, this tip leaves a brush stroke with a rounded end, which can be an aid when you want to establish a convex surface. The filbert can be patted, drawn, or "hatched" and no matter what hand motion you employ, the stroke it leaves will indicate rounded form.

Somewhat softer bristle brushes are recommended for modeling and building on the surfaces initially laid in with stiffer brushes. The no. 6 and no. 9 filberts are recommended for modeling and the no. 3 for drawing.

Sable Brushes

When the forms have been firmly established, you will use small brushes to locate the features and to check proportions. The sables—large and small—are employed for refining the features. The no. 1 sable long round will enable you to produce fine, linear accents, and precise highlights.

A no. 2 sable long flat will be useful for ear lobes, eyes, lips, and other critical details; nos. 5, 6, and 7 long flat for nose, forehead, cheek, chin, and neck.

I also suggest you examine the same numbers in the sable bright variety, since you may prefer the shorter hair length.

The no. 10 sable filbert will provide a most useful tool for the delicate tinting and modeling involved in refining your portrait. In the final stages of the portrait, a no. 20 sable bright can be of use. Used dry or semi-dry (with very little medium), the large brush can be gently pulled across a freshly painted surface to soften, unify, and integrate the surface, and to solidify the painting of a forehead, cheek, or sleeve.

These brief suggestions on brushes should assist you in their initial use. In the demonstration chapters, you will see how they are used in still greater detail. You will find it to your advantage to experiment with the brushes I have described and with other brushes of different sizes and makes. Brushes will be used for different effects by each painter. By trial, you will become familiar with the possibilities of each brush and make your selection based on experience.

Palette Knives

The palette knife can be employed to produce painting effects quite varied and different from those of the brush and is often used as an adjunct to it.

The knife is available with a straight blade, and also in the form of a trowel. The straight blade is made for scraping dried paint and, if the steel is sufficiently flexible, can also be employed for painting. The trowel blade is made only for painting and should not be used for scraping anything other than wet paint.

Many interesting (often accidental) color and textural effects can be attained with the palette knife. Under the pressure of its smooth blade, the colors attain great clarity and the surface becomes enamel-like, as smooth as glass; like glass, this type of surface magnifies the richness and depth of color. Palette knife treatment is useful in large mass areas, and especially in darkened areas where the knife finish allows the dark colors to glow in all of their depth and luminosity. Because paint applied with the knife is so concentrated, you should use it only as the *final* coat.

There are palette knives of many sizes. Examine the selection and find the ones that fit your hand.

I will deal with the use of painting tools and materials in some detail throughout this book and describe their performance as they relate to my experiences. You will discover that these materials and tools give better results under some conditions than under others and you will, in time, come to recognize these conditions.

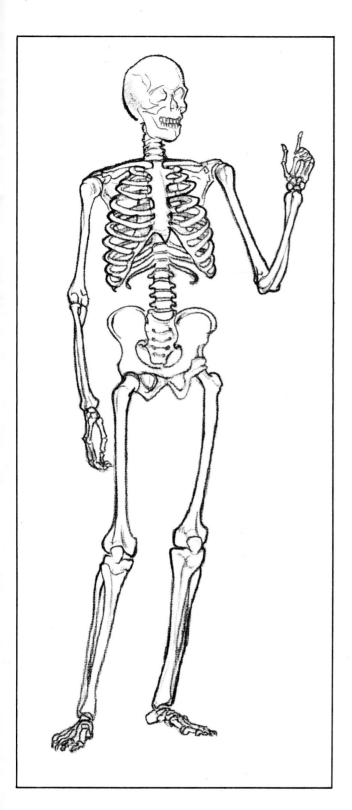

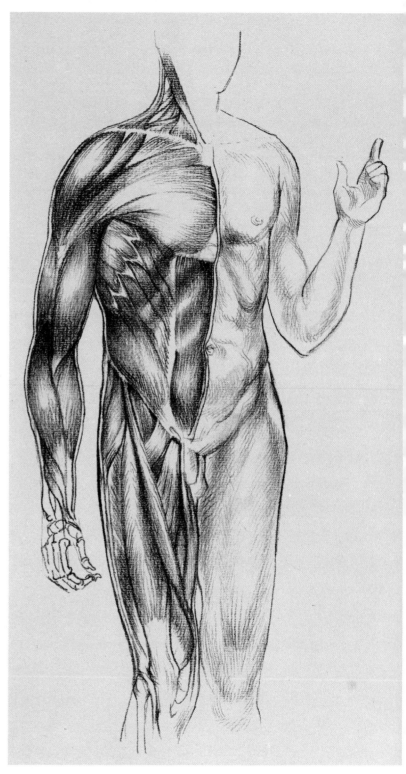

(Left) The human frame contains a skeletal, bony structure. (Right) The muscle of the body is covered by fat and the fat is covered by skin.

4
Studying figures and faces

Familiarity with human anatomy will enable you to understand the forms you will define in portraiture. The human frame contains a skeletal, bony structure which is held in place and animated by the overlay of muscle. This muscle is covered by fat and the fat by skin. Bones and muscles are functional in design; their shapes are the direct result of the work they do.

All parts of the body are supported by, suspended from, or reach to the vertebral column, and through an interlacing of these parts, the body becomes an animated whole.

Think of the head, the shoulder girdle, and the pelvic girdle as three cubical solids. Any movement between the head and shoulders will take place within the area of the neck, and any movement between the shoulders and the pelvis will take place within the abdominal area. Note that as the subject poses, the clothing will pull and fold, especially in those areas of movement, and the total effect will be live and graceful. You can emphasize and extend the movement, if you desire. Many artists do this by seating their subject in a chair placed to the side and away from the direct view of the artist. As the sitter takes his position in the chair, he is obliged to turn in his seat in order to address himself to the artist, rotating at both the abdomen and the neck and so enlivening the pose. You might also try tilting the chair forward; place a book under each back leg. The forward pitch of the chair usually prevents the sitter from slouching or sinking too deep into its upholstery.

The more you know about the function of the body, the keener your observation. Some over-all information on anatomy will suggest what you should look for when you examine the human form.

Movement

The body is constructed in a way that permits movement easily. But these movements are limited. For example: the elbow joint provides only for a forward action of the lower arm; any backward action must be performed by the upper arm at the shoulder. The elbow joint allows a limited action to the right and left and a rotary action of the wrist. The knee joint is constructed to allow for a backward swing of the leg, the forward motion being

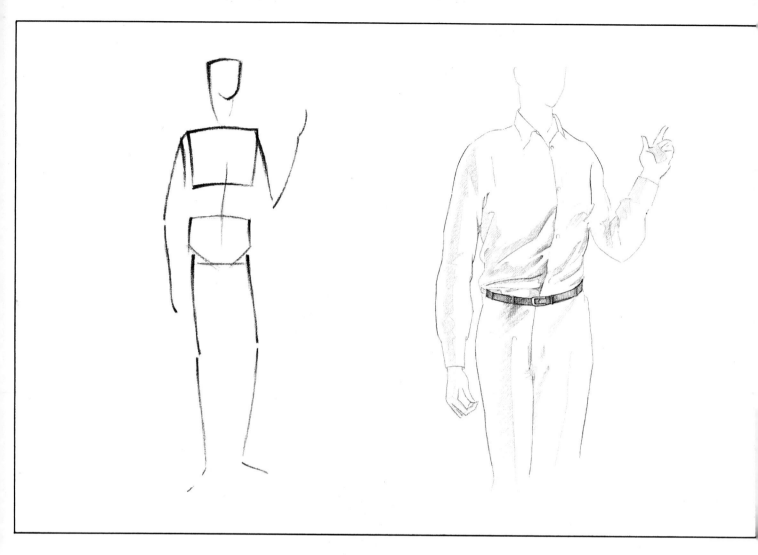

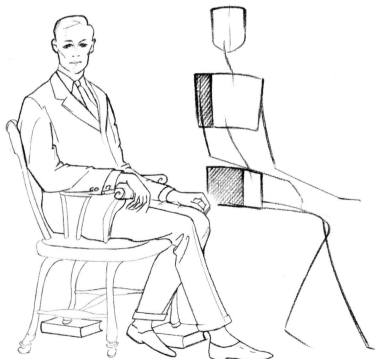

(Above left) Think of the head, the shoulder girdle, and the pelvic girdle as three cubical solids.

(Above right) Note that as the subject poses, the clothing will pull and fold, especially in the areas of movement.

(Left) The sitter—by being placed to the side and away from the direct view of the artist—is obliged to turn in his seat in order to address himself to the artist, rotating at the abdomen and neck, and so enlivening the pose.

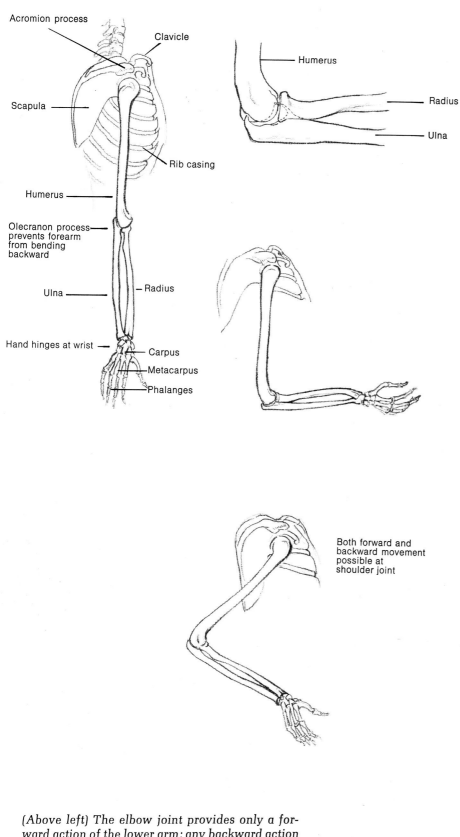

Acromion process

Clavicle

Scapula

Rib casing

Humerus

Olecranon process prevents forearm from bending backward

Ulna — Radius

Hand hinges at wrist

Carpus

Metacarpus

Phalanges

Humerus

Radius

Ulna

Both forward and backward movement possible at shoulder joint

(Above left) The elbow joint provides only a forward action of the lower arm; any backward action must be performed by the upper arm, at the shoulder.

(Right) The elbow joint allows a limited action to the right and left and a rotary action of the wrist.

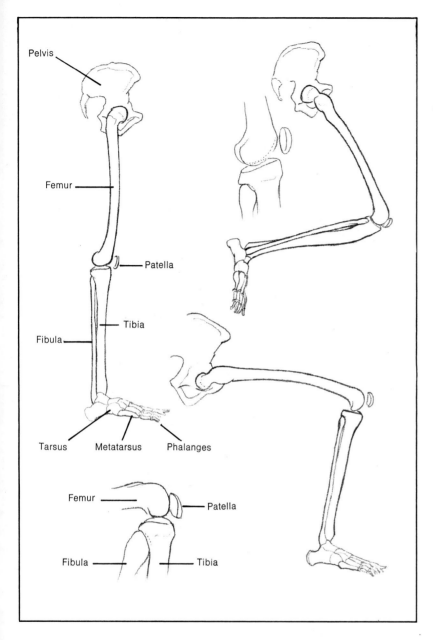

Pelvis

Femur

Patella

Tibia

Fibula

Tarsus Metatarsus Phalanges

Femur Patella

Fibula Tibia

The knee joint is constructed to allow for a backward swing of the leg, the forward motion being limited to the joint of the thigh.

limited to the joint of the thigh. The head has a prescribed sideways and up-and-down action. Hands hinge from the wrist and, in combination with the rotary motion of the elbow, have a wide degree of movement. Feet move up and down and have some sideway action, but are not as free as the hands.

The bones and muscles align themselves within these patterns of movement and you must observe these patterns when drawing. Knowing their limits will enable you to make correct observations.

Balance and Symmetry in the Body

Examine the physical action of your subject. His pose becomes a composite of the multiple, muscular action of all involved parts of his body.

Since both sides of the body are symmetrical, it is useful to observe this symmetry as a means of keeping your subject in balanced proportion. Note the different positions the body assumes to maintain its equilibrium. For example, if the figure adopts a pose resting on the right foot, this action will raise the position of the right hip in relation to the left hip. The right leg, receiving the weight of the body, tenses, while the relaxed left leg will extend and advance. In an attempt to retain balance, the head will locate directly over the supporting right heel. Consequently, the right shoulder drops and the left shoulder rises proportionately.

Search for this balance between features as well. There is a natural similarity between one feature and its opposite, between one limb and its opposite. When setting one feature into your composition, place it in relation to its opposite. Although the features are not identical, checking one feature against its counterpart can be helpful in overcoming problems of proportion and placement. Before you set the position of one shoulder or one hand, relate it to its opposite and set them at the same time.

Perhaps the pose reveals only one eye or one shoulder, what then? Carefully approximate the position of the other, and indicate a reference mark on the drawing where it belongs. This reference mark should then become the absent feature and you can relate the visible feature to that point. You must learn to

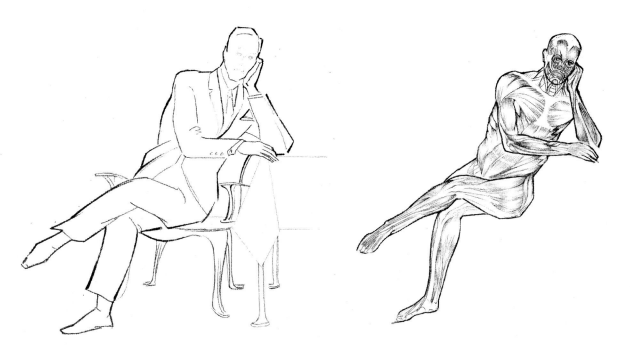

Examine the physical action of your subject. His pose becomes a composite of the multiple muscular action of all involved parts of the body.

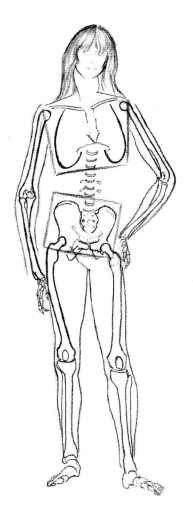

Note the different positions the body assumes to maintain its equilibrium.

Before you set the position of one shoulder or one eye, relate it to its opposite and set them together.

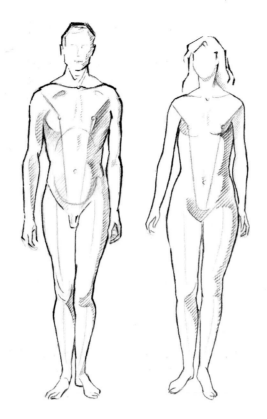

On the male figure, the widest measurement of the body is across the shoulders; on the female, the widest measurement is across the hips.

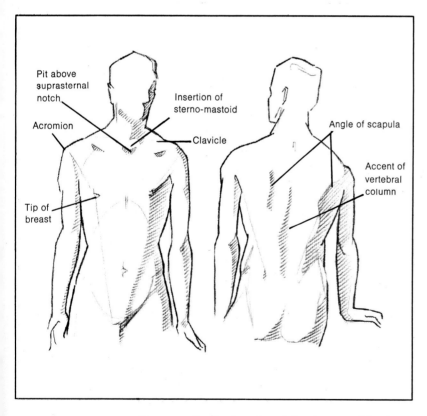

Here are the landmarks of the front and back regions of the body.

visualize the hidden anatomical forms and include them in your observations.

Planes of the Torso

On the male figure, the widest point of the body is across the shoulders; on the female, the widest point is across the hips. On both male and female, the projection of the chest is a dominant plane which extends from the acromion (furthermost point of the shoulders) to the tips of the breast. This plane picks up light. Below this plane, the form drops to meet the waistline. Above this plane, the clavicle and the insertion of the sternomastoid muscle locate the elevation of the shoulder girdle, the pit above the suprasternal notch, and the upward thrust of the neck from the chest.

On the back, the vertebral column divides one side from the other, while the angle of the scapulae—the shoulder blades—locate familiar planes on its broad expanse away from the center of the back.

Head

The head contains two parts, the cranial oval above and the facial oval below. Considering these two parts elemental, place them together like two interlocking ovals when you draw the head. This plan allows for the initial inclusion of more character in the head and you avoid the tyranny of the single, oval shape. Draw a vertical center line from which you can locate left and right horizontally the approximate position of the features.

The cranial oval crosses the facial oval at approximately the mid-point of the total head form; we shall call it the mid-point between the top of the head and the bottom of the chin. This mid-point indicates the relative position of the eyes. The length of the nose extends from the eyes to a point midway between the eyes and the bottom of the chin. The line parting the lips will fall at a point midway between the bottom of the nose and the bottom of the chin. Ears fit into the space between the line marking the placement of the eyes and the line marking the separation of the lips, if you carry these lines around to the side of the head. This plan for locating features is approximate, because each subject has his own character,

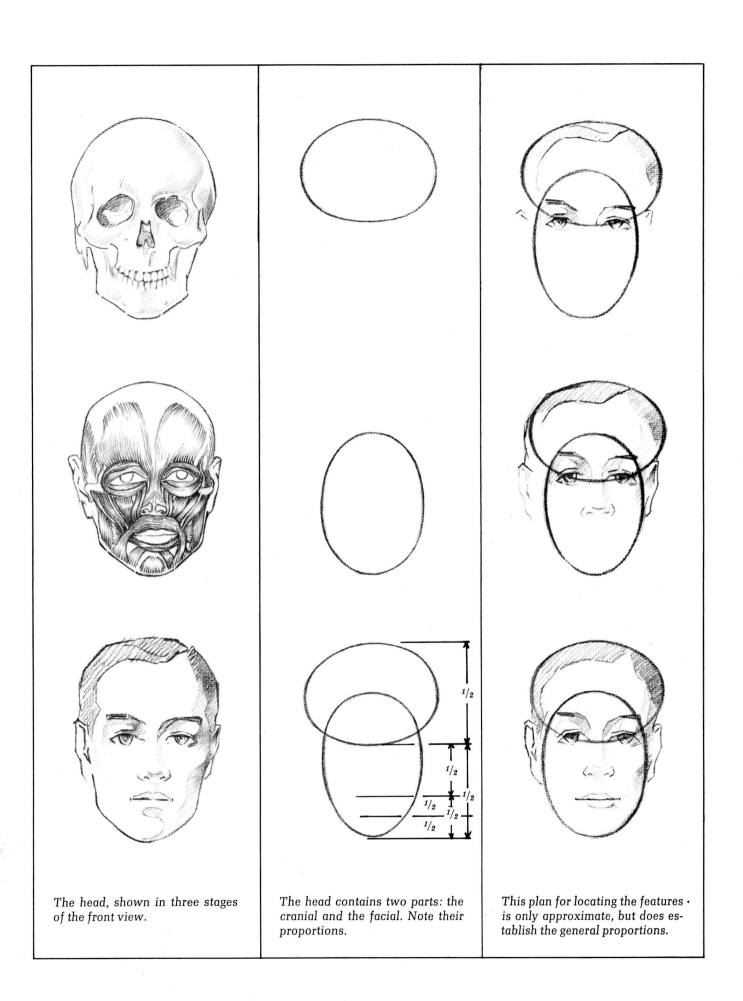

The head, shown in three stages of the front view.

The head contains two parts: the cranial and the facial. Note their proportions.

This plan for locating the features · is only approximate, but does establish the general proportions.

As you draw, first sketch in the features roughly.

When you view the portrait with a fresh eye, you should observe the eyes, mouth, and nose in this order. Notice the shapes and proportions of the features, light and dark, which are most dominant.

which will influence proportions, making slight alterations necessary.

Do not overemphasize muscular proportion when you develop the head. In portraiture, the head should be thought of as a frame for the features. Any overstatement that alters the head's simple, basic form will be distracting. The head rests on the neck which is supported on the shoulders. As the head moves, the neck will accommodate to it.

First sketch in the features roughly. This suggestive treatment provides for a sketchy approach which allows for gradual development and refining. Eyes will be given important definition. Suggest the mouth, the most mobile feature, which activates rapidly with the slightest change of expression. The nose, while carefully placed, should be understated. When you view the portrait with a fresh eye, you should observe eyes, mouth, and nose—in this order.

The proportions of these features must now be identified with the accompanying shapes of light and dark that animate the surface of the face. The large plane of the forehead, the bridge of the nose, the prominence of the cheek, and the projecting chin all catch light. You will notice pockets of dark areas in the recess of the brow, the pocket between the upper eyelid and the bridge of the nose, under the nose, and under the chin. As you develop the features, model these areas of light and dark.

Contour of Head

While placing the features and noting the character of each, study the contour of the head. As you move around the head, notice that the contour constantly changes and that whatever happens on the surface of the head seems more critical when it is caught up on the contour. This is common in the case of an eye in a three-quarter view portrait.

As a feature appears on the contour, study it carefully. As you render the feature, imagine it in its full form—visualize the total shape— as you would in sculpture. Let your initial sketches carry around the contour, beyond the point of visibility. Your sketches should pursue the feature from a point nearest to you, to its diminishing on the contour, and finishing

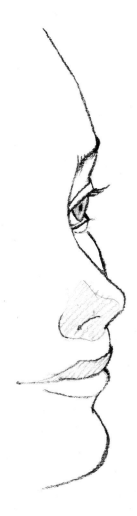

Your sketches should pursue the feature from a point nearest to you, to its diminishing on the contour, and finishing behind that point, around the contour.

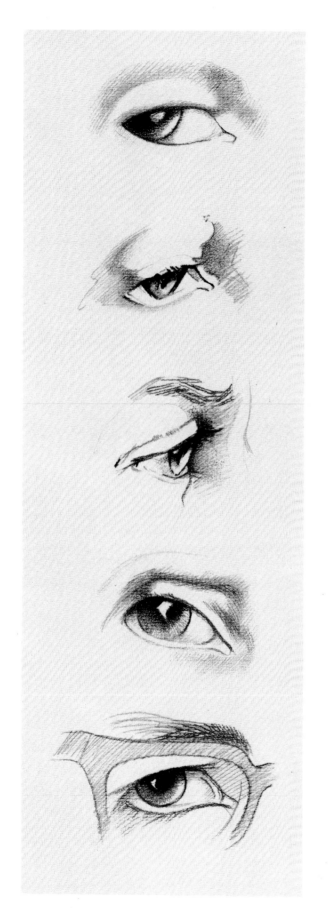

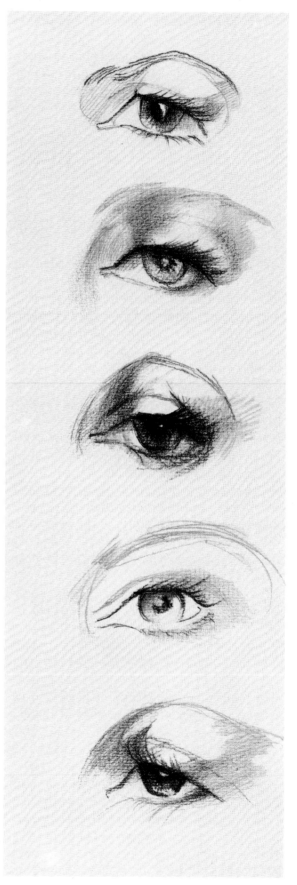

The eye is the mirror of personality.

behind that point, *around* the contour. This searching study will surely conclude your statement with emphasis, giving the feature and the area involved a sense of third dimension.

Eyes

When you address yourself to your subject, you look him in the eye, for the eye contains the image of his personality, the focal point. Therefore, the eyes must be especially considered by the artist.

The visible portion of the eyes contains the pupil, the iris, and part of the sclera, or white. Surrounding this are the brow, the lids, the lashes, and the lacrimal papillae. The socket for the eye is a hollow orbit in the skull, into which the eyeball fits. Within the socket, the eye is protected, while its position insures an extensive range of sight. The eyeball is held in place and animated by the four rectus muscles: the first, superior; the second, inferior; the third, lateral; and the fourth, medial. The eyelids make a shield or protective covering, and when they are closed, the rounded form of the eye can be easily seen. The upper lid is raised and lowered, folding and unfolding like a bellows; it is longer than the lower lid, extending farther at the outside corners, covering much of the eye when it is closed.

Because of its attachment to the orbicularis oculi—the muscle encircling the eye socket—the upper lid arches inward, being higher toward the bridge of the nose, while the lower lid, following the zygomatic projection—the high part of the cheek—reaches its lowest point of curvature lateral to the middle of the socket and away from the nose. If a construction line were projected between these two extreme points, it would extend from the outside of the cheek inward, meeting the construction line of the opposite eye on the middle of the forehead. It does not extend on a vertical course, as many people think. As the eye turns, the lids adjust slightly to facilitate vision, but this will not alter the basic position of the construction lines.

As you view your subject, the light coming from above, you will notice the pronounced dark shadow cast across the eye by the upper lid. This dark creates an accent that blends with the pupil, cloaking it in mystery.

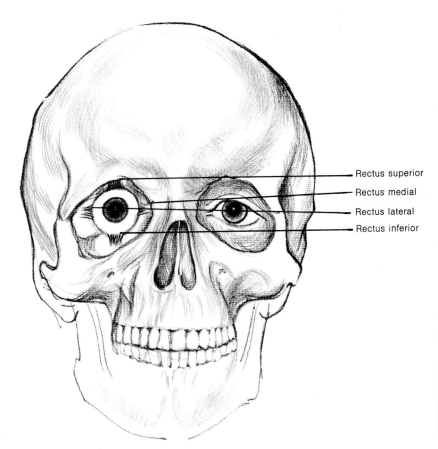

Rectus superior
Rectus medial
Rectus lateral
Rectus inferior

Within its socket, the eye is protected, while its position insures an extensive range of sight.

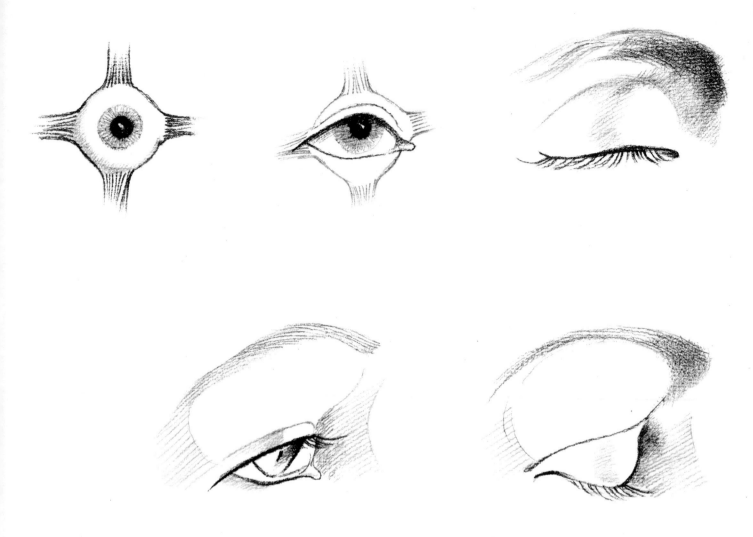

The eyelids make a shield or protective covering and when they are closed, the rounded form of the eye can be easily seen.

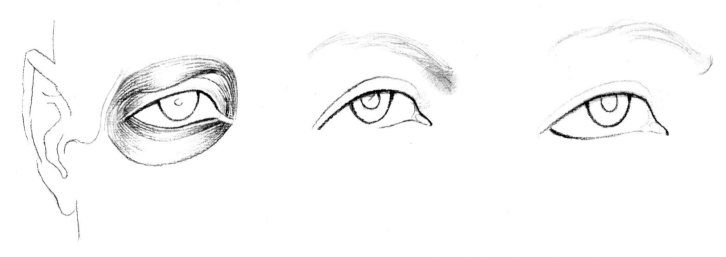

The upper eyelid arches inward, while the lower lid reaches its lowest point of curvature lateral to the middle of the socket and away from the nose.

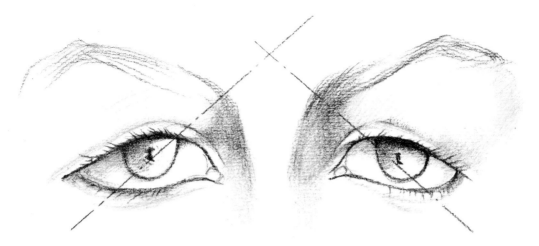

If a construction line were projected between these two extreme points, it would extend from the outside of the cheek inward, meeting the construction line of the opposite eye on the middle of the forehead.

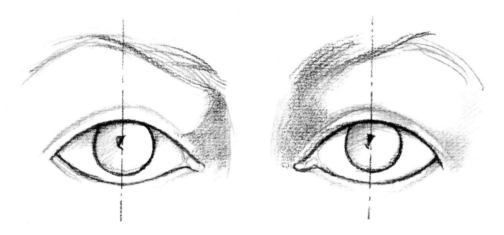

The construction line does not extend in a vertical course as many people think.

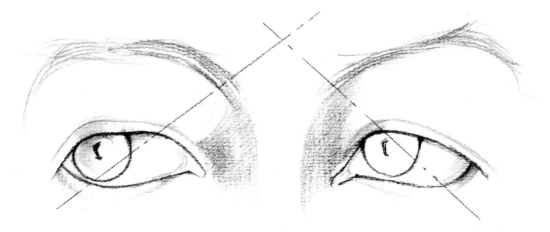

As the eyes turn, the lids adjust and raise slightly to facilitate vision, but this does not alter the basic position of the construction lines.

You will notice the pronounced shadow cast across the eye by the upper lid. This dark creates an accent that blends with the pupil, cloaking it in mystery.

When the eye is in repose, the iris is partly hidden under the shield of the upper lid.

The range of expression from sorrow to laughter does not occur within the eye, but, rather, in the movement of the lids and in the muscles of the surrounding areas.

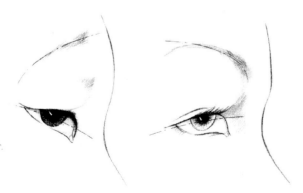

Generally speaking, the relation of the eyes to the brow in the oriental is in reverse to that of the occidental.

The dark of the upper lid becomes one of the dark "landmarks" of the head, like the eye, the dark beneath the brow, the dark caught between the eye and the bridge of the nose, and the other darkened areas. The top edge of the lower lid, in turn, will pick up the light and will connect with the lights of the eye and relate to other lighted, adjacent areas. When the eye is in repose, the iris is partly hidden under the shield of the upper lid. Generally, no part of the iris is ever covered by the lower lid, although the eye is always partially covered by one of the lids.

The eye rests securely in its orbit and can move only within the socket. The range of expression from sorrow to laughter does not occur within the eye, but rather in the movement of the lids and in the muscles of the surrounding areas. Take laughter, as an instance. Laughing energizes certain muscle fibers, the result of a sudden change of mood, and contracts the muscles of the mouth, cheek, and forehead. The pull that results from this contraction will raise the eyelids, changing the frame of the eye. In extreme laughter, the iris becomes partly covered by the lower lid, freed from the covering of the upper lid. In other words, the expression "laughing eyes" really means laughing eyelids.

Because of the position of its socket, the eye is slightly lower at its outside tip and rises slowly to meet the bridge of the nose at the point of its lacrimal papilla. The brow, however, reverses this order and rises from the bridge of the nose, running along the orbital ridge about two thirds of the length of the upper lid, when it drops slightly in a curve to the temple.

In some orientals, the facial structure is flatter, the brow shallow, and the cheek bones high. Muscles and skin stretch tightly over the prominences, and the features all seem nearer to the surface. Eyes become slits as the overhanging lids conceal thin lashes. Generally speaking, the relation of the eyes to the brow in the oriental is the reverse of that of the occidental.

Eyes will continue to intrigue the artist. It is his first point of interest and one of the last features for considered, critical study as the portrait nears completion. Study them closely to ensure a more convincing portrayal.

Mouth

The mouth animates the face more than the other features. It has pronounced movement of expression and will require some concentrated effort to capture its character. Approach it in a sketchy manner and keep it this way until you are ready to make your final statement. The mouth of a woman is rich and full and can be painted prominently, while a man's mouth, less vivid, may often blend with the lines of the cheek and become part of the overall proportion of the jaw.

The mouth is composed of two lips and, like the eye, is encircled with an orbicular muscle, the orbicularis oris (A), which accounts for some of the fullness around it and which gives it infinite variety and expressive subtlety.

Although the upper and lower lips parallel and complement each other in forming the mouth, they vary somewhat in their shape. The upper lip, which overhangs the lower lip, is influenced by the philtrum (B), a median groove which divides the upper lip form into a right and left side and which continues across the lip to its lower border (C). The lower lip, under and just slightly behind the upper lip, moves across the jaw without interruption.

Fullness marks the character of the mouth, and pink to red is its color range. The light and dark areas of the lips are subtle and varied. There is a slight undercut of halftone in each corner of the upper lip and a corresponding light area in the corners of the lower lip, balancing halftone with light. The philtrum of the upper lip picks up light, and the shadow, under the lower lip, creates a balanced indication of dark. As another interesting note, although the philtrum is light, the upper lip is dark (in shadow) and while the accent below the lower lip is dark, the lip itself catches the light. This action of light and dark opposites creates the interest.

There is no line *around* the mouth. The only actual line of the mouth appears in the parting of the lips. Their upper and lower borders are merely a change in the grain of the skin covering of the lip from that of the face. The redness of the lips indicate that their skin covering is an extension of the membrane which lines the inside of the mouth.

An indication of shadow, often associated

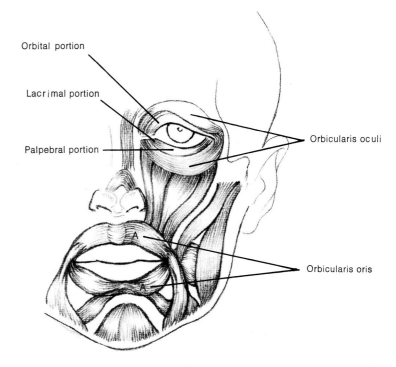

The mouth is composed of two lips and, like the eye, is encircled with the orbicular muscle, the orbicularis oris (A), which accounts for some of the fullness around it and which gives it infinite variety and expressive subtlety.

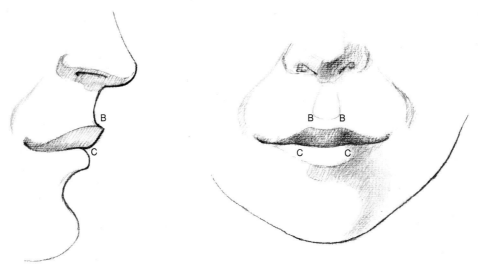

The upper lip which overhangs the lower lip is influenced by the philtrum (B), a median groove which divides the upper lip form into a right and left side and which continues across the lip to its lower border (C).

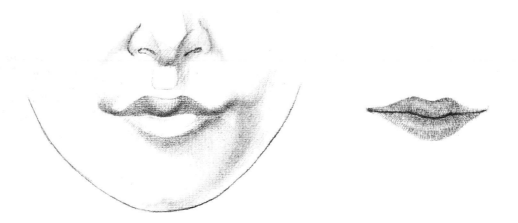

Although the philtrum is light, the upper lip, in shadow, is dark. While the accent below the lower lip is dark, the lip itself catches the light. The only actual line of the mouth appears in the parting of the lips.

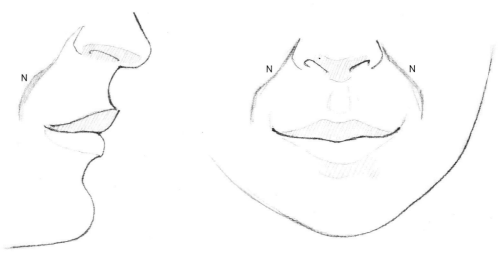

The shadow (N) caused by the distribution of superficial fat, much less in the area of the lip than in that of the cheek, is known as the nasal-labial groove.

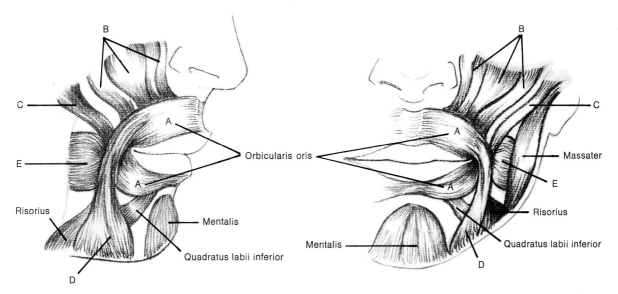

The nasal-labial groove occurs at the insertion of the cheek muscles, namely at quadratus labii superior (B), zygomaticus (C), and the muscles of facial expression, triangularis (D), and buccinator (E), behind the orbicularis oris (A) which encircles the mouth.

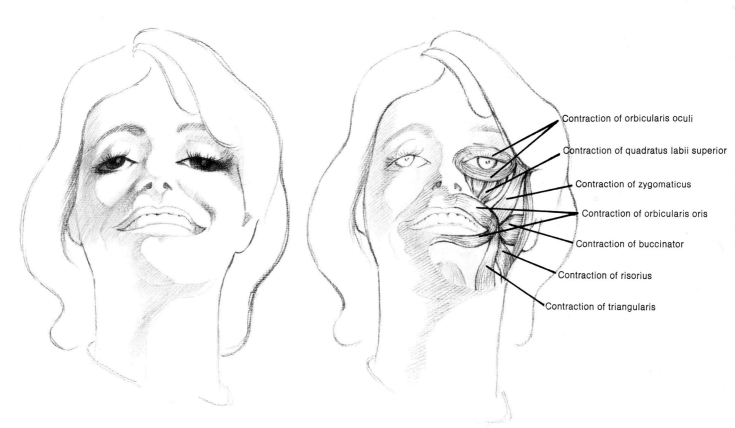

What muscle action animates this smile? The smile is animated by contractions of the orbicularis oris, orbicularis oculi, quadratus labii superior, zygomaticus, buccinator, risorius, and triangularis.

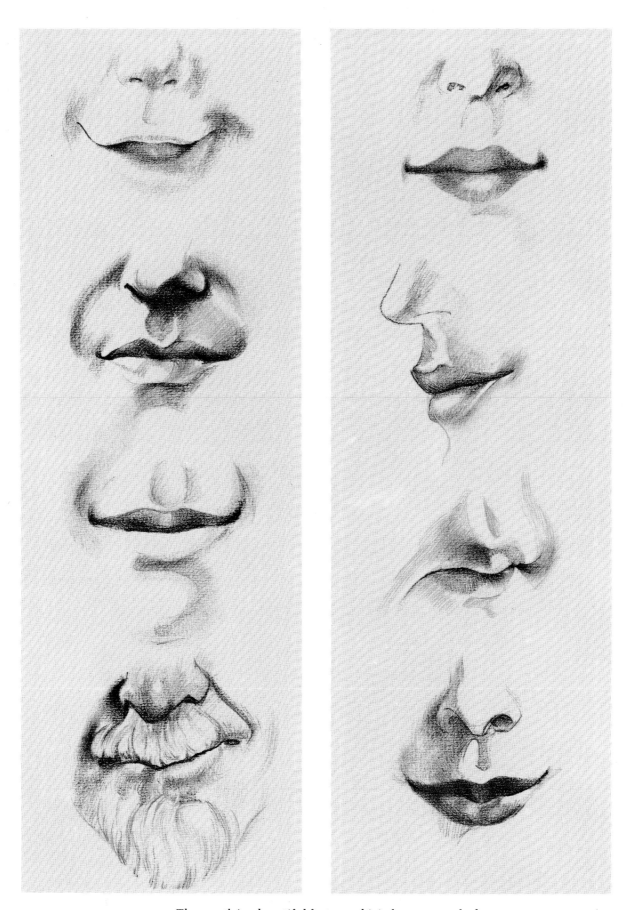

The mouth is a beautiful feature which does not need adornment or exaggeration.

with the mouth, runs from the wing of the nose around the outer corner of the mouth, and separates the cheek from the area of the philtrum. This shadow, caused by the distribution of superficial fat, much less in the area of the lip than in that of the cheek, is known as the nasal-labial groove (N). It occurs at the insertion of the cheek muscles, namely at quadratus labii superior (B), zygomaticus (C), and the muscles of facial expression, triangularis (D), and buccinator (E), behind the orbicularis oris (A), which encircles the mouth.

This area of the face is important because it describes character. In a young face, it is no more than a dimple. In a woman's face it must be underplayed, since it is the area where wrinkles and skin folds appear. In a man's face, especially if he is elderly, this indentation can often be given as much importance as the mouth. It can suggest the trace of a smile while no smile is apparent on the mouth itself. It is a linear form to be studied and used when you want a face of strength and firmness in your portrait.

The mouth is a beautiful feature which does not need adornment or exaggeration. Render it with understanding and subtlety; it will prove a constant source of fascination for the observer.

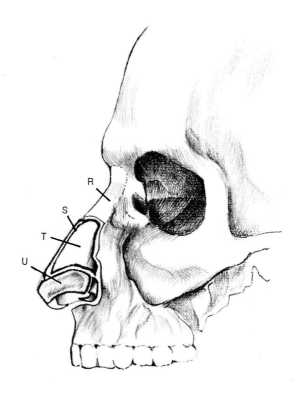

Nose

Although the nose occupies the central facial area, it should not be over-emphasized. You must fully comprehend its structure. Study it carefully, render it well. Just as a woman powders her nose to reduce its importance, you should underplay it in your painting. Framed by the brow, cheeks, and upper lip, there is individuality and character contained within the forms of the nose.

The structure of the nose is partly bone (R), but the prominence is predominantly of cartilage, (S) and (T). At its summit, the nose is rooted in the forehead (R), and this portion covers the right and left nasal bones. As it moves downward, its ridge becomes the cartilage of the septum (S). At its base, the pair of greater alar cartilages (T) and lesser alar cartilages (U) make the sides and wing forms which embrace the nostrils. At the point where the wing of the nose meets the cheek, observe

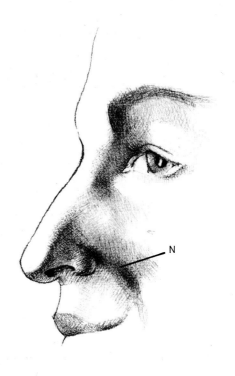

The structure of the nose is partly of bone. But the prominence is predominantly of cartilage.

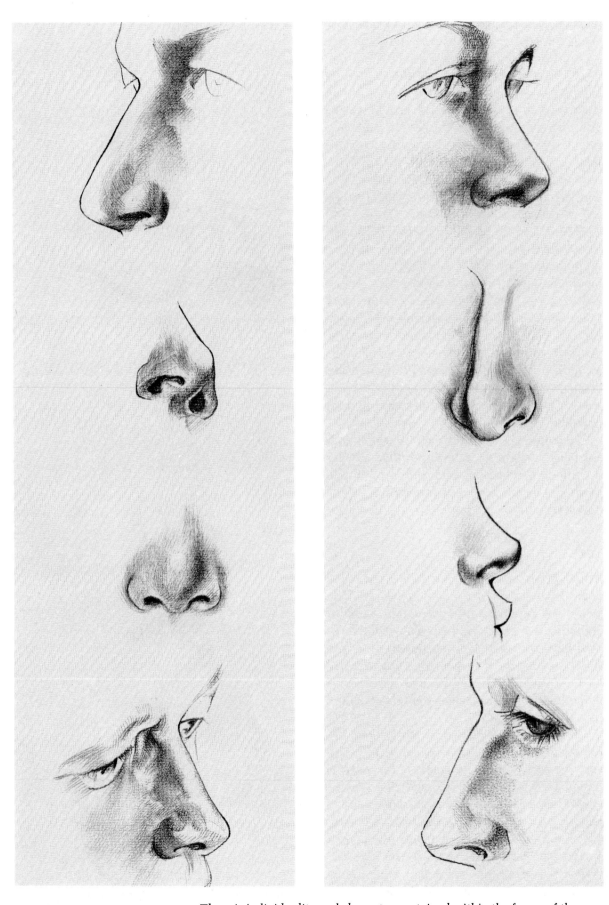

There is individuality and character contained within the forms of the nose.

the nasal-labial groove (N), just previously mentioned.

The eyes, mouth, and nose are the three features which contain the principle source of facial expression and should be considered in just that order.

Ears

The organ of hearing is made up of three parts, the external, the middle, and the inner ear. It is the external ear which concerns us, since it is the only visible part. The ear is attached to the side of the head about midway between the forehead and the back of the cranium. It is an ovoid shape and its outer surface is a multiform convolution of cartilage which acts as a baffle to capture, enclose, and direct sound to the ear drum. In short, the ear is an expanding spiral designed to catch and funnel sound.

On this form, each different level or track follows a separate channel that moves like the thread of a screw from head to point. The outer rim is called the helix and moves from the lobe to the concha, the acoustic baffle. An inner rim, the antihelix, follows the same course and terminates in the concha cavity behind the helix. To the side of the cheek, a small rounded eminence—the tragus—guards the opening of the ear. These four portions—the ear lobe, the helix, the antihelix, and the tragus—should be studied and properly placed when drawing the ear. Like the facial features, the ear has its character, its angle and position, and its essential shape will contain unique proportions and characteristics directly relating to the facial features and to the individuality of your subject.

All features are critical and your success in portraiture will depend on your skill in reproducing and properly relating them. While you set in features, it is good practice to focus on an adjacent area which you see out of the corner of your eye. For example, while rendering the right eye, focus on the left eye. Even though no two features are exactly the same, this practice will help you to locate their placement properly. This will insure each feature's location before you describe its specific characteristics.

Some people have ears that fan out from the head; some have large noses; some have pro-

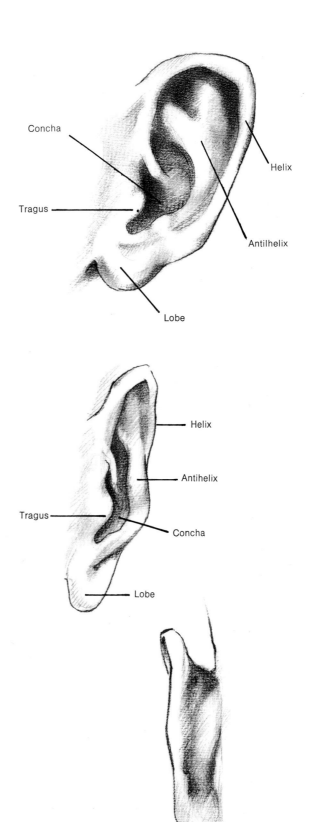

The ear is an expanding spiral designed to catch and funnel sound.

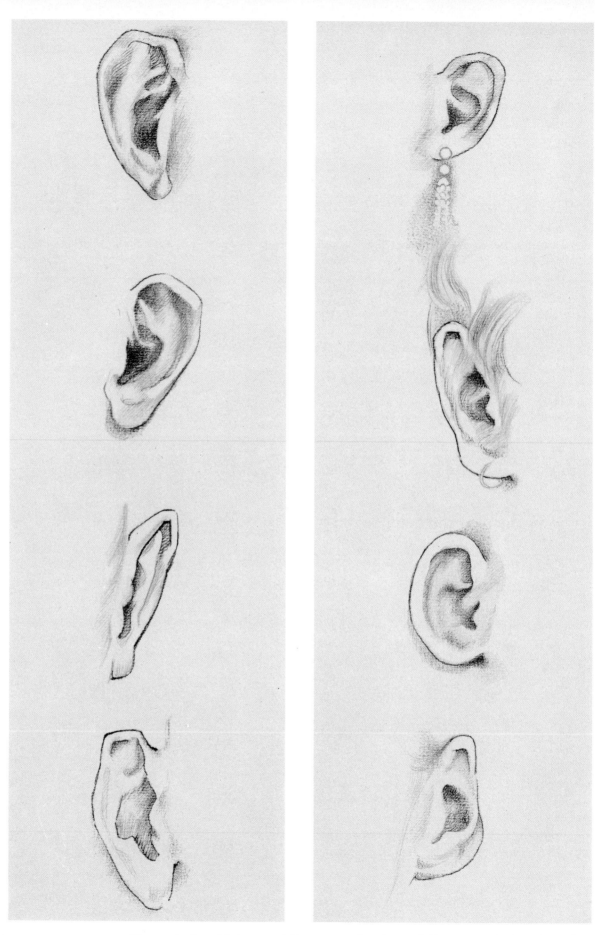

The ear is an ovid shape and its outer surface is a multiform convolution of cartilage which acts as a baffle to capture, enclose, and direct sound to the ear drum.

truding lips; still others have bulging eyes. Bear in mind these distinctions, pose the model to minimize them, beware of excessive distortion. Emphasize the favorable characteristics. Avoid any semblance of caricature.

Hands

Hands are as individual and personal as the features of the face and are most expressive of character. The fingers operate against the thumb. Compare the hand to a claw. Like the claw, the construction of the hand emphasizes the position of the index finger and its relation to the thumb. If the hand is moved to pick up a pin or to handle a small instrument, the index finger and thumb are generally employed. As the weight of the object is increased, other fingers are used to add strength to the grasp. When drawing the hand, be sure to study the position of the first finger in relation to the thumb. Once you see this, you will capture the character of the hand and it will be easy to place the other fingers.

You will detect the joint of the wrist below the cuff of the sleeve where the two bones of the forearm—the radius and ulna—meet and join with the carpal bones of the hand. Such a joint marks a break in the anatomy, creating a new plane, making a new directional movement. On the back of the hand, tendons and knuckles create a familiar pattern.

The palm of the hand is hollow, with the pollicis muscles (P) making a noticeable bulge at the thumb. The body of the hand is longer on the palm side and produces folds and ridges when it is closed. The second finger is the longest; the first and third, somewhat shorter, are of approximately equal length. The last finger is the shortest. Each finger tapers to a graceful end and a fingernail terminates the tip. It is useful to make a critical study of the fingertips, noting the position and angle of each tip in relation to the others. If you study the hand carefully, you will have effective results in a key portrait area.

Feet

Hands and feet are constructed similarly, although in portraiture the feet are seldom emphasized. Where the hand has a hollow palm,

Like the claw, the hand emphasizes the position of the index finger and its relation to the thumb.

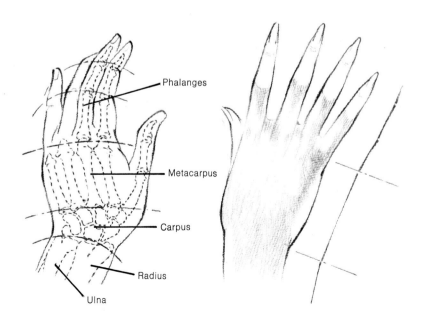

Phalanges

Metacarpus

Carpus

Radius

Ulna

The two bones of the forearm—the radius and the ulna—meet and join with the carpal bones of the hand. The wrist creates a new plane.

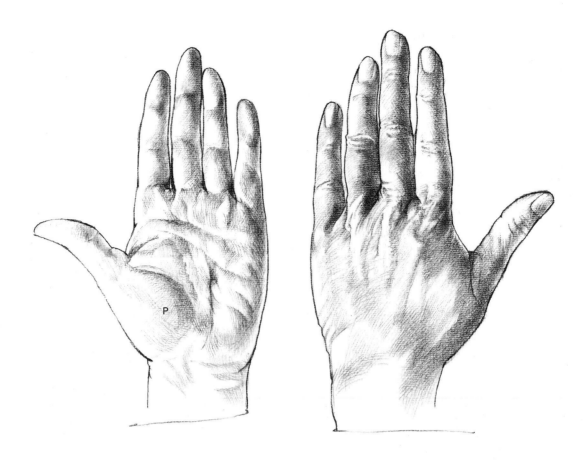

The palm of the hand is hollow, with the pollicis muscles (P) making a noticeable bulge at the root of the thumb. The second finger is the longest; the first and third, somewhat shorter, are of approximately equal length. The last finger is the shortest.

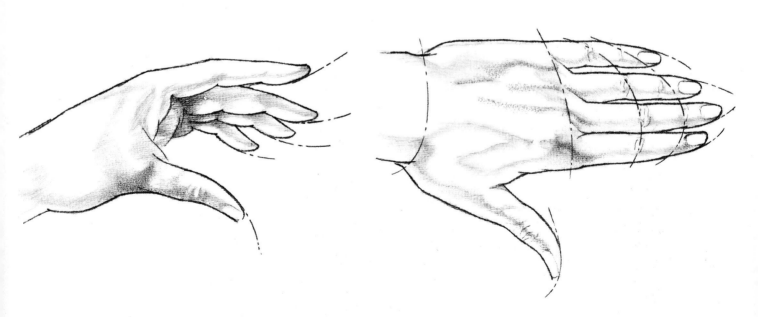

Each finger tapers to a graceful end and a fingernail terminates the tip. It is useful to make a critical study of the fingertips, noting the position and angle of each tip in relation to the others.

If you study the hand closely, you will have effective results in a key portrait area.

the foot has a hollow arch. The arch lies between the heel and the ball of the foot. Just as the design of the hand relates thumb to fingers, so the proportion of the foot separates the large toe from the others. Just as the relaxed hand shows thumb turning away from fingers, so the relaxed foot shows the large toe turning slightly upward, while the four smaller toes turn down in a gripping action. Your subject will generally be wearing shoes. If you understand the construction and proportion of the foot, you will understand the shape and character of the shoe.

No matter how you place them, feet should be considered as they relate to one another. Hands have a wide, expressive range and can be portrayed individually as separate units. Feet, usually seen in shoes, are related as a single unit.

Hands and feet are constructed similarly—where the hand has a hollow palm, the foot contains a hollow arch.

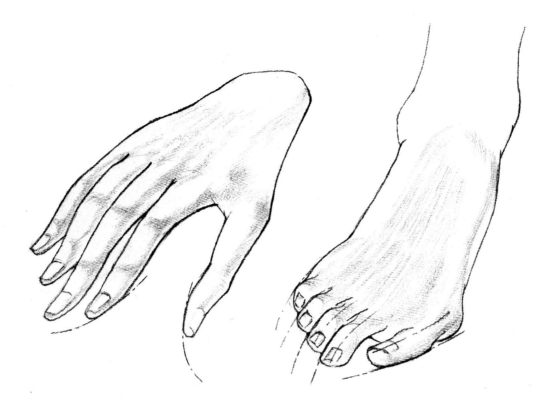

Just as the relaxed hand shows the thumb turning away from the fingers, so the relaxed foot shows the large toe turning slightly upward, while the four small toes turn down in a gripping action.

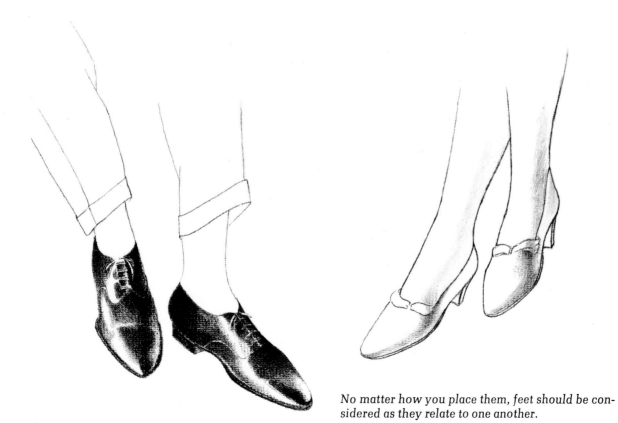

No matter how you place them, feet should be considered as they relate to one another.

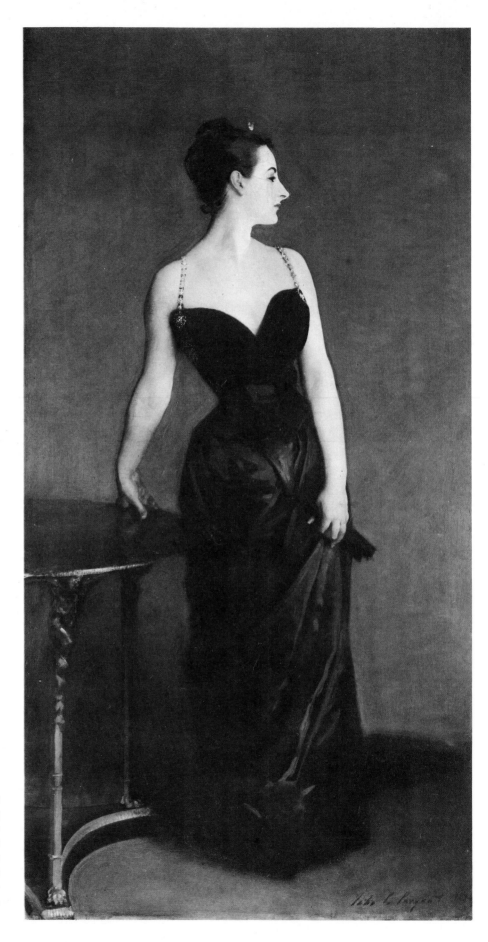

**Portrait of Madame X
(Mme. Gautreau)**
by John Singer Sargent.

*The profile is appealing because
so much can be contained along
the edge. As you begin the out-
line of the profile, carefully relate
the angle of the forehead and the
direction of the bridge of the
nose. Collection, The Metropoli-
tan Museum of Art, Arthur H.
Hearn Fund, 1916.*

One of your most elementary decisions in portrait painting will be your choice of the appropriate view of the head you are about to paint. Basically, there are three possible views —profile, three-quarter, and full front—and each has its own particular characteristics and advantages. Naturally, there are many possible variations within those three basic categories. You should experiment with every possible view and combination of views.

Profile Portrait

Of all the positions of the head, the profile distributes the features most evenly. The profile is appealing because so much can be contained along the edge.

If you choose to do the profile, remember that its outline contains the key to success. As you begin this profile outline, carefully relate the angle of the forehead and the direction of the bridge of the nose. When you draw the mouth, do not make the philtrum too small or the upper lip too narrow, so that they might be dominated by the projection of the nose. As you place the nostril and the line of the mouth which indicates the separation of the lips, relate the angle of one to the other. The profile will show the variation that usually exists between the upper lip and the slightly broader lower lip. Since you are only doing one side of the mouth, avoid the tendency to make it too narrow. The mouth assumes considerable importance in the profile because it competes with only one eye; study it carefully, place it well, and give it the fullness it requires.

Because the profile registers along the center line of the face, within so limited an area, any pronouned anatomical variations along this line become magnified. This is particularly true of the nose and chin. Do not overhook the nose, or overdevelop its tip, or allow it to seem to project too far.

In a three-quarter to full face, an advancing nose or receding chin can be contained or concealed either by strengthening the surrounding anatomical form, or by intensifying the color. But if the subject has a receding chin, you must record it as such on your profile. Should the chin seem weak, it is possible to gain strength—without distorting it—by emphasizing the prominence of the cheek and the jaw

5
Views
of
the
head

The Hon. Edward N. Allen,
as Lieutenant Governor of Connecticut,
by Furman J. Finck.

At or near the three-quarter position, two views of the head are visible at once. Collection, State House, Hartford.

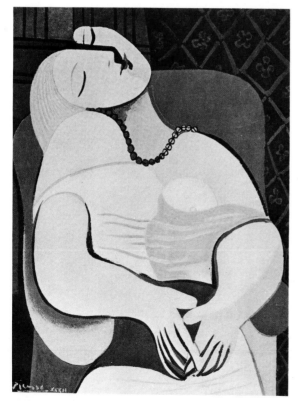

Marie-Therese Walter (The Dream)
by Pablo Picasso.

In this single portrait the artist has incorporated both profile and full front view. Courtesy, Mr. and Mrs. Victor W. Ganz.

line, by straightening the line that runs from the underside of the chin up to the ear, and by minimizing any indication of a double chin. An advancing chin should be balanced with the projection of the nose by considering similar means.

There is a tendency in the profile to slight the indentation of the brow—the area from which the bridge of the nose rises—not making it deep enough. As you place the eye, remember that its socket is part of this indentation and you should allow ample space for it. Make certain that the eye is set far enough in and is not crowded against the profile line.

Focus on the zygomatic prominence of the cheek and the temple, rather than on the ear. You will see the side plane of the cheek and temple as it moves around and becomes the frontal plane of the head, then again becoming a side plane as it describes the nose. A reminder: careful study will enable you to place the eye correctly within this passage, for it is couched within this double curve. The outer tip of the eye begins on the curve, the eye resting on the frontal plane and the lacrimal papilla turning with it as it becomes the side of the nose. In this position of the eye, you can easily compare the larger upper lid, and its long lashes, with the smaller lower lid.

The ear will mark the plane nearest to you. Like the nose, the ear should not be rendered so that it seems too large. It is secondary to the frontal features—the eyes, nose, and mouth—and, although the portrait is in profile and the ear is shown in full view, it must not dominate the portrait.

Three-Quarter View

As the head is moved from profile to full view, the positions obtained at or near the three-quarter view are most often sought by the portrait painter, for here there is greater variety. At or near this position, two views of the head are visible at once, and the painter obtains an illusion of three dimensions as he incorporates into his study both front view and side view. This position of the head makes visible the second eye and cheek, and their relation must be studied for form and placement.

The central profile line, which dominated the profile portrait, now becomes a construc-

tion line, and it should be located in this three-quarter view. At this time, also establish the line separating the front from the side plane. This line runs from the hairline between forehead and temple, behind the outside corner of the eye, over the zygomatic projection, across cheek and jaw. On or between these lines, you must now locate, in order, the position of the eyes, the brow, the length of the nose, the line dividing the lips, chin dimple, the location and size of the ears.

If you decide on a shallow three-quarter view, and the far eye or far corner of the mouth touches the contour, or disappears around the edge, make certain that the lines describing these features move around the contour; they should be drawn to turn the edge.

Avoid the tendency to place the mouth too close to the nose. It is less disturbing to have the philtrum and upper lip a trifle too wide than it is to have this area too narrow.

As you move from three-quarter to full view, the frontal plane is emphasized and the facial features cover this larger area. In this position, the head is almost in full view, but one ear will be out of sight or, if still in view, will flatten along the far side. As the head is turned toward full view, the foreshortening of the side plane becomes more pronounced. In contrast with the flattened ear of the far side, the ear on the near side will take on fullness. This variation must be correctly noted to insure the solidity of the head.

Full Front View

The full front view is attained when each proportion is seen directly in balance with its opposite. There is a formality in the full view; the choices are limited and the artist must work within their range. The full front view, like the profile, becomes a pattern.

Because of the even distribution of interest, there is a superficial tendency towards sameness and some flatness and loss of interest may result. But the two sides of the face are not exactly the same and this is the opportunity to explore their differences. Be sure to emphasize the foreshortening so that the nose will project from the face and the sides of the cheeks and the ears will recede.

The profile represents the side, and the full front represents the frontal of the head seen on dead center. The conditions for these poses are fixed and the artist must work for his interest within their set limits. Often the subject can best be portrayed to advantage in one or the other of these poses and the limitations involved usually demand a stylized presentation.

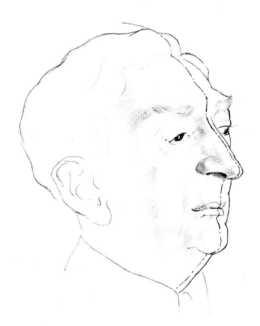

The central profile line, which dominated the profile portrait, now becomes a construction line, and it should be located in this three-quarter view.

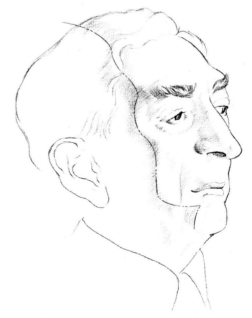

When doing the three-quarter view, also establish the line separating the front from the side plane.

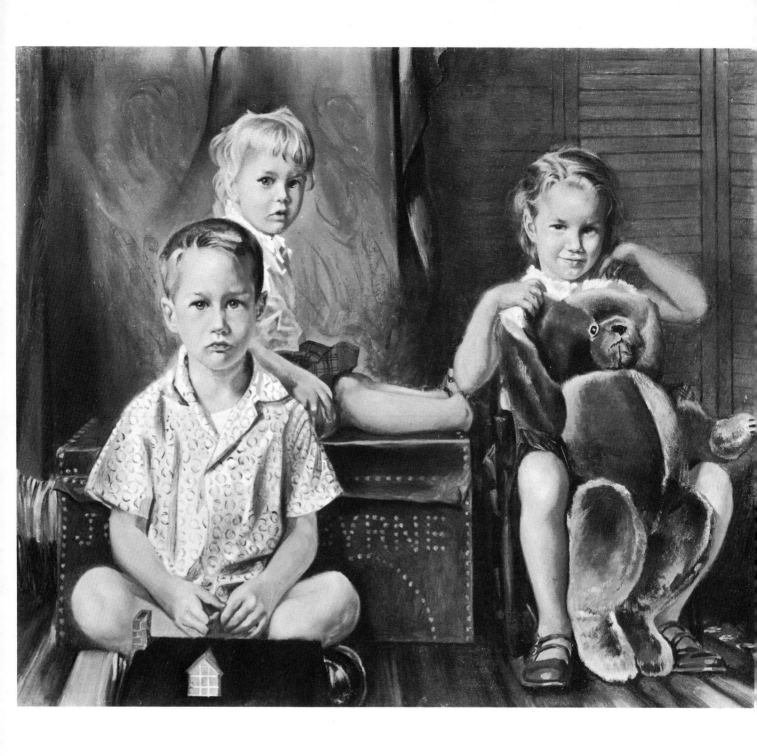

The Byrne Children by Furman J. Finck.

Oil, 24″ x 30″. I used a reader when I painted this triple portrait. Posing had to be established in the young sitters' minds as the purpose for their visit. Even though I worked on one child, two were always engaged for the pose. Collection, John Byrne.

What is a good portrait? Simply stated, a good portrait is a living statement about a person. The portrait is a successful combination of your understanding of your subject and your mastery of the medium.

Putting the Sitter at Ease

There is romance in portraiture. When you paint a person you must come to know and like him. Then the commission to paint him becomes the opportunity to paint a friend. When you meet a stranger whose portrait you will paint, make him a friend before you begin. As a friend, he will lend himself to your project, cooperating with interest and understanding.

The conquest of your subject—winning his confidence and putting him at ease—can be a fascinating and intriguing adventure. In all of your painting experiences, none will be more varied nor more interesting than your working relationship with the model.

After a while, when techniques become familiar, your work in portraiture will develop and intensify as your experience with people grows. Your paintings will come alive. A sitter's personal traits and character are not always easy to define in terms of design and color; but as you learn to capture an attitude, a pose, a gesture peculiar to your subject, you will greatly increase the human content of your work. An observer, studying your portraits, will feel that he is in contact with real people.

Your First Session

Your first session with the sitter should be devoted to getting acquainted. Feel your way with him; put him at ease. Be a good listener. In a casual give-and-take conversation, what can you find out about his professional accomplishments, his special interests? The subject will delight in telling you about himself. The atmosphere grows casual; the sitter begins to feel at home. He chats with you, exchanges ideas, expresses opinions. While he walks about the room, he examines a sketch, picks up a book, seats himself in a chair.

In this atmosphere, the psychological advantages are obvious. You have an opportunity to build rapport with your subject. Learn

6
Getting to know the sitter

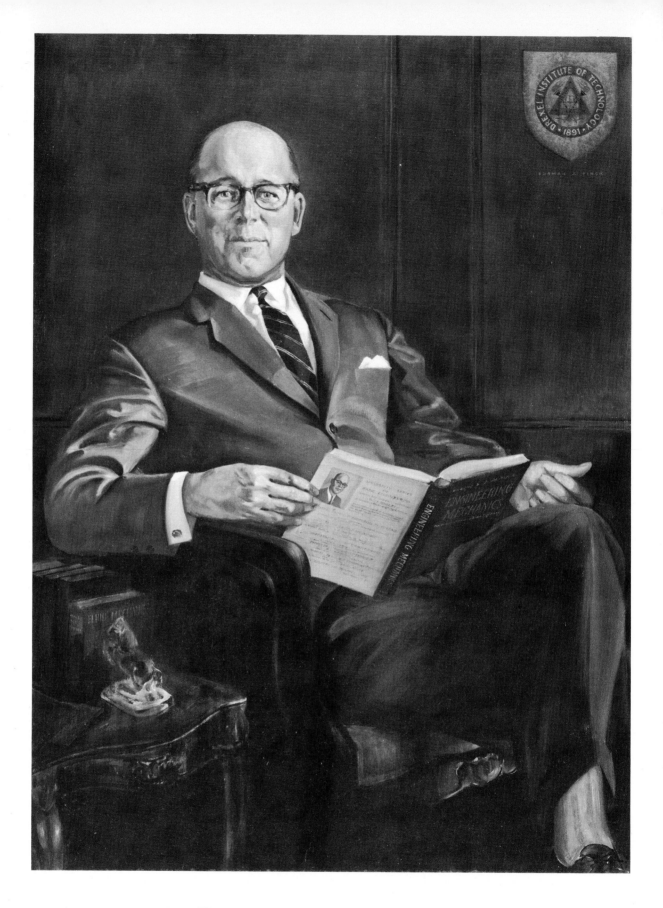

Dr. William W. Hagerty by Furman J. Finck.

Oil on canvas, 44" x 35". If you succeed in putting your sitter at ease, in creating a casual atmosphere, an observer, studying your portrait, will feel that he is in contact with real people. Collection, The Drexel Institute of Technology.

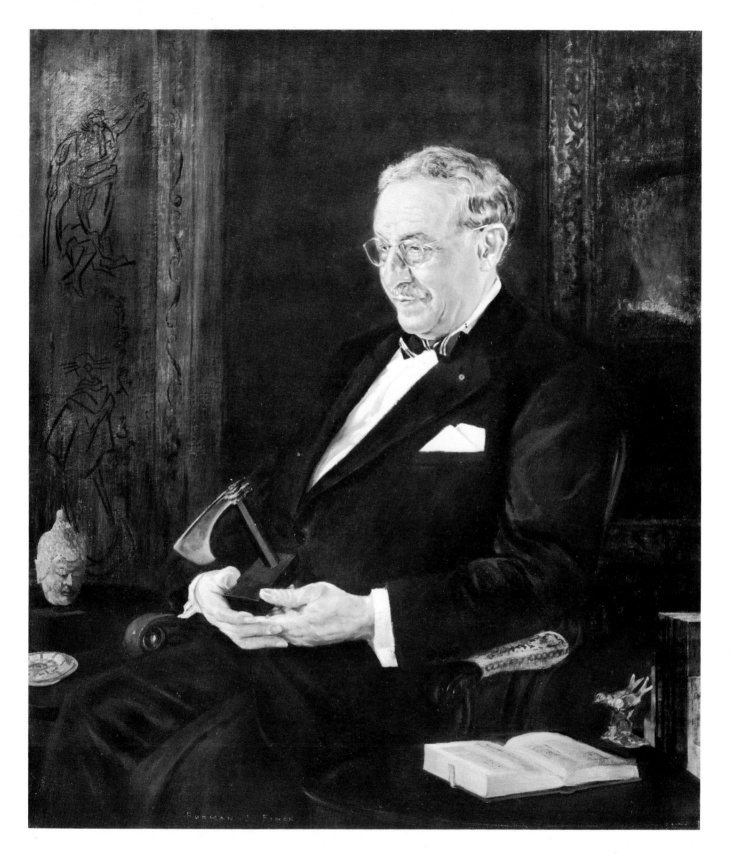

Dr. Joseph E. Milgram by Furman J. Finck.

Mixed technique on hand-sized linen canvas, 44″ x 35″. The portrait is a successful combination of your understanding of your subject and your mastery of the medium. A sitter's personal traits and character are not always easy to define in terms of design and color; but as you learn to capture an attitude, a pose, a gesture peculiar to your subject, you will greatly increase the human content of your work. Collection, Hospital for Joint Diseases and Medical Center, New York.

all you can about him as he talks, moves about, and relaxes. No need to go into the working studio area at this time. At some point, you can simply take out a drawing pad and begin to draw without any urgency about setting a pose. In this casual way, you will give the sitter a first sense of posing. Let him understand that posing, in the artist's terms, means something characteristic, natural, and relaxed.

Engaging the Sitter

In order to overcome the tedium and fatigue that might accompany posing, you can introduce a sympathetic "third party."

When Miss Helen Hayes sat for her portrait, I placed three chairs for guests and friends near the model stand. The chairs were kept at a comfortable distance so that she could easily keep her position and still converse with her friends. There was always tea during or after the sitting.

While I painted Roger Baldwin, of the American Civil Liberties Union, he expressed opinions and presented ideas to his secretary for the future work of the Union. Dealing creatively with a matter close to his heart kept him in constant animation.

The presence of a reader or story-teller can keep a young sitter attentive while the artist works. At my studio in the country, I painted a triple portrait of the Byrne children with the assistance of a diligent reader. There were times when all three posed together; then two would pose and one was free. Posing had to be established in the young sitters' minds as the purpose for which they were visiting the artist. Even though I worked on one child, two were always engaged for the pose. This technique

prevented the children's attention from being drawn to any other activity. The reader kept the youngsters composed with absorbing stories, and always chose an exciting point in the story to break the pose. Wondering how the story would turn out, the children were always eager to resume the pose.

In the absence of a "third party" who participates live, radio and television can enliven the atmosphere and arrest the attention of the sitter.

When I was painting the *Babcock Surgical Clinic* (see Chapter 18), a large, multiple composition containing thirty-four portraits of surgeons and hospital staff, I acquainted myself with every individual included in the painting. Over a period of two years, I saw each surgeon operate a number of times. I read all available printed matter *on* and *by* each sitter. I was never deterred by the technical nature of a paper, for my reading gave me a topic of discussion to keep the interest of the subject during our work together.

Posing must never become a chore. If a two hour session with the model is planned, *call* it two hours, but keep it down to an hour and forty-five minutes.

While in most instances you may be working in your own studio, there are occasions when you must paint the sitter in his quarters. At such times, you will still be required to put the subject at ease, as you accustom yourself to these surroundings and conditions.

With each new sitter you must repeat the practice of building a successful association, improving your relationship each time you meet. If your portraits are to be distinctive, you must learn to treat your subject with warm, personal interest.

Mr. Hans Obst by Furman J. Finck.

Polymer colors, 12″ x 9″. This painting was completed with F. Weber colors, applied to Frederix No. 190 single prime A linen canvas. The application of paint is just thin enough to allow the texture of the canvas to show through.

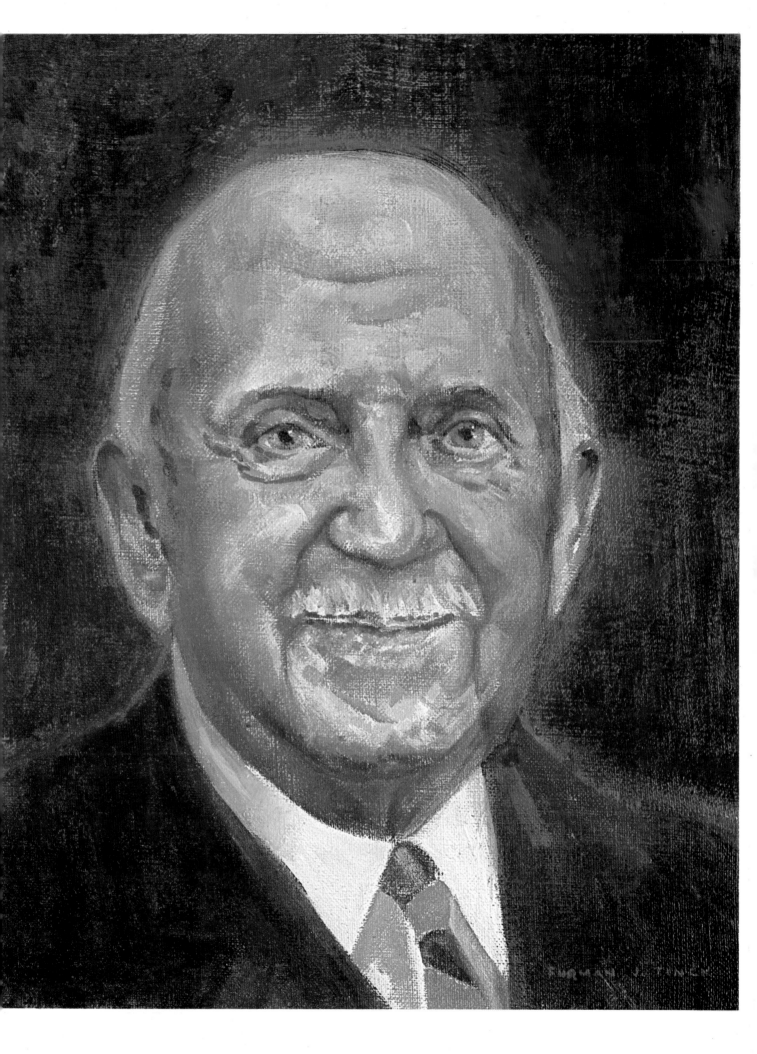

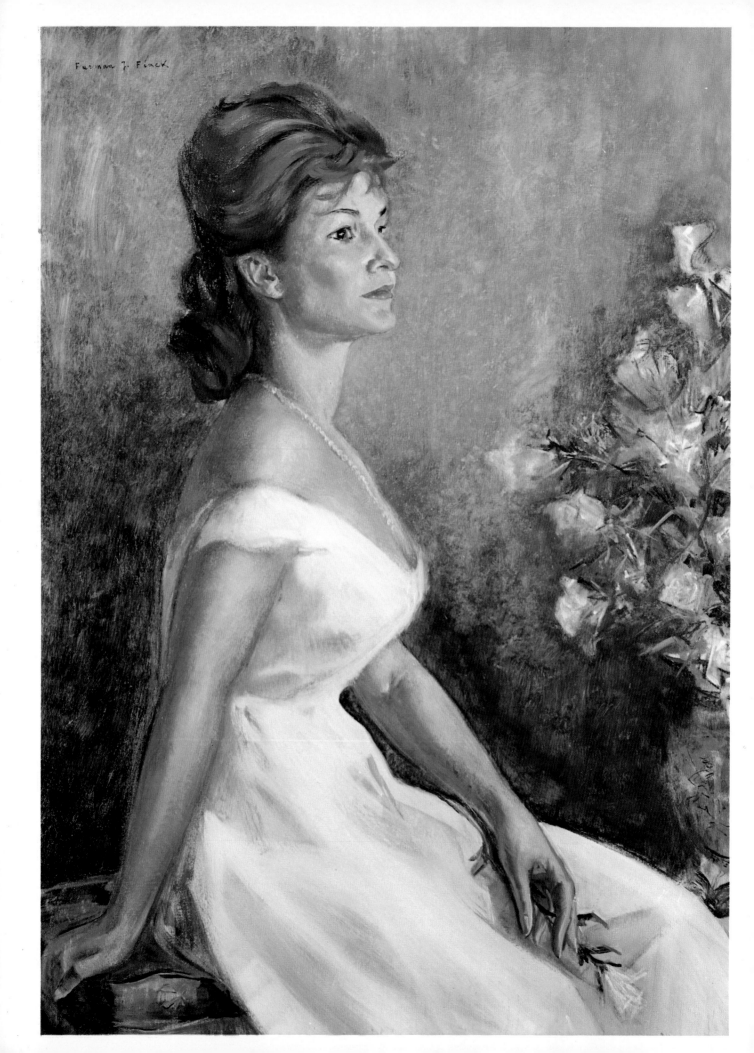

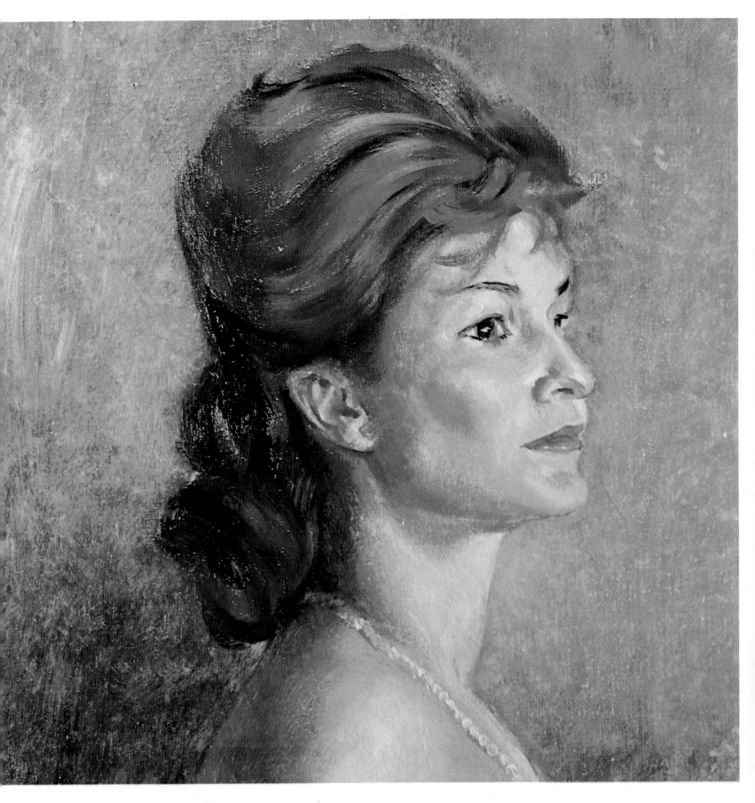

Detail of Arlene. The outline of the profile is the key to success. The angle of the forehead is carefully related to the direction of the bridge of the nose.

Arlene by Furman J. Finck.

A rose presents a form of great diversity and interest. With its stem and leaves, the flower—wild or cultivated—is a natural note that can be effectively employed in fragment, or repeated many times with telling results. Collection, Dr. and Mrs. Barton Green.

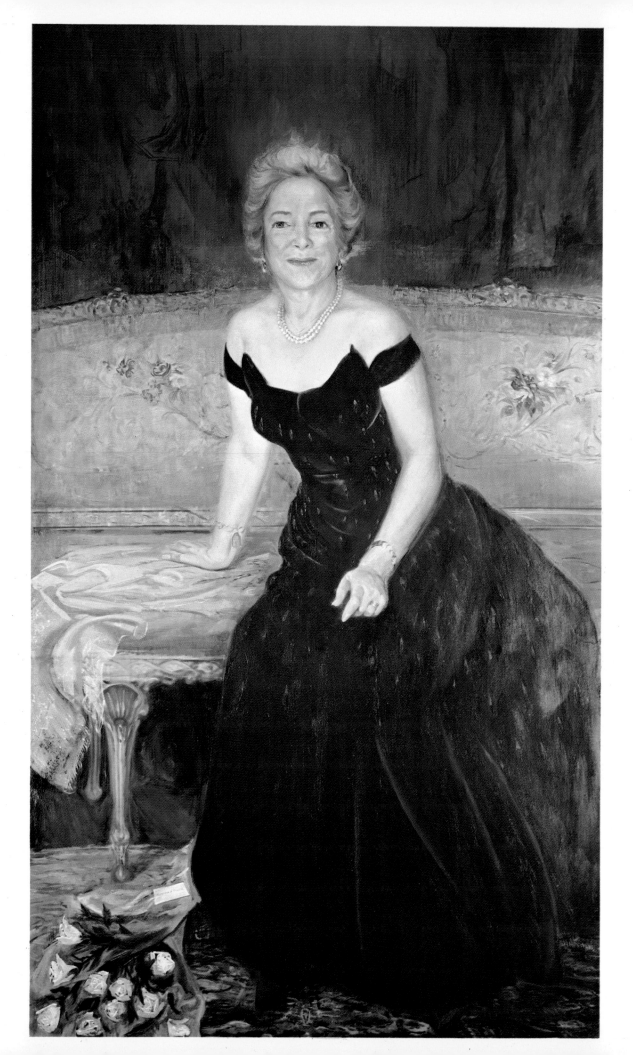

Detail of Miss Helen Hayes. The delicate accessories—the necklace and earrings—enhance the femininity of the sitter.

Miss Helen Hayes by Furman J. Finck.

Oil, 72" x 48". When Miss Helen Hayes sat for her portrait, I placed three chairs for guests and friends near the model stand. The chairs were kept at a comfortable distance so that she could easily keep her position and still converse with her friends. There was always tea during or after the sitting. Collection of the artist.

Becky by Furman J. Finck.

Mixed technique, 24" x 18". The portrait of a child represents an intimate account of character as the parent or guardian wishes to remember it. Thus, the clothing chosen will be that which appeals to the senior member as well as to you and the child. Collection, Dr. and Mrs. William W. Tomlinson.

Dr. and Mrs. William W. Tomlinson by Furman J. Finck.

Mixed technique on canvas, 66" x 40". Before painting a group or a couple, study the relationship of the subjects to each other by observing them together. Because it contains more than one person, the group portrait can offer you exciting compositional possibilities. Courtesy, Tomlinson Theater, Temple University.

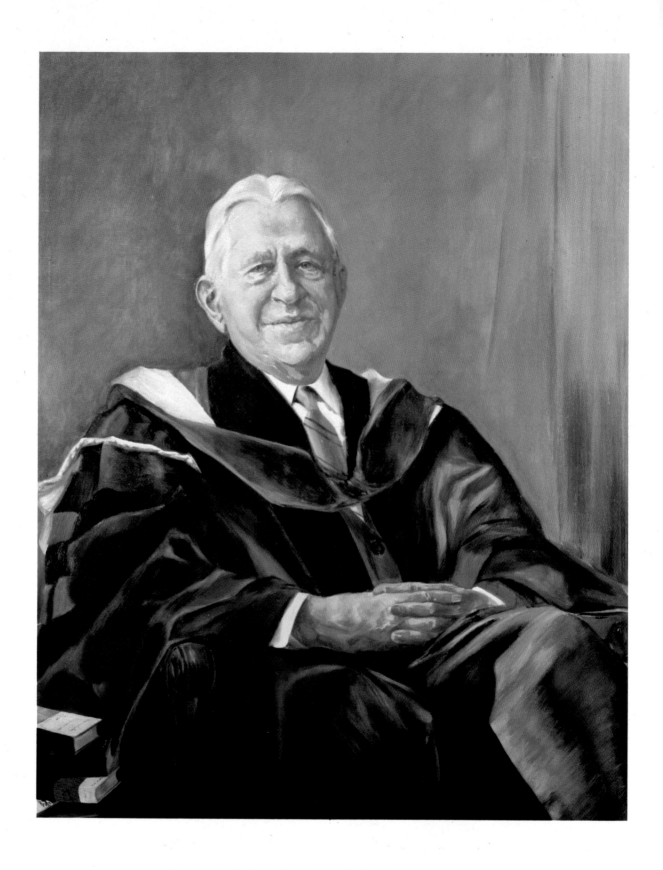

Dr. Andrew G. Truxal by Furman J. Finck.

Oil on canvas, 34" x 28". A portrait may be painted against a simple back drop. If you are painting a professional portrait, you generally emphasize professional achievement. Thus the judge is shown in the robe of his office and the academician wears the hood of his doctorate. Collection, Ann Arundel Community College.

The character of your portrait—pose, gesture, costume, environment—will be influenced by the need which the painting is to serve.

Intimate Portraits

The portrait may be meant to record a likeness at a given age. It may portray a member of a family for that family, or record a loved one for a friend. These concepts, usually done in a small scale, will have a charm and intimacy appropriate to the purpose.

Painted freshly and directly, the sitter is depicted in close view; often just the head is seen, painted at eye level, affording the observer a more intimate study. You are not limited by conditions and requirements that attend more formal portraiture. You will, therefore, enjoy the opportunity to make a more selective and sympathetic statement about the sitter.

Consider a casual pose, perhaps the head resting on a hand, or the pipe held for smoking. A background treatment of bookshelves or desk array may be suitable. In all of its aspects—pose as well as surroundings—an informal treatment will bring the viewer closer to the sitter.

Some of the finest portrait work, intimate in character, represents the artist in close personal contact with his subject. The father paints his child; the artist paints his friend. Think of the memorable portraits which Rembrandt, Rubens, and Renoir painted of their families.

Professional and Official Portraits

In the professions, it is the practice to collect and record all historic data on the growth of an organization. For this reason, portraits are commissioned by universities, professional associations, corporations, and other organizations that wish to establish a graphic history. A most significant addition is made to this record by the portrait painter. He creates and leaves to posterity the likenesses of professional leaders, depicting on canvas something of their character, manner of dress, and accomplishments.

Portraits of professional people usually emphasize professional achievement. Thus, the

7
Various types of portraits

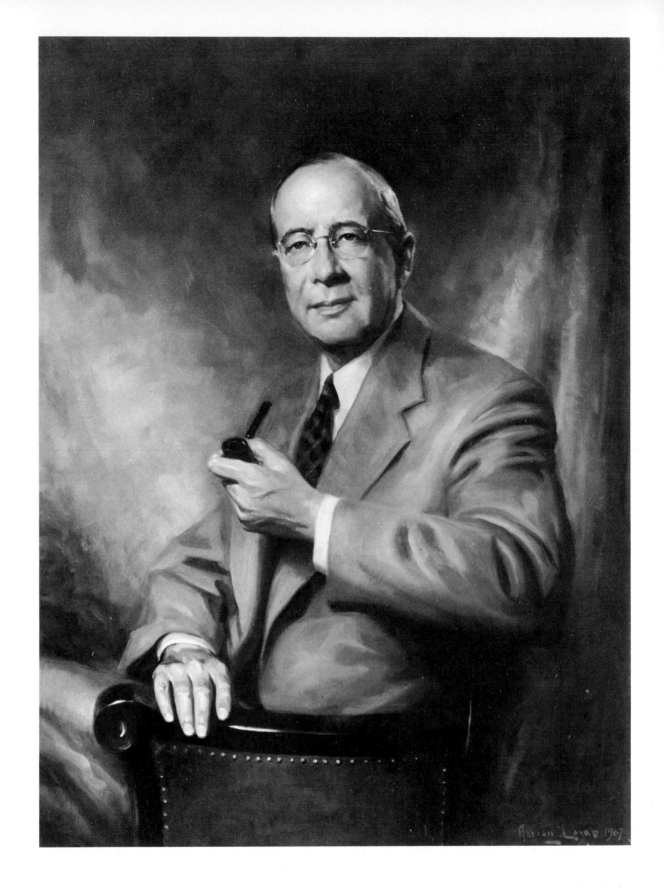

Mr. David Steinman by Adrian Lamb.

Oil on linen canvas, 40" x 30". Consider a casual pose, perhaps the head resting on a hand, or the pipe held for smoking. In all of its aspects, an informal treatment will bring the viewer closer to the sitter. Courtesy, National Society of Professional Engineers, Washington, D.C.

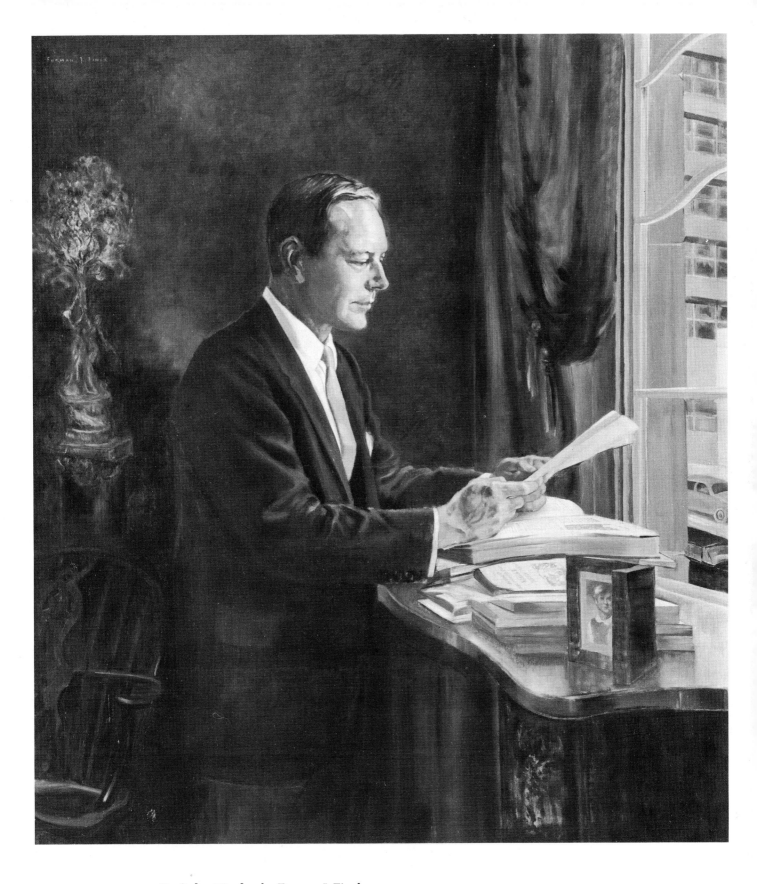

Dr. Robert Bucher by Furman J. Finck.

Mixed technique on canvas, 54" x 48". When the eyes of the portrait are painted to look directly out at the viewer, a hypnotic effect is created. If the subject's eyes are turned away and into the canvas—and a book or some object is placed in his hand— the focus of the viewer is no longer fixed by the dominance of the painted eyes. Collection, Temple University Health Sciences Center.

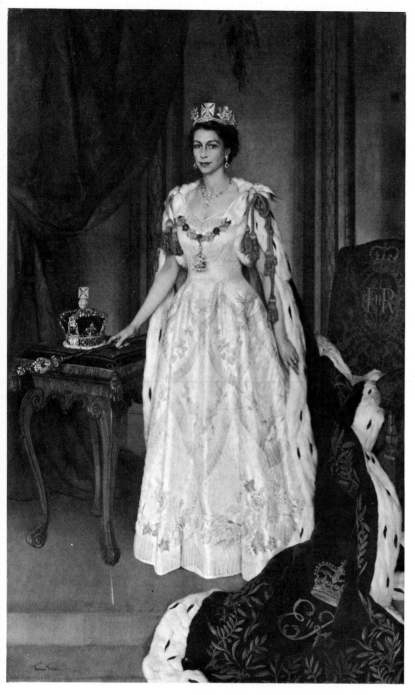

Her Royal Highness, Queen Elizabeth II, State Portrait by Sir James Gunn.

If the office—not the sitter—is the dominant theme, the portrait is considered an official portrait. The official royal portrait of England, for example, shows the monarch with crown and sceptre, the symbols of office, standing in a pose designed to exemplify the idea of the throne. British Crown Copyright, courtesy Ministry of Public Buildings and Works.

judge is shown in the robe of his office and the academician wears the hood of his doctorate. An admiral is portrayed before his flag and a general poses in a position that shows his rank and service stripes.

Heraldry, which has fallen into disuse in many branches of professional life, is carefully observed by the military. Family and professional shields, crests and coats of arms are still occasionally employed to identify heads of families, civic leaders, heads of church, and industrial chiefs.

If the office—not the man—is a dominant theme, the portrait is considered an *official portrait*. To denote his term and position in public office, an archbishop, pope, president, or king sits for his official portrait. The official royal portrait of England, for example, shows the monarch with crown and sceptre, the symbols of office; the king or queen stands in a formal attitude, carefully designed to exemplify the idea of the throne.

As a rule, official portraits follow a pattern which has been set by predecessors. Precedent may prescribe a standing or seated position. The subject may have to be shown taking oath, his hand on a book, or holding a gavel; he may be wearing full robes of office, with additional display of escutcheons, emblems of affiliation, and other symbolic accessories.

In posing the subject, the portraitist generally chooses an attitude of formal restraint, which befits the nature and importance of the sitter's rank.

Group Portraits

The group portrait contains two heads or more. Before painting a group, you should study relationship by observing these people together. One person may be the acknowledged leader or chief because of his position in the group; he may be the head of the family or president of the corporation. Another may dominate the atmosphere by his attitude and appearance. Resolve as many of these problems as you can before you begin to compose, so that you have some order and relationship in mind when you start to paint.

Because it contains more than one person, the group portrait can offer you exciting compositional possibilities, as well as multiple re-

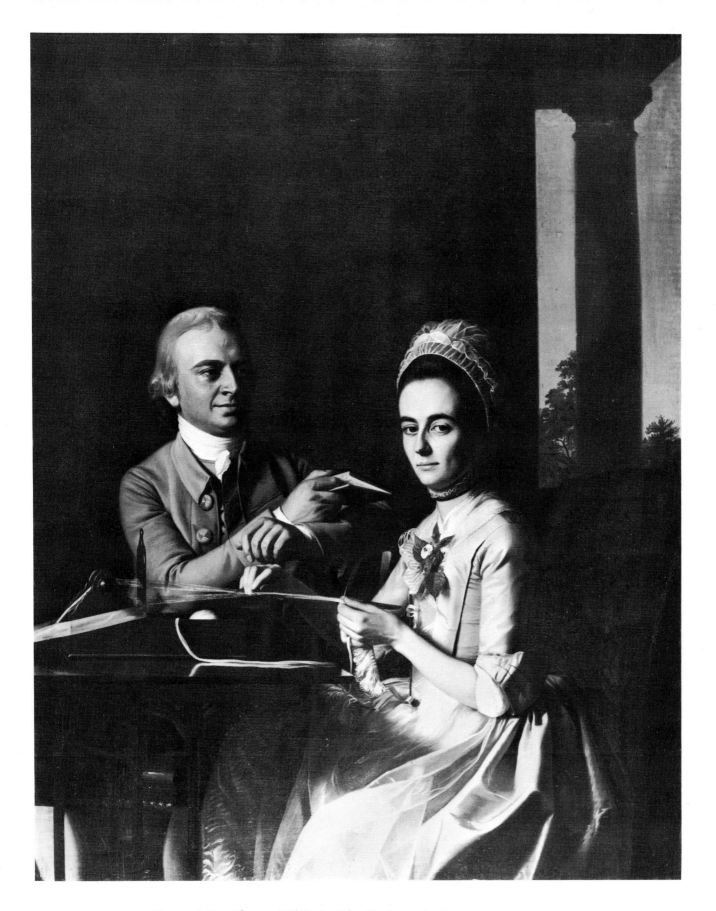

Gov. and Mrs. Thomas Mifflin by John Singleton Copley.

If you are doing a portrait of a man and wife, it is customary to place the male figure in the dominant position, while the female subject attracts the greater amount of light, color, and detail. Courtesy, The Historical Society of Pennsylvania.

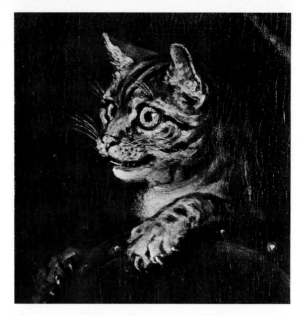

The Cat (detail from The Graham Children)
by William Hogarth.

Pets can add interest and vitality to the work. Collection, The Tate Gallery, London.

sponsibilities. You must come to know *each* person, so that you are familiar with him, before including him in your painting.

If you are doing a portrait of man and wife, it is customary to place the male figure in the dominant position, while the female subject attracts the greater amount of light, color, and detail. Considering these points, balance your composition.

With the addition of more figures—children, pets, etc.—the problem becomes one of creating an ordered composition. In the single or double portrait, you may paint the eyes of the subject or subjects so that they are focused directly on the viewer. He can address himself intimately to one or two persons, which he does when he views a single or double portrait. But when the portrait becomes multiple, the painting takes on a static quality if many of the pairs of eyes are rendered to focus on the viewer. In the multiple portrait, it is more effective to have your figures grouped to focus on some activity within the composition.

Examine a multiple portrait arrangement, such as *Governors of the Old Men's Alms House* by Frans Hals, where so many eyes are upon you. In addition, each one seems a separate entity, appearing not to be aware of the other members of the group. Compare the static effect of this group with the attitude of Eakins' grouping in the *Gross Clinic*. In the Eakins composition the figures, all portraits,

are intent on some activity. The difference, mainly psychological, is worthy of some thought. While it does not involve *artistic* competence, the psychological factor does influence the character of your portrait.

When the eyes of the portrait subject are painted to look directly at you, "the viewer," they have a hypnotic effect, and will follow you no matter where you move. In a single portrait, this treatment can give strength to the characterization. But in a group portrait, it can become a distraction.

On the other hand, if the subject's eyes are turned away and into the canvas—and a book or some other object is placed in his hand—the focus of the viewer is no longer fixed by the dominance of the painted eyes. The painting takes on an over-all interest. Now the eyes become *part* of a portrait that also involves the subject's posture, gestures, and the secondary features of the environment.

An intuitive understanding of these human aspects can make the difference between just a *likeness* and a good *portrait*.

Self-Portrait

The self-portrait has always been a challenge and artists of all ages have painted themselves. Both professional artists and students, lacking a model, have turned to the mirror to reveal a subject. Here they will be assured an attentive model. The mirror image shows the features in reverse; it also flattens the form.

If you wish to paint yourself, explore the possibilities of good lighting. Let the lighting reveal the character before you interpret it in paint. The artist is now the sitter, and the experience of painting himself will broaden his understanding of the total problem of portraiture.

Some well-known examples of self-portraiture are those painted by Rembrandt, Goya, and Cézanne, and some painters of the contemporary school.

"Pop" Portraiture

In his "Pop" representation of Marilyn Monroe, Andy Warhol has rendered portraiture in a simultaneous and continuous statement, removing it from a single to a multiple frame.

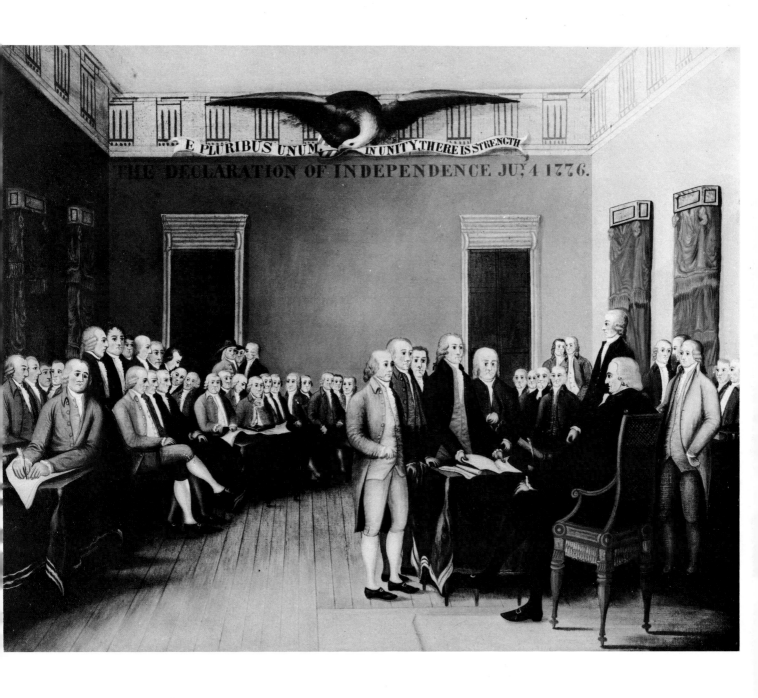

Signing of the Declaration of Independence by Edward Hicks.

In the multiple portrait, the painting takes on a static quality if many of the pairs of eyes are rendered to focus on the viewer, as in this early American painting. Collection, Abby Aldrich Rockefeller Museum, Williamsburg, Virginia.

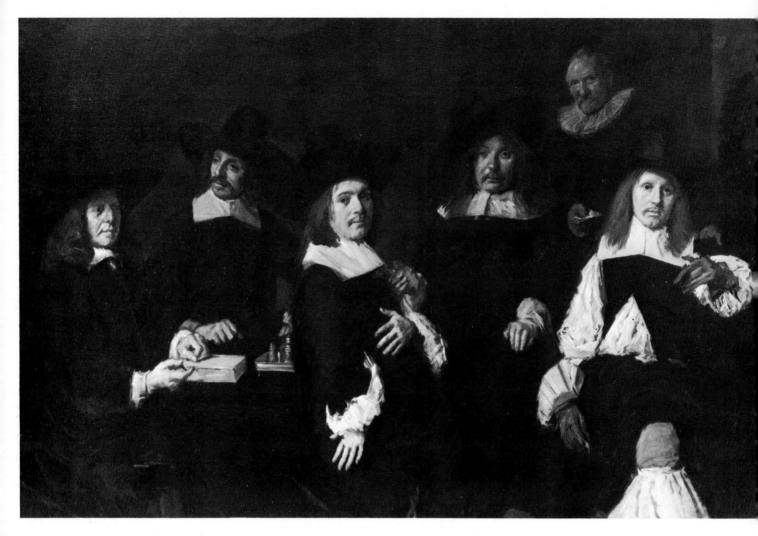

Governors of the Old Men's Alms House by Frans Hals.

In this multiple portrait arrangement, many eyes are upon you, and each subject seems a separate entity, apparently unaware of the other members of the group. Collection, Frans Halsmuseum, Haarlem.

Gross Clinic, 1875 by Thomas Eakins.

Compare the static effect of the Hals portrait with the attitude of this group. Here, all figures are intent on some activity, a feature that gives this painting an altogether different psychological aspect. Courtesy, the Jefferson Medical College of Philadelphia.

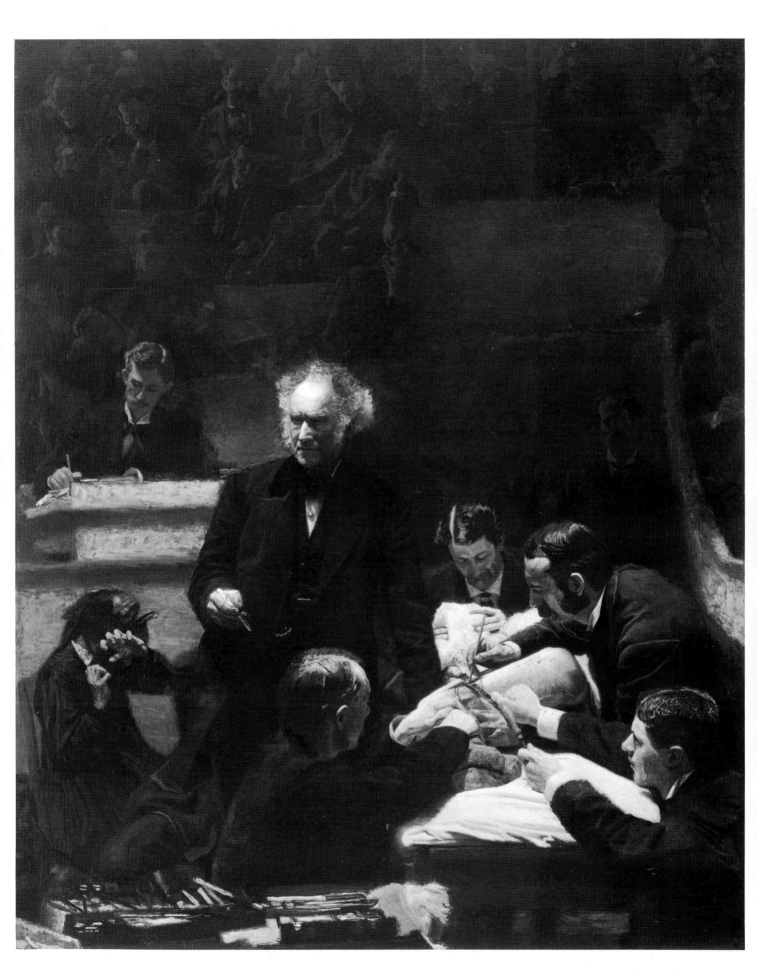

Ben Shahn by Joseph Hirsch. (Above left)

Oil sticks on canvas, 15¹/₂″ x 11¹/₂″. Some of the finest portrait work, intimate in character, represents the artist in close personal contact with his subject. Here the artist used a child's set of oil sticks which he spread here and there with brush and turpentine to minimize the crayon-like strokes.

Self-Portrait by Oskar Kokoschka. (Above right)

32¹/₂″ x 19¹/₂″. If you wish to paint yourself, explore the possibilities of good lighting. Both professional artists and students, lacking a model, have turned to the mirror to reveal a subject. Collection, Museum of Modern Art, New York.

Self-Portrait by Paul Cézanne. (Left)

The self-portrait has always been a challenge and artists of all ages have painted themselves. The mirror image shows the features in reverse; it also flattens the form, elements which must be overcome by the artist. Photo, Roger Viollet, Paris.

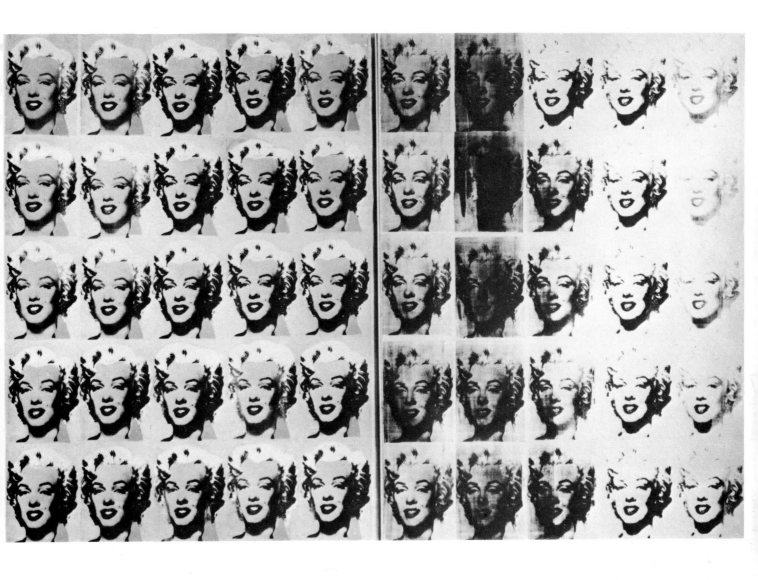

Marilyn Monroe Diptych by Andy Warhol.

Oil on canvas, 82″ x 114″. In his Pop representation of Marilyn Monroe, Warhol has rendered portraiture in a simultaneous and continuous statement, removing it from a single to a multiple frame. Collection, Mr. and Mrs. Burton Tremaine.

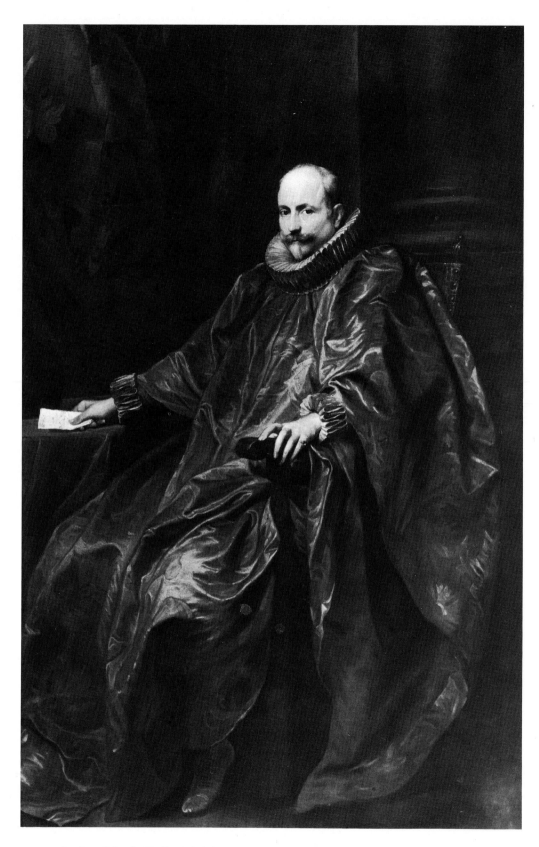

Andrea Stinola (Pallavicini) by Sir Anthony Van Dyck.

86¹/₄″ x 56¹/₄″. The multipleated, magnificent robe or gown—a costume which may envelop and transform the person—is characteristic of the attire of another age, not of contemporary times. Collection, J. Paul Getty Museum, Malibu, California.

8
Treatment
of
clothing

Compared with the more elaborate attire of other periods, contemporary dress is designed to meet the needs of twentieth century living. The look is trim, well styled, and uncomplicated; the colors, created for utility, are usually conservative, but colorful attire is available and is becoming increasingly popular.

Unlike the multipleated, magnificent robe or gown—a costume which may envelop and transform the person—contemporary clothing takes on the character of the figure. The wearer enjoys free physical action, and the artist is enabled to reveal anatomy and proportion within it.

You may be troubled by the pattern of conformity in men's dress which is so evident at this time; you may feel that the colors are too muted, that one gray suit looks like every other gray suit. But the suit in its simplicity, formal or informal, is a stylized form and is good to paint; then too, the sitter will give it character.

Formal and Informal Portraits

The formal portrait tends to emphasize first the office and then the person. Here elegance of attire, particularly in the male portrait, is still in evidence: the dress of the court and church, the military uniform, and the academic gown and hood, to cite only a few.

In the informal portrait, the garment may represent, for example, sport, laboratory, or studio attire. In this case, the rendering of a sweater, shirt, or technician's coat will suffice.

Male Portrait

In most circumstances, the man poses for his portrait in a business suit. It is always a courtesy to the sitter to allow him the choice of what he wishes to wear. But you are free to express views about this, since your subject must look well by *your* standards. His professional interests and his personality, as well as his color and complexion, will guide your thoughts; then you must consider the design of the suit, the pattern of its material, its color, and the character of the wearer.

Dark suits are usually preferable because they are more generally used. Black and gray will work well with any complexion without

Mr. Neil Horgan by Frank Bensing.

Oil on canvas. Painted on Frederix double primed no. 111 linen canvas, this portrait is in the alla prima technique. Dark suits are usually preferable because they are more generally used. Moreover, black and gray will work well with any complexion without altering its color value. Courtesy, Mr. Neil Horgan.

altering its color value. Brown emphasizes brown hair, brown eyes, a ruddy complexion. Blue accents blue and gray eyes, blond types, graying hair. A vertical stripe in the cloth emphasizes tallness. Plaids and mixed fabrics should be understated so that their patterns do not become too distracting.

Portraits of Children

Children are likely to be dressed for display and, for portraiture, a wide range in color and design of garment is available.

Children are part of the family which older people control. When the artist plans a portrait of a child, he must satisfy a parent or guardian. Such a portrait represents an intimate account of character as the parent or guardian wishes to remember it; thus the clothing chosen will be that which appeals to the senior member, as well as to you and the child.

Portraits of Girls or Boys

Emphasis on youth is the first consideration in painting a young subject. A girl's portrait can be tastefully treated with velvet and lace, with figured material, and with pastel shades of solid color. Where the figure is not yet developed, place attention on the dress. Dresses follow feminine lines and are more appealing than slacks. Jewelry and other accessories are unnecessary.

Boys can wear bright colors in an informal style. Although a fitted jacket with shirt and necktie is appropriate, it is more common for the young boy to wear just a shirt and tie, a shirt with an open collar, a sweater or jersey, as a complement to slacks or shorts.

Children's clothing should be rendered simply but effectively so that it will enhance the total design without distracting from the portrait.

Female Portraits

In choosing what she should wear for the portrait, a woman may select from a wide range of dress. As she poses, she will take on the character of the garment. Practically every material has been used to dress women: cotton, wool,

Girl with a Cat by Daniel E. Greene.

Oil on canvas, 30″ x 25″. Emphasis on youth is the first consideration in painting a young subject. In a young girl, place attention on the dress where the figure is not yet developed. Courtesy, Portraits, Inc., New York.

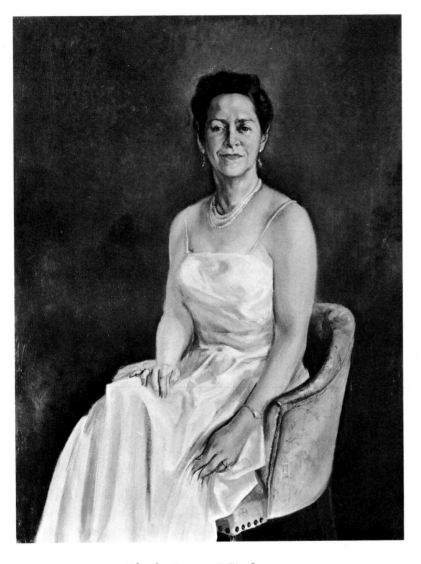

Edna by Furman J. Finck.

Oil on canvas, 40" x 32". In choosing what she should wear for the portrait, a woman may select from a wide range of dress. As she poses, she will take on the character of her garment. When the hair is in a simple style, a pattern or print dress may be sufficient to create the necessary variety, or this simple hair style may have its simplicity repeated in a dress of solid color. Plain within itself, such a dress may properly accent the simply styled coiffure and show the portrait to advantage. Collection, Mr. and Mrs. Frederick Kuser.

silk, lamé, fur, and the many new synthetic fabrics. In some cases, the material will mold to the figure; in other instances, the character and texture of the material will dominate. There are black and white and solid colors of all shades and intensities, and prints and woven designs in a great variety of patterns to dress one type or another, all suitable for portraiture. A dress of plain material may need more jewelry and accessories to suggest a glamorous note; a patterned material will need less.

If your subject wears her hair in an ornate style, it is best that she wear a compatible style of attire, utilizing jewelry and accessories as well. When the hair is worn in simple style, a pattern or print dress may be sufficient to create the necessary variety, or this simple hair style may have its simplicity repeated in a dress of solid color. Plain within itself, such a dress may properly accent the simply styled coiffure and show the portrait to advantage.

When features and complexion are delicate, materials and colors of refinement and subtlety must be sought to develop and not destroy the delicacy. Strong features, and darker skins, accept bright colors and large patterns and are generally shown to advantage when the garments lend supporting strength.

Mature Women

For painting an older woman, you might think in terms of a dark color—such as black or midnight blue, or a neutral color such as gray—to enhance the sitter's dignity. But your sitter might say, "I do not feel matronly and I do not want to be painted that way." On second thought, something bright and glamorous might capture her personality more truly. Then, too, white is conservative and neutral; it is an acceptable substitute for a dark color and is more youthful. You *do* want a spirited portrayal of your subject.

For a woman's portrait, the dress may suggest the theme. Give careful consideration to the coiffure, use of jewelry, neck line, shape and length of sleeves, color and design. Paint the gown to compliment the sitter. If this means resetting proportions or otherwise taking liberties with its pattern or detail, be thoughtful and tasteful.

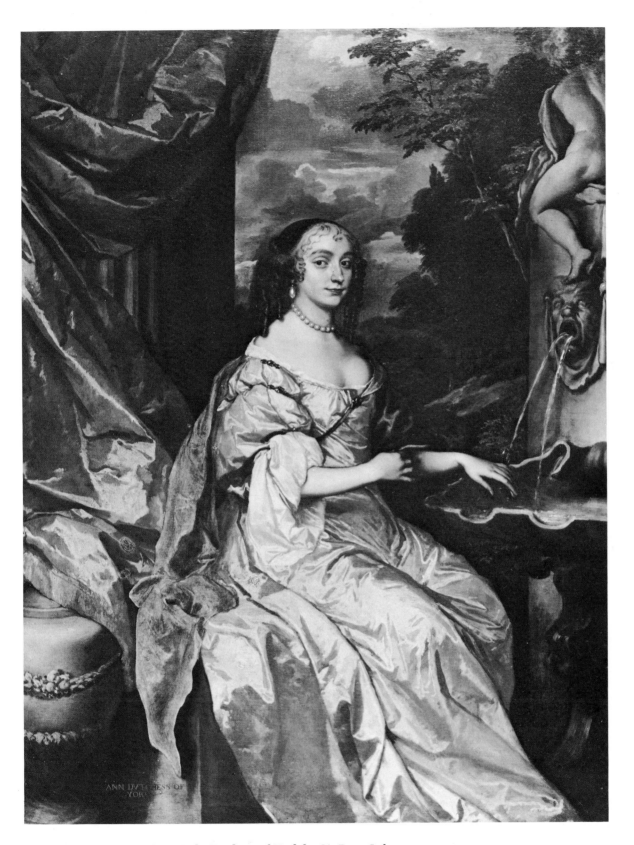

Ann Hyde, Duchess of York by Sir Peter Lely.

See the form, then observe the folds and creases of the clothing as it conceals, then enhances the form. Cloth will follow the lines of the body, stretching and pleating to accommodate the shape of the figure. Courtesy, Scottish National Portrait Gallery, Edinburgh.

The fold contains a ridge—the raised surface of the cloth nearest to you—and a furrow—the part of the surface which is away from you.

In a longitudinal direction, folds expand and contract in accordian fashion. Seen laterally, they will often merge, two folds becoming one, one fold becoming two, the ridges forming a figure Y at the point of change.

As you consider the possibilities of dress, you will find a diversified wardrobe from which to select. Whatever your choice, be sure to consider the form of the figure beneath the clothing when you render the garment.

Cloth and How it Folds

See the form, then observe the folds and creases of the clothing as it conceals, then enhances the form. Cloth will follow the lines of the body, stretching and pleating to accommodate the shape of the figure. It will pull across the outside of the elbow and, at the same time, wrinkle on the inside.

Cloth is flexible and when it covers a form, it assumes any required shape by means of the fold and the crease. The fold contains a ridge —the raised surface of the cloth nearest to you—and a furrow—the part of the surface which is away from you. Folds and creases accept and yield, allowing cloth to change its form without losing its identity. A fold passes from one projection and flows to the next. Its sides move out and under, from the ridge into and around the furrow, and out again to the next ridge, and so on. In a longitudinal direction, folds expand and contract in accordion fashion. Seen laterally, they will often merge, two folds becoming one, one fold becoming two, the ridges forming a figure Y at the point of change. Because its character permits useful definition of form, the drawing of the fold must be clear so that the ridge and furrow are always identifiable.

The quality of the material may influence the character of the fold to some extent, but will not change its essential nature. Stripes and patterns may augment as well as complicate a convincing rendering of the fold, but with study and careful application these features will add authority to your statement.

The Dutch and Flemish masters are known to have posed their models in robes that had been saturated in starch. When the starch had dried and the folds set, the model was cut out of the robe, so that the artist was free to work at leisure, making a thorough, detailed study of the pleats which described the human form that had been inside them.

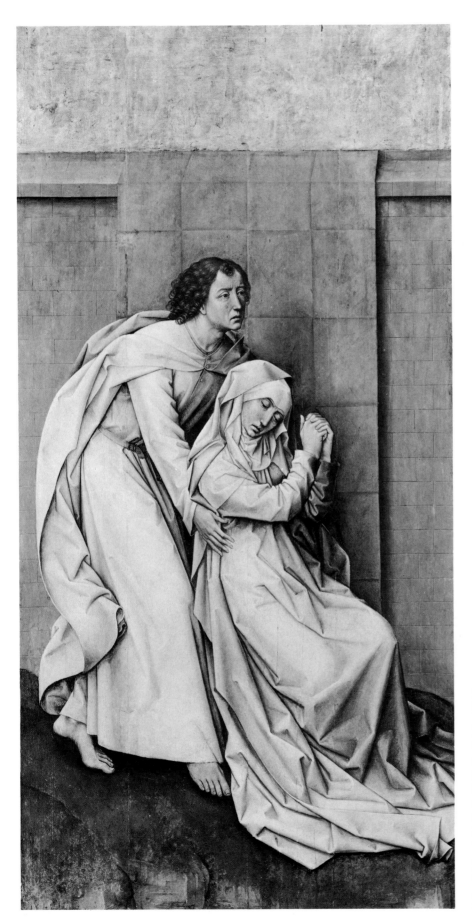

The Virgin and Saint John
by Roger van der Weyden.

The Dutch and Flemish masters are known to have posed their models in robes that had been saturated in starch. When the starch had dried and the folds set, the model was cut out of the robe, so that the artist was free to work at leisure, making a thorough, detailed study of the pleats which described the human form that had been inside them. Courtesy, John G. Johnson Collection, Philadelphia.

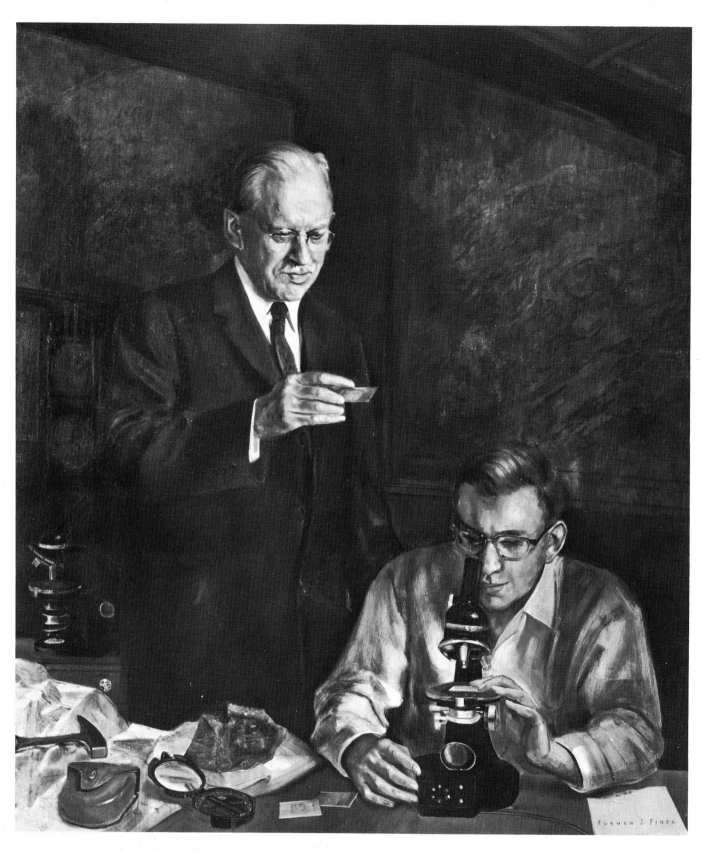

Dr. Arthur Buddington by Furman J. Finck.

60″ x 50″. The subordinate areas in a portrait, mainly background and foreground, must be handled so that they center attention on the subject in the middleground, while remaining out of direct focus. Collection, Princeton University.

9
Props and lighting

Some portraits are painted against a simple back drop, while others may be composed in an environment containing a variety of objects. Your subject must be lighted. Whether simple or complex, you must resolve your composition and your lighting of it so that the final version is lively and easily understood.

Purpose and Placement of Props

Props and drapery, effectively handled, can enhance the presentation of your subject. Selective props are an important adjunct to the composition, as well as a complement to the sitter. A world globe nearby will suggest a geographer or traveler; an architectural interior suggests a public figure; books are suitable for the scholar, flowers for a lady, toys for a child. Such objects help characterize the sitter and dramatize his image.

As a rule, these props should be placed in the background, although the foreground and middleground will occasionally be used. Since backgrounds reflect the subjects being portrayed, they may differ in character, but never in their role. Whether it is a simple, neutral tone, or an area of multiple, focal interest, the background should augment the subject by creating a field of space behind him. The middleground involves the subject. Any prop in this area—such as gloves or a handkerchief held in the lap—becomes one with the subject. The foreground leads the eye into the picture; any object here stands in front of the figure.

The introduction of a wall mirror behind the sitter gives you the opportunity to portray the back view as well as the front, and to include in the background a reflection of objects in the foreground or out of view, creating an added illusion of depth. Some portrait painters enjoy the challenge of painting an object against its reflected image in order to obtain this greater sense of depth.

To identify the subject, you might add a note of history, an appropriate architectural unit or heraldic detail. For example, you might paint the board chairman of a corporation seated before the image of its founder, or the prime minister in the halls of parliament, or, in a personal portrait, you might include the family crest.

A simple treatment generally befits the con-

temporary style and the more modest attitude of the present day sitter. The leader of industry may sit for his official portrait in a conservative business suit, devoid of any special identity, against a simple background without contrast or subject interest.

The subordinate areas, mainly background and foreground, must be handled so that they center attention on the subject in the middleground, while remaining out of direct focus. If all color is muted, brushwork broad, and detail merely suggested, these areas will remain supplementary to the figure. The subordinate areas can then gradually be strengthened after the subject is established—but only to the degree that they complement, but do not compete with it. Though only suggestion is required in the reciprocal areas, any prop—such as the portrait of the founder in the background—must be an identifiable impression of the original, not an imaginary one. If you paint your sitter in a Hepplewhite chair, make sure that you observe all details of the chair correctly as you work.

Selecting the Props

Choose still life material for its suitability and the beauty of its form. It should, in some way, be identified with your subject. If you are not familiar with the proportions of a pitcher, a candlestick, or a musical instrument, do not guess. Place the object before you so that you catch its most distinguishing features, enabling you to develop the form in a deliberate manner. A badly conceived secondary passage can impair the total result. Although your painting of props need not be precisely defined, your impression should be authoritative.

Flowers and fruit offer a variety of colors, forms, and textures from nature. For example, a rose presents a form of great diversity and interest. With its stem and leaves, the flower —wild or cultivated—is a natural note that can be effectively employed in fragment, or repeated many times with telling results. Some blossoms may be painted singly while others bunch well. The addition of leaves and stems adds profusion and a softening touch.

Study the difference in shape between an orange and an apple. Both are round, but the apple has a variation in its roundness that makes it distinct from the orange. Now add a banana. This shape is radically different. A bunch of grapes dropped across these fruits brings about a fusion and softening of the combined forms.

Examine a small silver or pewter pitcher; its form, though functional, represents the taste of the designer. Add a plate by Wedgwood, or a piece of Steuben glass. These are of different texture, and will support the fruit and define its contour. Do you have a crystal glass or a decanter? Pour an ounce of wine into the glass; push it into the rays of the light. Now add a fresh napkin which you have partially opened, a folded newspaper, or a wicker mat.

Objects of still life, each designed for a useful purpose, can be composed with taste to add a secondary note of real beauty which may become the key to one's interpretation of the portrait. *Three Musicians* by John Koch is a good illustration of this use of still life objects. A characteristic example of the artist's work, these portraits are informal studies of a London trio, a group of young musicians who often visited Koch's studio. Here the still life, so involved with portraiture, is a complement to the trio relaxing from music to enjoy tea and cake. The artist establishes his subjects in an easy, natural grouping, in a surrounding of diverse, graphic interest. In this canvas, the artist has effectively combined still life with portraiture.

Another prop, frequently used in painting, is the curtain or drape. Of various materials, curtains or draperies can lend interest and variety to your composition. Their multiform surfaces are good for drawing. Materials such as velvet, damask, or freshly ironed sheeting, drape in strong folds. Each is different and will have a character peculiar to the material and to the weave. The use of such props will often enable you to conclude a complementary passage with pronounced definition.

Gradually, you will assemble props and still life objects of your own choosing that lend themselves to painting. Since these objects represent your choice, they reflect *your* taste. Give thought to this fact, and when you use props in your portrait that represent the choice and taste of your *subject,* you will discover that their use intensifies your statement of him.

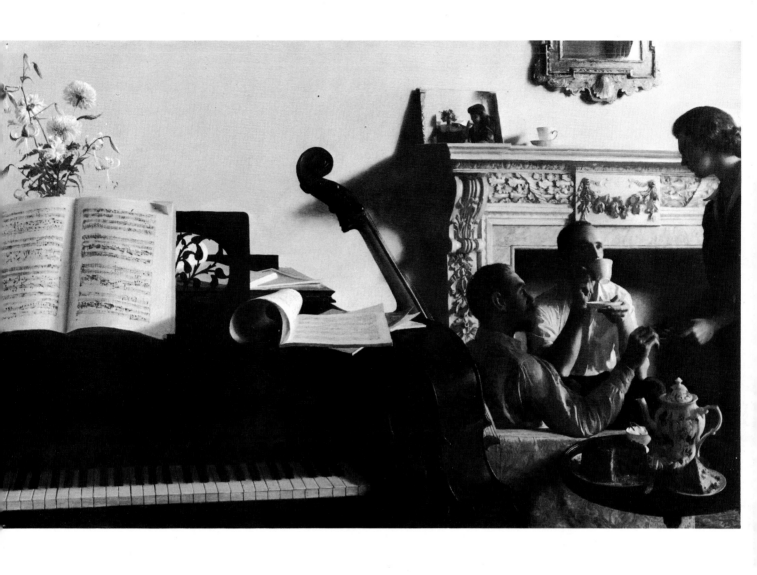

Three Musicians by John Koch.

30" x 48". This is a good illustration of successfully using still life objects: each adds a secondary note of real beauty, a complement to the trio relaxing from music to enjoy tea and cake. Collection, Mr. and Mrs. Charles C. Lucas II.

Using Artificial Light

Effective lighting must be considered elemental, a means of presenting your subject to advantage. A high, north window or a north skylight has traditionally been used by the artist for painting. Although natural light may be preferable, artificial light can now be recommended, due to the improvement of its quality.

There are a number of lights manufactured for the artist—some on floor standards with supple tubing which can be bent to set the light in position; some which hang from the ceiling; and others, having multiple joints, which can be clamped onto the easel or placed elsewhere in the room, and pulled into the desired position.

A Sylvania flood light 150W-125V will flood the working area with a yellow light, adequate for brilliance. A simple incandescent General Electric daylight bulb of 200W-120V will give a single source of light. A double socket containing two incandescent bulbs, a 200W-120V daylight and a 200W-120V white will double the light power, give a warmer light, and also cast a double shadow. You can place a bulb in a Dazor swivel socket in a grip bracket. This can be mounted anywhere and turned on to focus on the working area. (For more information about Dazor, you can write Dazor Mfg. Corp., 455-99 Duncan Avenue, St. Louis, Mo. 63110.)

Opinions are divided regarding fluorescent lighting for painting, since some fluorescent combinations deaden warm colors. Industry has improved the fluorescent tube and a lighting similar to daylight can now be approximated. The Viplex Natural Light Luminaire (Viplex Natural Lighting Co., Inc., 527 Madison Avenue, New York, N.Y. 10022) can be obtained in multiples of two, four, six, and eight, and can be used in existing fluorescent fixtures. It is guaranteed to produce a light in which the color curve is uniform and accurate. Place all fixtures high enough to insure the proper diffusion of light and even distribution over the working area.

Controlling the Lighting

As you experiment with lighting, you will quickly discover its potential. Notice the structure of the head as the light picks up anatomical forms and planes. There is a great variety of interest created when the surface is illuminated. When your subject is seated on the model stand, move the lights about and watch the lighting effects. A pattern of hair under the influence of light becomes the crown of the design, while the head, neck, and shoulders form the cameo.

Most often, the light source comes from above. It would seem reasonable then, to paint your subject sitting under the light. But light coming from above may not properly amplify the features. You must, therefore, control the use of light to serve your need.

At some point, you will prefer one arrangement of lighting to all the others. As you settle upon this arrangement, examine it candidly, critically. Light is a dramatic force and all surfaces within its influence become intensified. By applying it sensitively, you will enjoy more fully the many subtle personal characteristics of your sitter. Light, like line and color, must be directed and edited if you are to use it effectively.

When you seat your model in a single source of light, you have an image which is partly light, partly dark. The concept of light-dark, as the painter uses it, calls for a balancing of these opposites. If the direct light is warm, the darkened area, being opposite, will seem cool by comparison. Then, too, the lighted area will seem to advance the form, while the area in shadow will seem flat in contrast.

For added interest, a secondary light can be created. Fasten a silver foil reflector or a sheet of white paper on a screen and move it about, close to the darkened side of the model. Within the influence of this reflected light, the tones awaken; features that have been lost in the darkened areas are relocated; useful accents are reestablished; and objects once reduced to silhouette now become reformed.

If artificial light is employed, a floor lamp with a covering shade or a light bracket with a shield is recommended. It is better that this kind of light be indirectly applied. Direct light from an electric bulb, when beamed to the model, causes light and shadows of such sharp definition that they challenge, if not distort, the proportion of the features, introducing accents not conducive to portraiture. The incan-

Notice the structure of the head as the light picks up the anatomical forms and planes.

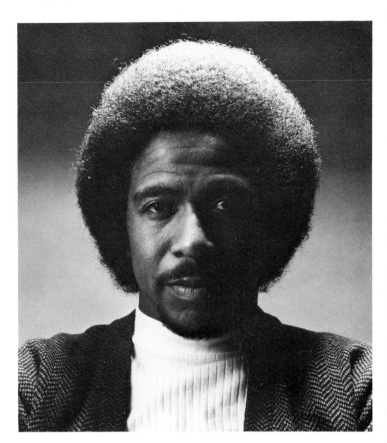

A pattern of hair under the influence of light becomes the crown of the design, while the head, neck, and shoulders form the cameo.

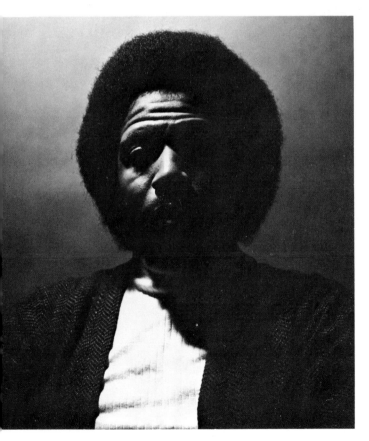

Light coming from above may not properly amplify the features.

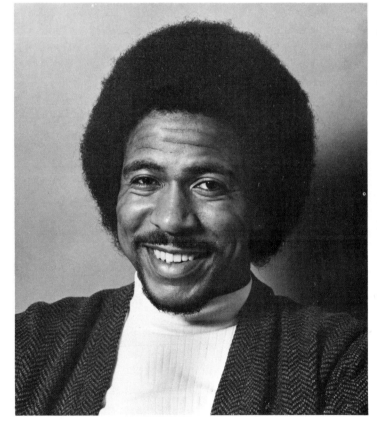

Light, like line and color, must be directed and edited if you are to use it effectively.

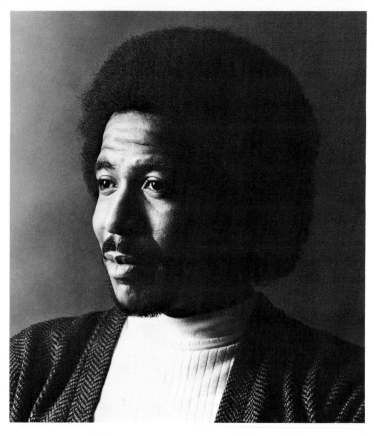

When you seat your model in a single source of light, the image is partly light, partly dark.

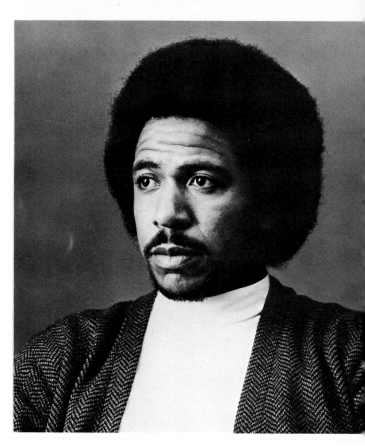

For added interest, a secondary light can be created.

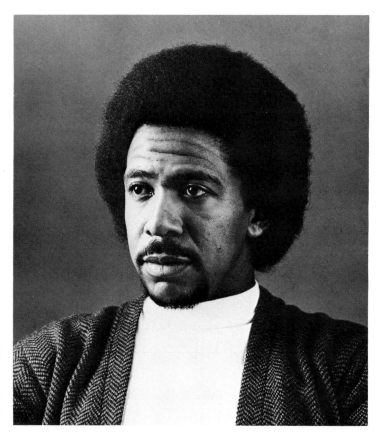

Within the influence of this reflected light, the tones awaken.

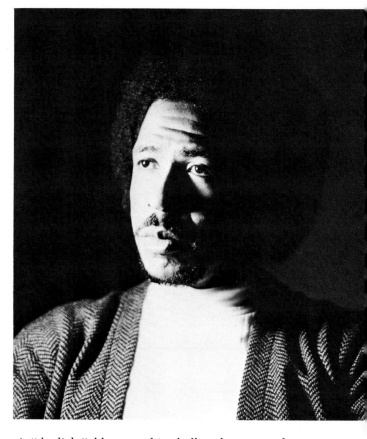

A "daylight" blue or white bulb, when not subdued, tends to make the figure glassy, sharp, and unreal.

descent bulb produces a warm light which comes up as yellow when painted, while the illumination from a "daylight" blue or white bulb, when not subdued, tends to make the figure glassy, sharp, and unreal. But a light suspended behind a screen of transparent white onion skin paper will cast a soft, diffused glow that will not destroy the subtle form of the head.

The electric light is not a substitute for natural light and, when used, should not be overplayed. It is an artificial source of light and lends an artificial glow to every form it touches. Keep this in mind when you use artificial light.

Lighting and Composition

When you have chosen the most suitable means of lighting, you are ready to study its effects on your composition. As you set the design of your model, now lighted, study your drawing for its balance of light and dark and relate this to the anatomical form. This related pattern supports the portrait and can be made to dramatize the features. Place the light so that you avoid any sensational or startling effects that might be distracting to the finished work.

Where the light and dark fall will be determined by the position of the light and by the angle of your viewing. Place an apple on the table with the source of light to one side and above the apple. Note that at one point, where the light hits the apple directly, there is a highlight in direct line with the source of light. The light pours down the side of the apple, diminishing in brilliance as the form turns. The table also picks up the direct light, absorbing some of it, reflecting some of it. This reflected light from the table will move up the under side of the apple to meet the oncoming but diminishing light from the direct source. At the points where the lights meet, notice the definition of contour and form.

You will observe that light similarly influences the human form. See the example shown here in a portrait by A. Henry Nordhausen of Mr. Ben Hurt Hardaway III. In this work, light establishes the existence and direction of the planes of the head as part of the structure of the painting.

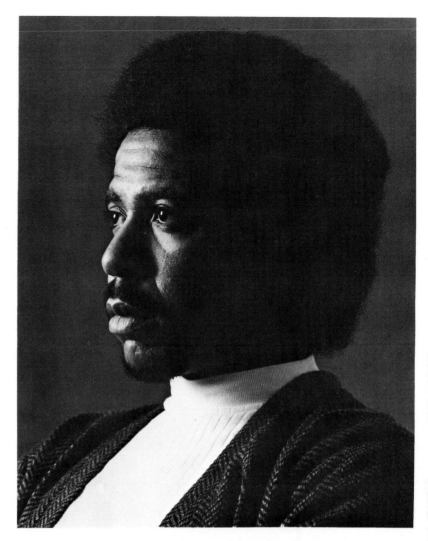

But a light suspended behind a screen of transparent white onion skin paper will cast a soft, diffused glow that will not destroy the subtle form of the head.

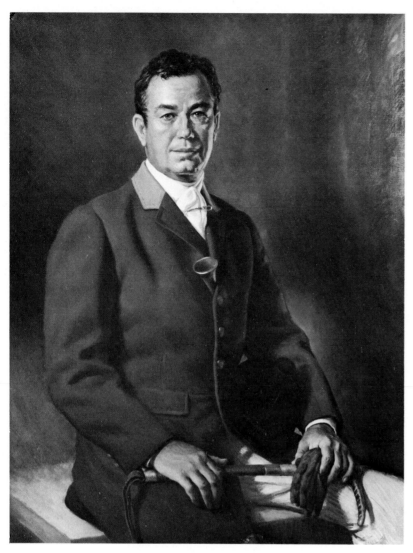

Mr. Ben Hurt Hardaway III
by A. Henry Nordhausen.

Oil on double primed linen canvas, 40″ x 32″. Notice that light influences the human form. In this work, light establishes the planes of the head as part of the structure of the painting. Collection, Mr. Ben Hurt Hardaway III.

It is particularly important to note the effect of light on form and to watch the change as the light is moved. Although the lightest and darkest accents may be in close proximity to each other, they will not be *immediately* next to each other. Can you define the nature of a surface on a form at the exact point of its turning from the light? This form will seem to attain its darkest intensity just out of the direct light. As your eye moves across the form, away from the direct light, you can observe some reflected light. The dimension of form can be directly influenced by your treatment of this secondary reflected light. If you emphasize this reflected light in your modeling, you reduce your form; if you subdue it, you will enhance the roundness of your form.

Chiaroscuro

In the multiple portrait composition entitled *The Night Watch* by Rembrandt, the play of light takes on dramatic proportions, and assumes importance equal to the theme. Here you can see light on form used to amplify features and dramatize studies of the head. This use of light and dark, as Rembrandt employs it in painting, is known as *chiaroscuro.* If Rembrandt develops the light, he also gives the same full range in the shadows, for they are luminous and spacious. Unless they are handled luminously, shadows have a tendency to become opaque and thus reduce the form, creating flat, neutral areas. Generally speaking, lighted forms advance and darkened ones recede. Too much light can bleach the form, too much dark obscure it. Therefore, both light and shadow must be used with care.

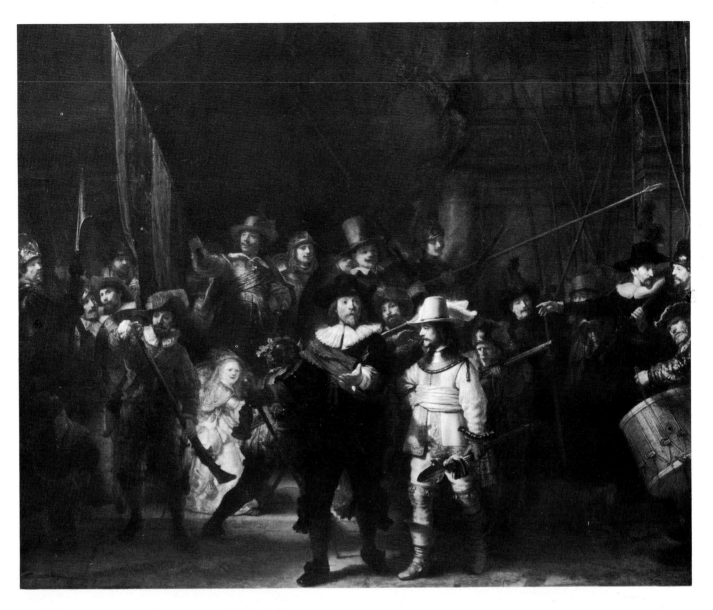

The Night Watch by Rembrandt Van Rijn. (Above)

In this multiple portrait, the play of light takes on dramatic proportions, and assumes importance equal to the theme. In his use of chiaroscuro, Rembrandt develops both the light and the shadows. Unless they are handled luminously, shadows have a tendency to become opaque and thus reduce the form. Rembrandt's shadows are luminous. Collection, Rijksmuseum.

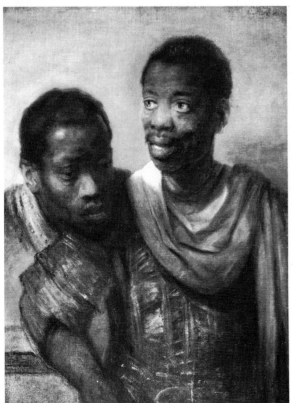

Two Negroes by Rembrandt Van Rijn. (Left)

Effective lighting—the quality Rembrandt is so renowned for having created—is elemental, a means of presenting your subject to advantage. Notice the structure of the head as the light picks up anatomical forms and planes. Collection, Foundation Johan Maurits Van Nassau, Mauritshuis, the Hague.

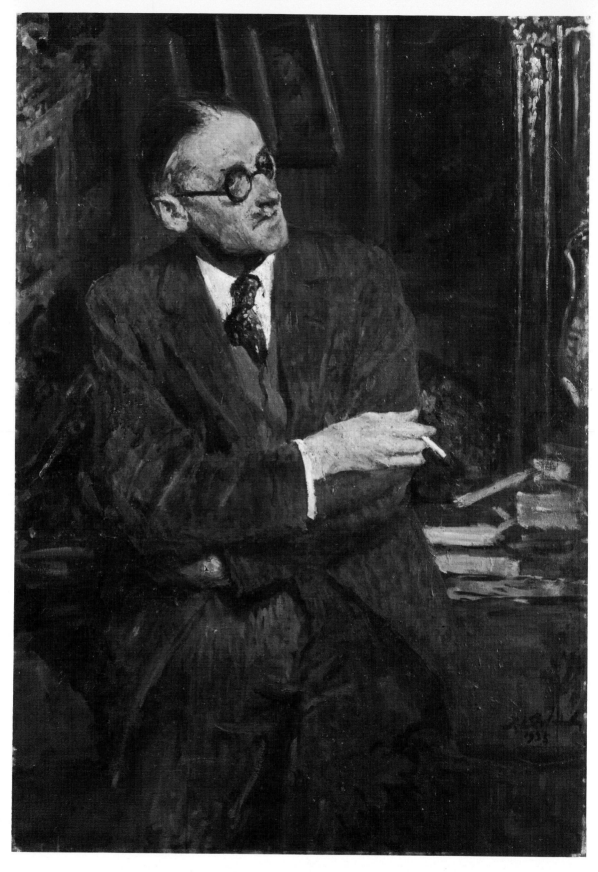

James Joyce by Jacques Emil Blanche.

49¹/₄″ x 34¹/₂″. *As you pose your sitter, note actions and gestures that seem charac-*
teristic. What does he do that is natural to him? He may fold his arms, hook his
thumb into his vest, or thrust his hand into the pocket of his jacket. Collection,
National Portrait Gallery, London.

You will think best with a pencil in hand. Drawing is your natural language, your most immediate means for communication and expression.

Your First Quick Sketches

Your first meeting with the sitter will be to gather first impressions and your drawings made during that meeting will reflect those fresh images.

What makes each person different? Can you discover something unique in your subject and describe it?

Roundness of features usually indicates a stocky person, perhaps a person with comparatively short arms and legs. As this person poses, his legs will remain close to each other, his arms close to his body. If the sitter is a tall person, he may be large boned, inclined to sprawl when he sits. As you pose your sitter, note actions and gestures that seem characteristic. What does he do that is natural to him? He may fold his arms, hook his thumb into his vest, or thrust his hand into the pocket of his jacket. Seek the individual characteristics that make him distinct and portray him at his ease.

These personal qualities constitute the elements of a portrait painting, elements which are inseparable from the design, likeness, and technique. Since portraiture embraces these living characteristics, concentrate on your subject as you draw. Tell us of the whole living subject in a statement that the viewer can detect at a glance.

As you pose your subject, you should begin sketching. Examine the pattern of his pose. Can you envision its boundaries? Make many drawings expressly to capture the shape of this pattern until you arrive at one that pleases you.

These drawings are mainly for "roughing in" the contours and, though they are unrefined, they will have directness and vigor. They will catch something of the identity of the sitter, for these early studies represent your first impression. Thereafter, you must retain this vigor in all of the work that follows.

For these first sketches, use a soft drawing pencil (nos. 4B, 5B, or 6B) or a piece of thin vine charcoal, and a drawing pad of newsprint. You may prefer a Conté pencil or Conté crayon

10
Preliminary studies

Thomas Hardy by Augustus John.

Charcoal sketch. Preliminary drawings are mainly for roughing in the contours and, though they are unrefined, they will have a directness and vigor. They are your first impressions. Reproduced by permission of the Syndics of the Fitzwilliam Museum, Cambridge, England.

Thomas Hardy by Augustus John.

Oil on canvas. Using the sketches for your final painting, you must retain the vigor of your first impressions in the work that follows. Reproduced by permission of the Syndics of the Fitzwilliam Museum, Cambridge, England.

in black, brown, or sanguine (a brick red tone); the choice is yours.

At this early stage, it is not necessary to sketch in full size. However, keep the eventual size in mind as you work, and plan the sketch on your pad as though it were the drawing on the canvas. No matter how small you make your sketch, let your *concept* be big; a free and broad statement should result. Hold the pencil or charcoal loosely, applying little or no pressure, using the flat of the point. Whether you draw the point slowly or quickly across the paper, always maintain an easy, broad, flowing line.

As you search your subject for that first, over-all shape, concentrate on the general impression of the sitter until it is indelible in your mind, but do not focus on any one part. Then, translate the image in a soft line simply and directly, using a fluid arm and wrist motion. Drawing is something like dancing—any stiffness will impair its form.

Preliminary drawings should not be elaborate. Select a few details that describe the sitter's character and underplay all secondary elements. As a result of these drawings, you should arrive at a good, general impression. As you work, transfer your concentration to the model; talk with him and keep drawing. Make many free, linear drawings with no attempt at shading. Use this exercise as a means of familiarizing yourself with your subject. Emphasize expressive gestures and movements. You are not seeking a finished portrait drawing at this time, but a layout composition. This approach should enable you to establish the foundation and the framework for the development of the painting which follows.

If they are drawn lightly, these sketches will allow you to use an eraser for improvements and corrections. Keep all your drawings in the order in which you make them. When something in a drawing does not satisfy you and you find it difficult to locate what is wrong, examine the other sketches in the series and you will usually discover the error.

Reviewing the Sketches

As you review your studies, certain characteristics of the subject will become pronounced. The sitter will show interest in your drawings,

Duke of Wellington by Francisco Goya y Lucientes.

At the early stage of sketching, it is unnecessary to sketch in full size. However, keep the eventual size in mind as you work, and plan the sketch on your sheet as though it were the drawing on the canvas. Courtesy, the Trustees of the British Museum.

No matter how small you make your sketch, let your concept be big.

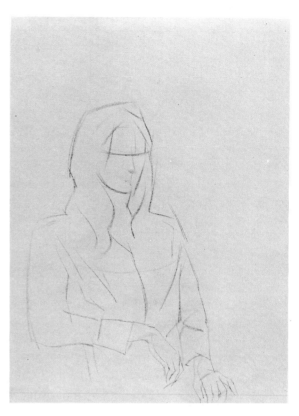

As you sketch your subject for that first, over-all shape, concentrate on the general impression of the sitter until it is indelible in your mind.

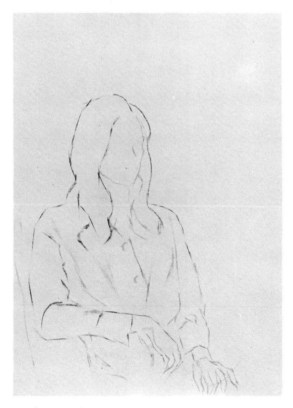

In these early sketches, avoid focusing on any one part. This unevenness will only distract you.

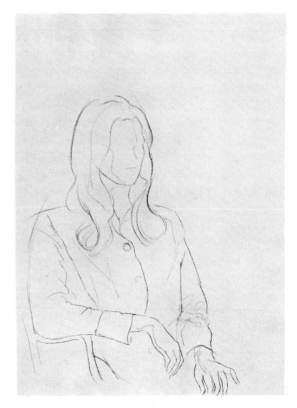

Then, translate the image in a soft line, simply and directly, using a fluid arm and wrist motion.

expressing preferences for certain ones; his recommendations will help you focus on the pose and gesture that seem most appropriate. Some qualities of his character and pose will recur throughout your drawings and will strengthen your impressions. You can also combine some aspects of one drawing with elements in another.

Gradually, as you review the drawings, you will arrive at a pose that suggests the mood you want. The characteristic stance of the sitter will emerge. Without realizing it, you will assume the spirit of the pose and seem to participate in it along with your subject. He, in turn, will respond with interest and give you the cooperation you want. Throughout this introduction, discuss your sketches with the sitter.

Once you have examined the drawings and compared one with another, exchanging thoughts with the sitter about the action and character of the composition, you should now begin to agree on a suitable approach. After you have done so, you can determine the size and shape of the canvas on which you will execute the final painting.

Establishing the Pose

Now that you have agreed on the general approach to the portrait, you are ready to examine the sitter for painting purposes. If you look closely, you will find that the proportions and expressions of one side of the face differ from those of the other. Examine the features for their similarities before seeking their differences.

As a result of your discussion of the sketches with the sitter, it is evident that some attitudes seem more natural than others. Referring to these drawings, have the sitter assume the pose. This is a period for exploration and a time for decisions, because once the pose is set, you should stay with it to the finish. When the position is not entirely satisfactory, do not try to make an adjustment by rearranging just one element of your subject—like changing the position of a hand or the tilt of the head. Rather, ask him to reseat himself. Any attempt to shift or reset some part of your model may make him stiff and tense. Until the stance seems right, make the sitter change his position *rad-*

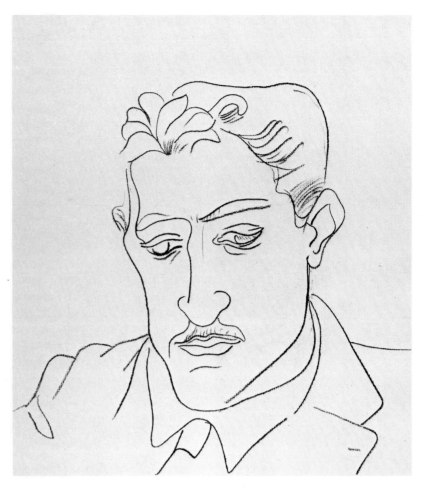

Furman J. Finck by Arshile Gorky.

Make many free, linear drawings with no attempt at shading. You are not seeking a finished portrait at this time, but a layout composition. This approach should enable you to establish the foundation and the framework for the development of the painting which follows. Collection, Mr. and Mrs. Furman J. Finck.

ically from one pose to another; this will help him remain fresh, relaxed, and receptive toward the idea of being painted. Avoid any preconceived, set notions; vary the stance, vary the lighting. If you make these early decisions carefully, you will not need to take time later to make corrections. Remember, you are trying to capture the spirit and character of the sitter which emerged from your sketches.

Suppose you have tried a standing pose, but you have finally decided on a seated pose. You ask the subject to sit on a chair or couch. The couch is pulled into the working area and the model seats himself. He slouches; the upholstery is too deep. You try the chair. Now you want the head of your subject slightly above your vision, which means that the chair must be raised. The model stand is rolled out, the chair placed on it, and the posing resumes.

The large wall mirror behind you allows the model to view his pose. This device, used by many artists, will help him keep critical watch on his position, a reminder that he should not slump. Since he can examine his position, he will compose it himself, gradually assuming a pose of his own creation.

As the artist draws, he makes light conversation with his subject. Without emphasizing the pose, he proceeds to rough in drawings at an easy pace. He speaks of this as "doodling." Lunch is served in this intimate setting and afterwards the pose is resumed. The sitter does not become self-conscious because he is relaxed. This technique is usually successful because it allows the subject to act upon his own impressions of himself, as he sees his pose in the mirror.

One method of keeping your subject animated is to use a third person who reads, converses, and keeps him alert. This will free you to pursue your study.

While you are not at work with the model, assume the pose yourself before the mirror. Study the position; put yourself in the sitter's place. Any practice that increases your familiarity with the problem will give you greater command of it.

Further Studies for Painting

Begin again on your drawing pad or toned paper, with charcoal and a light shade of pas-

tel. Make another series of action drawings and work again for the feel of the pose. Reestablish your feel of the pose, using light and dark values. Can you artificially light your subject to compliment his best features? Try a spot lamp; notice the interesting shapes of light and dark which the beam produces on the figure. As the lamp is moved, watch these shapes change, blend, interconnect.

Does the pose created from the preliminary drawings offer interesting possibilities for the development of a pattern of light and dark? Have you placed the head in balance? Is there ample space around the head so that it does not seem crowded? Keep your composition simple; think of each part as it relates to the head. Do the shoulders amply support the head? Does the placement of the hands emphasize design, dramatize the head?

Tailor the design to compliment the character. For example, if the subject is short and you feel that his shortness should not be emphasized, place the head high in the composition and try placing vertical objects in the background—such as a hanging curtain, a window, or a pilaster—to suggest height. As you work, bear in mind both the character of the subject and the design of the painting.

Refining Your Study

Once the pose is decided, you will begin to refine your drawings. With sharp, incised lines, establish the features; by selective shading, clarify the features. To obtain roundness in the form, model from the center toward the contour—not from the edge inward—just as a sculptor establishes the roundness of form by developing the surface nearest to him, always working out toward the contour. If you think in terms of sculpture, your drawing will attain solidity.

Some faces are heavy set; some are slight. There are subjects whose features blend into the lines of the face; there are others with fragile, delicate proportions, whose features stand out. As you develop the forms, establish the features more firmly, but do not fix them permanently at this time.

How does the hair shape the head? Examine the eyes and make a note where you think each belongs. How does the cast of light de-

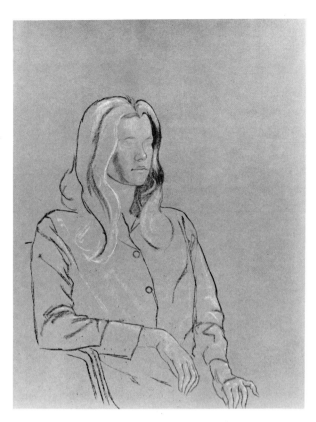

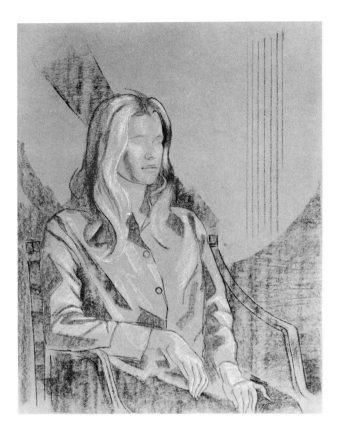

Begin again on your drawing pad or toned paper, with charcoal and a light shade of pastel. Reestablish the pose, using light and dark values.

Does the pose created from the preliminary drawings offer interesting possibilities for the development of a pattern of light and dark?

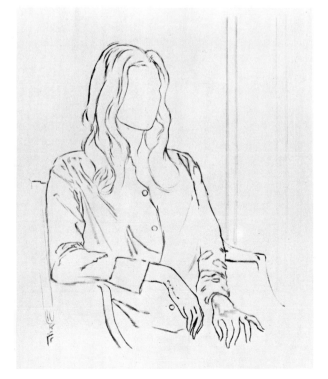

If the subject is short and you feel that the shortness should not be emphasized, place the head high in the composition and try placing vertical objects in the background.

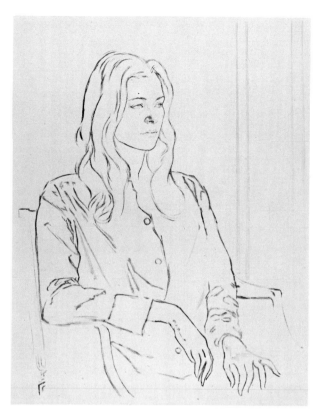

Now refine your drawing. With sharp, incised lines, establish the features.

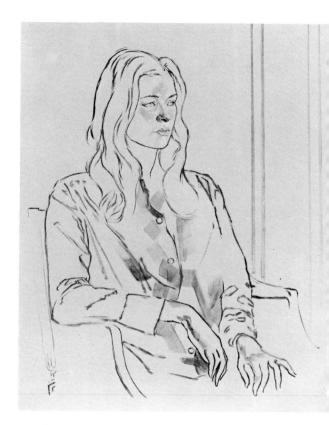

To obtain roundness in the form, model from the center toward the contour.

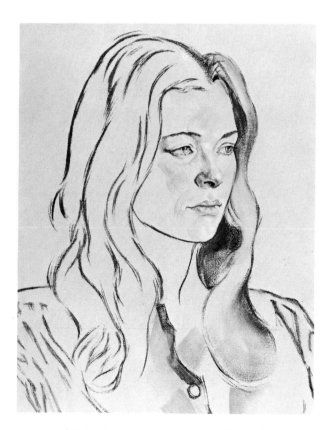

How does the cast of light define the cheek?

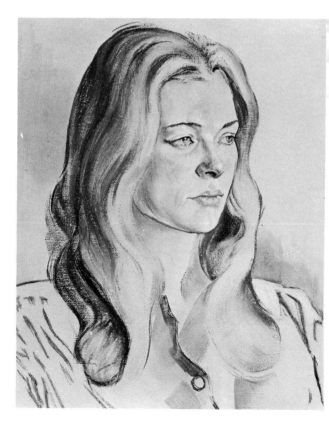

A dark is useful in the undercut where nostril touches cheek, behind the ear, or under the chin.

fine the cheek? A dark is useful in the undercut where nostril touches cheek, behind the ear, or under the chin. A light on the forehead, cheek, or tip of nose, by contrast, will add life to the whole head. Do not become preoccupied with polishing all forms equally, but keep the over-all design in mind. Be selective. Carry some forms, some details, further than others.

You may find it difficult to place each feature in its proper position and proportion immediately. Therefore, place them tentatively and adjust them gradually. In this way, you will establish their relationship.

Although these studies are only a step in the work plan, treat each sketch with the utmost thought. Study over and over again how the eye fits into the socket, how the upper lid seems to tilt toward the median. Note the action of the light on the forehead; the luminosity of the shadow on those areas sheltered from the light. Gradually, your portrait will emerge.

The visual concentration required will occasionally tire your eyes. If you become conscious of fatigue, leave your easel for the moment. To freshen your vision, examine the model from another angle, as the sculptor would do. A feature is factually the same from whichever angle you see it, but changing the view will freshen and clarify your vision. Then return to your easel and resume your work.

Using the Camera

If you are commissioned to paint a busy public figure and he is unable to give you much of his time, use a camera as a substitute for these preliminary sketches. You can photograph fifty different poses in the time you would require to make two or three rapid sketches. The camera is merely an aid, however, and its usefulness is limited. The photograph is a reference, not a substitute for a good sketch. Do not become completely dependent upon it, because it can restrict your work. The camera is only a mechanical device, and you must use it creatively.

The photograph will provide you with factual detail for further studies; it records and you must select from its recording. Do not copy the photograph; interpret it. The camera, revealing everything within its range, offers many clues and sometimes will catch an im-

probable stance which, on second viewing, will prove to be characteristic of the subject.

Use the same approach to put the subject at ease, whether you are drawing or photographing. Just as I suggested that you do many preliminary drawings, I also suggest that you take many photographs for the same reasons. Only if you have a large selection will you find one or two really good ones that will prove useful for your purpose.

Place the camera on a tripod and use a cable release to trip the shutter. This will prevent any jarring of the camera while you take the pictures. Although your *model* may move and blur the image, make certain that *you* do not blur any exposures through haste or lack of preparation.

Test the light in your room with a light meter; work with Plus-X or Tri-X film if you are using black and white; with Kodachrome or Anscochrome if you are using color. Since most of your work will be indoors, it is essential that you use the proper exposure, determined by your light meter. It is advisable to have a good camera with a critical lens. A camera that delivers a $2^{1}/_{4}''$ x $2^{1}/_{4}''$ negative (like a Rolleiflex) or a 35mm single lens reflex, are among the classifications of cameras that I would suggest.

An associate may operate the camera while you work with lighting. A clamp-on floodlight can be hand-held or fastened to a chair back, easily moved about for the purpose of lighting the model.

Keep the model engaged; direct his attention away from the camera. Photograph continuously. The rapid picture-taking is extravagant, but it records action, character, and likeness, so important to your work.

Let the sitter review the photographs with you; his observations will be useful. Where he may question your judgment in the drawing, the recording of the camera may enlighten him.

Putting the Photograph to Use

There are a number of ways to use the photograph as a substitute for the foundation drawing. The most common method employs a photographic enlargement of 11" x 14" or a similar size. Place the photograph under a

glass or acetate, the surface of which has been squared by a grid of vertical and horizontal lines. These lines will cross and locate the features on the photograph. Now the impressions of the photograph, as measured by the grid of the glass or acetate, can be transferred to similar points of measure on the canvas. Constantly refer to the photograph as the transfer is made. There is much room for error in this method and, since it is a mechanical process, care must be taken to employ it with precision.

Some painters, working with photographs, will have an enlargement made to the actual size of the painting. They then trace this onto the canvas, outlining features, light and dark areas, and general proportion. This gives a full-scale pattern. The photo is then shifted off the canvas, but placed nearby within easy view. By referring to the photo, the artist can develop the forms and establish the foundation for the painting.

Another process, somewhat more tedious, involves a color transparency of the subject which is projected onto the canvas. Working directly over this projected image, the artist can outline and block in the form and color. Once the key proportions are established on the canvas, the image can be projected onto a screen placed nearby. With the aid of a powerful projection light, you will be able to see the image in its true color even in a fully lighted studio. Referring to this projected image, you can carry the painting to its full development.

Interpreting the Photograph

There is always some mechanical distortion in the photograph, which must be overcome. This will entail some free drawing to extend the neck, reduce the hand size, clarify the features, and make whatever other adjustments you feel necessary.

The camera image is purely documentary. You can gather many important facts from that documentary, from the character of clothing to the carved detail of a chair. Each fact can be stored for later consideration. However, this unlimited recording requires selective editing; use only the details that seem desirable. An object can be included if it adds a descriptive note and improves the design. Do not clutter your composition.

If you think that a detailed, exact copy of a photograph will guarantee you an excellent portrait, look out! An inch-by-inch copy, a faithful reproduction of the photo, will produce only a map.

If using the photograph troubles your conscience and you are afraid that the marvel and flow of drawing will become restrained, meet the situation and rise above it. The photograph is a mechanical image; the drawing is live. The drawing must, therefore, carry the portrait beyond the tedium of a copied photograph. Nothing can equal the free styled, painted portrait, but the use of a camera can be an aid when circumstance does not offer you unlimited time and ideal working conditions.

11
Planning the portrait

Having gathered information in your preliminary studies (Chapter 10), whether in the form of sketches or photos or both, you are ready to plan the portrait itself. The best way is to make one or more large preliminary drawings, the actual size of the portrait, preferably in charcoal on a large sheet of paper.

A good portrait is the result of thoughtful planning. Look at your subject through a cardboard focal frame. Take two L-shaped pieces of cardboard and fasten them together with paper clips so that they make a rectangular frame the proportion of your canvas. View the model through the aperture of the frame, moving it about until your subject is placed well within the framed area.

As you view your model this way, train yourself to look at his image without focusing on any one feature.

Initial Plan

The head must be well placed in the composition. This does not mean dead center, for nature does not work on balance, but through harmony and contrast. The right side of the face is not exactly the reversal of the left side —the head is not precisely symmetrical—and yet the facial structure assumes a unity within the head. This is nature's way.

In order to locate the head in the right position, make it rest well within its surroundings. Arrange it within the upper half of the canvas; let the figure occupy the lower half. Place the head just off center so that your subject looks into the canvas. It must not be placed too high, for this will crowd the portrait, nor too low, for then it will become lost in space. If the head is placed too close to one side, it tends to fall out of the composition on that side. Experiment with these problems, solving each to your satisfaction.

When you think of a portrait, you probably envision only a head. But portrait character can be heightened by including other parts of the body which will support and dramatize the head.

Enough space must be retained around the central image of the head to allow other details to become part of your design. For example, when portraying the head, include the collar; a head and shoulders portrait should in-

In order to locate the head in the correct position, make it rest well within its surroundings. Place the head just off center so that your subject looks into the canvas.

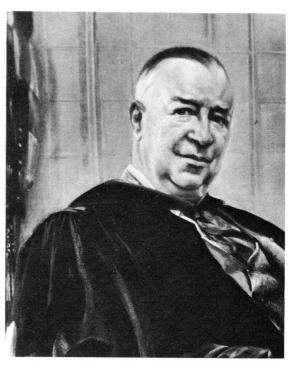

If the head is placed too close to one side, it tends to fall out of the composition on that side.

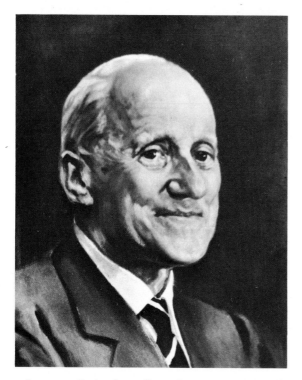

Always include the collar when you portray the head. This is an important aspect of your portrait.

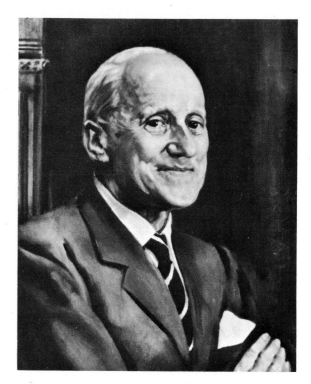

A portrait of the head and shoulders should include the area below the shoulders and above the elbow, as is shown here.

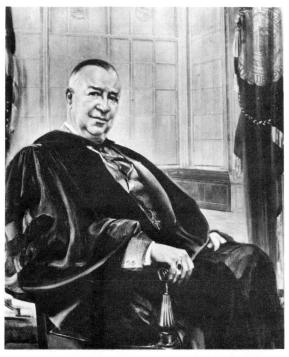

When you do a portrait which includes the head and hands, with the subject seated, you might also include the knees.

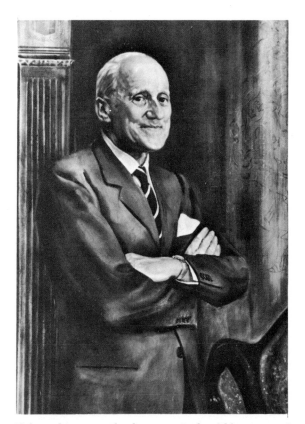

If the subject stands, the portrait should be cropped at the thigh.

Sir Evelyn Wrench by Furman J. Finck.

Mixed technique on linen canvas, 48″ x 28″. A three-quarter length portrait allows for a more generous arrangement on the canvas. Collection, English-Speaking Union.

Dr. Robert L. Johnson by Furman J. Finck.

Mixed technique on linen canvas, 66″ x 48″. The full length portrait. Collection, Temple University Health Sciences Center.

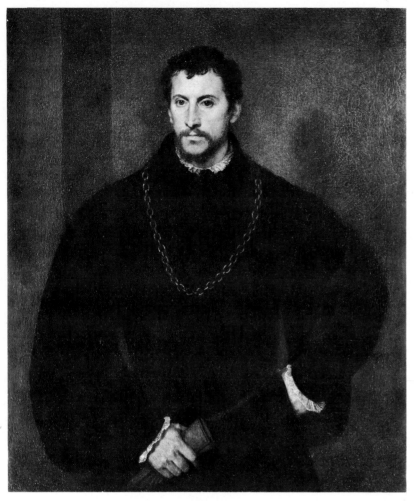

The Duke of Norfolk
by Tiziano Vecellio (Titian).

In the portrait of the man, the chest may be erect, with arms and legs slightly overlong, head, hands, and feet not overlarge. Collection, Galleria Palatina, Palazzo Pitti, Florence.

clude the area below the shoulders and above the elbows. A head and hands portrait, with subject seated, might include the knees; if the subject stands, the portrait should be cropped at the thigh. A three-quarter length portrait allows for a more generous arrangement. Then the subject is cropped below the knee. The full length portrait includes the entire figure with ample space surrounding it.

The cropping should be considered carefully. Do not crop right at a joint, but include the whole of the elbow, wrist, hip, knee, or ankle. If the elbow is included, be sure to show part of the forearm. If the wrist is included, show a portion of the hand.

Fix the design firmly in your mind; let the sitter suggest this for you. As he poses, he will assume a definite position and, in fact, actually create the basic design for you. If you want to include the hands, give them something to do.

Since the portrait will eventually hang slightly above eye level, and be viewed from this angle, take this into consideration by posing your subject on a model stand. This will adjust your view of him so that the work will look well when it is hung.

Making the Portrait Individual

To the inexperienced eye, all portraiture may seem alike. In some of the work of the American colonial period, portraits by itinerant painters did look alike because the pose was stylized. The figure, painted beforehand, was usually set in one of several positions. When a customer was found, he was posed to conform to the set of the pose and his head was painted in; except for the features, no character emphasis was attempted. As a result, these portraits seem stiff to us today.

There are certain subtle means frequently employed by the artist to distinguish masculine traits in the male portrait and to beautify and poetize the feminine in the portrait of a woman. These effects, in the male portrait, may take the form of a generous gesture in the pose: the chest erect, with arms and legs slightly overlong, head, hands, and feet not over-large. Examples may be found in most of the formal portraits of the Kings of England, the Titian portraits, and many of the full length portraits by Sir Anthony Van Dyke. Mindful

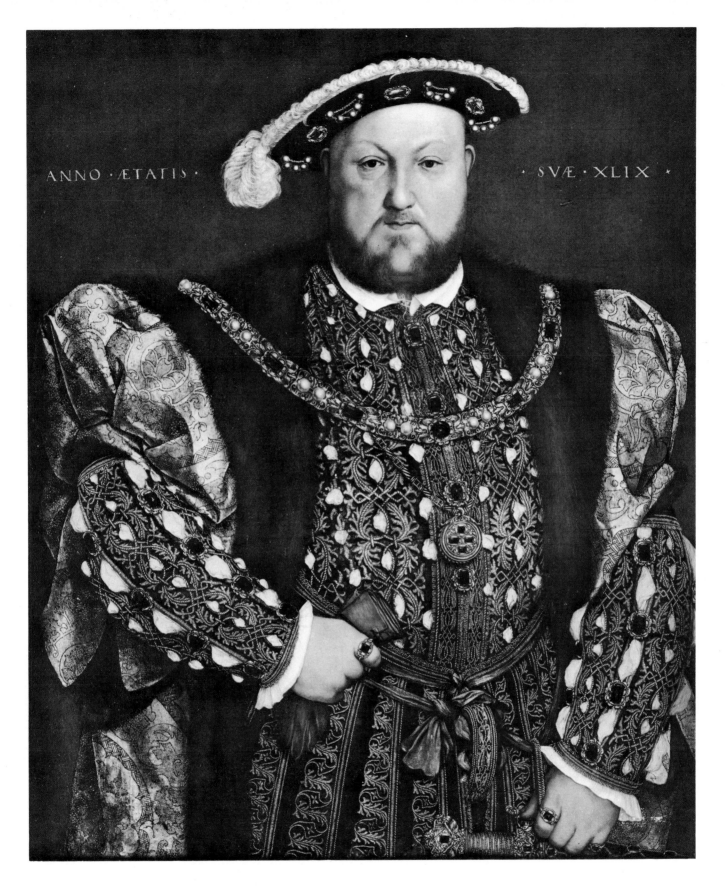

ANNO · ÆTATIS · · SVÆ · XLIX ·

King Henry VIII by Hans Holbein.

There are certain subtle means frequently employed by the artist to distinguish masculine traits in the male portrait and to beautify and poetize the feminine in the portrait of a woman. These effects, in the male portrait, may take the form of a generous gesture in the pose. Collection, Gallery Corsini, Rome.

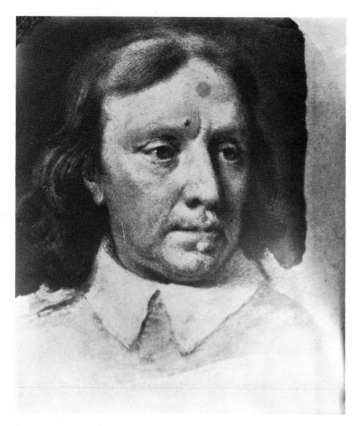 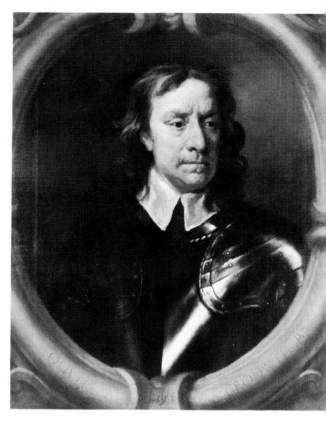

Miniature of Oliver Cromwell by Samuel Cooper.

"Cooper's and Lely's portraits are so close that one must depend on the other; no two painters could arrive at so identical an image from different sittings from the life; that it is Cooper's miniature that is the original is, I think, reasonably proved by a simple count of warts." From The English Face by David Piper (Thames and Hudson). Courtesy, The Duke of Buccleuch and Queensberry, K.T., G.C.V.O.

Sir Oliver Cromwell by Sir Peter Lely.

Compare this with the Cooper miniature of Oliver Cromwell to see how closely they do match in style and spirit. Collection, City Museum and Art Gallery, Birmingham.

of the artist's practice of flattering the sitter, Oliver Cromwell is reported to have said to his portraitist, Sir Peter Lely, "Mr. Lely, I desire you will use all of your skill to paint your picture truly like me, and not to flatter me at all; but remark all of these roughnesses, pimples, warts, and everything as you see me. Otherwise, I will never pay a farthing for it."

The female portrait stresses the more subtle feminine features: small ears, graceful neck, long fingers, the allure of the eyes and the mouth; sometimes the lips are slightly parted to accentuate this allure. Some lengthening of waist to ankle is acceptable, although anatomical proportions are best kept medium to small. Boucher's portrait of Madame de Pompadour, Ingres' portrait of Madame De Vauçay, as well as the pastel portraits of Edouard Manet, describe the charm of woman and emphasize one or more feminine qualities.

In either the male or female portrait, any enlargement of head, hands, or feet will seem awkward on canvas. Likewise, any emphasis on roundness or stoutness will accentuate bulk and may offend the observer. A slender proportion is always preferable. If your subject is stout, retain some largeness in the shoulder-chest area, while cautiously reducing it within the waist and hips. However, no such adjustments should be obvious.

Children's portraits accent the fresh and spontaneous movements that mark the behavior of the young. The charm and lightness of youth is emphasized through the softness of features; large, open eyes; delicacy of head; and smallness of figure. Some good examples include those of the Spanish royal family by Velasquez, the artist's daughters by Gainsborough, the sons of Renoir, and the children's portraits of Mary Cassatt, to suggest only a few. Children are bright, quick, and energetic; their complexions are delicate, often transparent in color and pastel shades. Children are erratic and vigorous, and their manner is instinctive, spirited, and natural; they can best be caught with an emphasis on the artist's direct impression.

In the single portrait, you will achieve a commanding effect if you paint the subject as he looks directly to the front. The eyes will then seem to follow the observer. This attitude, which suggests action, is most success-

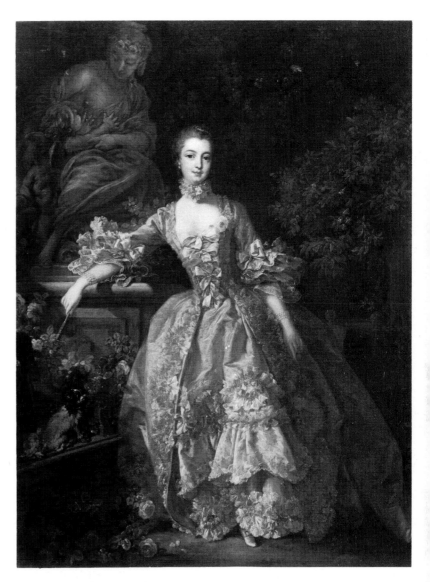

La Marquise de Pompadour
by François Boucher.

The female portrait stresses the more subtle feminine features: small ears, graceful neck, long fingers, slight lengthening of the waist to ankle. By permission of the Trustees of The Wallace Collection, London.

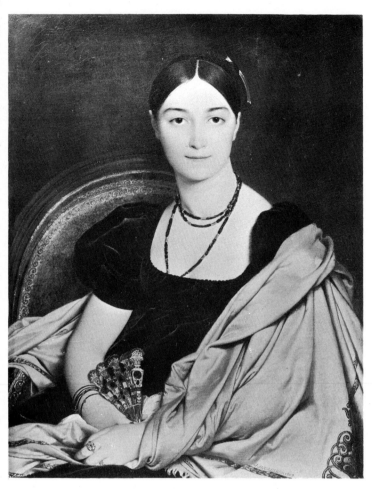

Mme. De Vaucay
by Jean Auguste Dominique Ingres.

Notice the allure of the eyes and the mouth, the way the artist has enhanced the femininity of the subject. Collection, Musée Condé, Chantilly, France.

Mlle. Valtesse de la Bigne by Edouard Manet.

Pastel on fine canvas, 21³/₄″ x 14″. The softness and delicacy of treatment in this portrait describe the charm of the woman and emphasize her feminine traits. Collection, The Metropolitan Museum of Art, bequest of Mrs. H. O. Havemeyer, 1929. The H. O. Havemeyer Collection.

ful when the face is in full to three-quarter position.

It is also common practice to activate the pose by showing the figure from a side view, while turning the head so that it faces over the shoulder in a three-quarter to full face position. Hair blowing or a jacket caught in the breeze also suggests action.

Scale

A life sized portrait seems "right" if it is actually somewhat smaller than life size, while a sculptor can produce a portrait just over the actual size and it will not seem too large. In both cases, the artist has undertaken to solve a visual problem. In the painting, the critic observes a portrait head against a painted background and views the whole canvas shape at one glance; in the case of the sculptured head, the entire area in which it is situated becomes the background and the head, therefore, must be big enough to compete and harmonize with other ornaments and architectural detail. Except in a painting of mural proportions—when the painted head can be extended to over life size—it is visually desirable to keep this dimension just under life size, since bigness is not an asset in the painted portrait.

Notice the Gesture

When you study the model, think of people who remind you of him. What aspects of his personality interest you? Is there something about the tilt of his head, straightness of hair, prominence of brow, or a gesture with the hand that holds your attention? One of these characteristics, properly emphasized, can make your portrait lively.

Next to the head, hands are the most expressive feature of a portrait. Watch your subject to see how he augments conversation with a gesture of the hand. How does he hold a pencil, pick up a glass? Professional, technical training accustoms men to different, precise uses of their hands. Watch a waiter as he is serving; watch the musician as he handles his instrument.

When you compose the hands as they relate to the head, observe their action. They can be painted brilliantly and in sharp focus—to

Sandra by Irving Katzenstein.

Oil on Masonite, 18" x 24". Children's portraits accent the fresh and spontaneous movements that characterize the behavior of the young. Beneath this oil painting there is a casein tempera underpainting. Collection of the artist.

Las Meninas (detail)
by Diego Rodriguez de Silva y Velasquez.

In this head of Princess Margarete, the artist has captured the charm and lightness of youth through the softness of features; large, open eyes; and delicacy of the head. Collection, Prado Museum, Madrid.

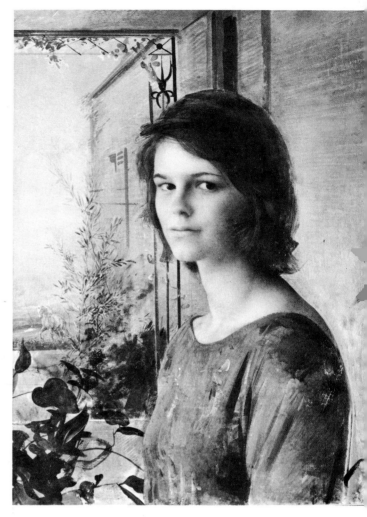

Miss Elizabeth Jay Stillman, 1962
by Pietro Annigoni.

In the single portrait, you will achieve a commanding effect if you paint the subject as he looks directly to the front. The eyes will then seem to follow the observer, an attitude that is most successful when the face is in full to three-quarter position. Collection, Mr. Chauncey Stillman.

Anne by Furman J. Finck.

32" x 36". A life sized portrait seems "right" if it is actually somewhat smaller than life size. In painting, the critic observes a portrait head against a painted background and views the whole canvas shape at one glance. Collection, Mr. and Mrs. Charles M. Johnson.

Frank Lloyd Wright by Dr. Boris Blai.

A sculptor can produce a portrait just over the actual size of the subject and it will not seem too large. The entire area in which it is situated becomes the background and the head, therefore, must be big enough to compete and harmonize with other ornaments and architectural detail. Collection, Florida Southern College, Lakeland.

Somerset Maugham by Graham Sutherland.

When you study the model, think of people who remind you of him. What aspects of his personality interest you? Is there something about the tilt of his head, straightness of hair, prominence of brow, or a gesture with the hand that holds your attention? Collection, The Tate Gallery, London.

equal the painting of the head—or they can be painted in a subdued and blurred manner with muted colors, to be included with the subordinate areas. Because they contain so much of the personality of the sitter, the hands will attract the viewer and he will seek them out. When you include them in your composition, you introduce a so-called *triangle of prime interest* in your portrait; namely, the relation of head to hands and of one hand to the other. The Rembrandt self-portrait in the Frick Collection is a good example of the expressive use of hands and this triangle of prime interest.

Perspective

As long as you show height and width in your painting, all is fairly simple, but when you attempt to place one object behind another, or to model an object to produce form, you create the illusion of another dimension—that of depth or space.

When attempting this illusion, think of your canvas as a window through which you may gain a view of your subject. You might open this window onto an intimate theme composed within an area of a few inches, a jewel-like still life. It is also possible to reveal a scene of panoramic splendor and expand your view over many miles of countryside, as in a landscape. All painted passages should function behind this opening, each suggesting distance.

Illusions of space and depth can be further amplified as perspective is introduced. If an object is enlarged, it will advance; if it is reduced, it will recede. As you move one object behind another, that object will seem to decrease in size. The near object seems sharp and clear, while the far one becomes blurred. Although we know both objects to be of the same size and equally sharp, we accept these illusions.

Just as objects seem to grow smaller as they recede, they also seem to soften in color, flatten in form, and lose detail. This illusion is due to the presence of atmosphere which contains moisture and dust and comes between the viewer and the object being viewed. At the same time that a receding object seems to grow smaller, the introduction of atmosphere tends to reduce the clarity of its form. This phenomenon is referred to as atmospheric per-

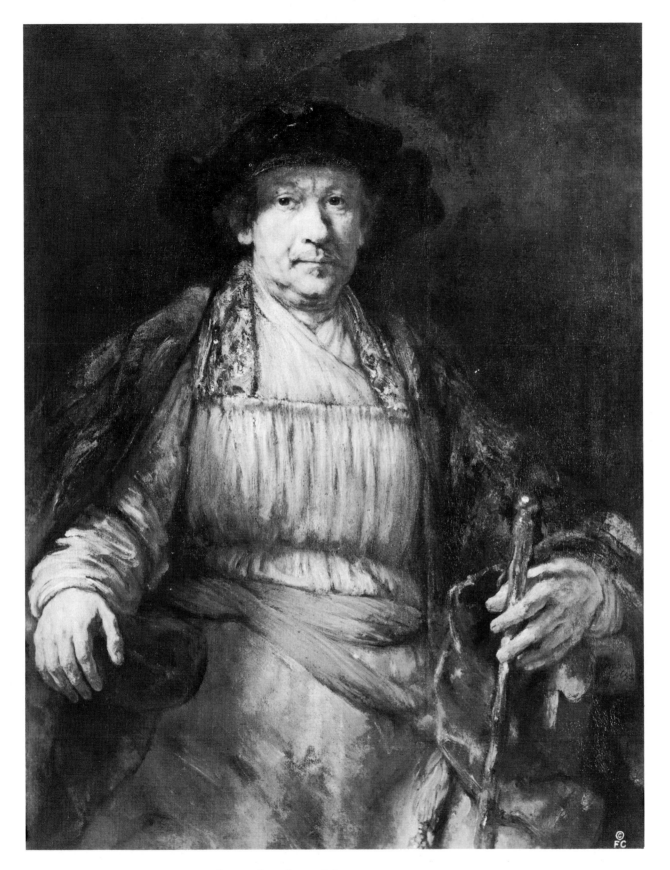

Self-Portrait by Rembrandt Van Rijn.

Because they contain so much of the personality of the sitter, the hands will attract the viewer and he will seek them out. When you include them in your composition, you introduce the so-called triangle of prime interest in your portrait; namely, the relation of head to hands and of one hand to the other. Collection, The Frick Collection, New York.

Treat your painting as though it were a stage and your canvas the proscenium. The foreground leads the eye into the composition, the middleground contains the theme, the background the accompaniment.

spective and can be used to suggest spatial relationships in your composition, as well as to intensify the mood.

Foreground, Middleground, and Background

A painting, which is in two dimensions, can be rendered to give the illusion of three dimensions. In order to establish clearly this sense of a third dimension, divide the interest in your composition among the foreground, middleground, and background.

Treat your painting as though it were a stage and your canvas the proscenium. The foreground leads the eye into the composition, while the middleground contains the theme. The background contains the accompaniment, while serving to keep your picture in focus and your composition orderly. This division should be developed thoughtfully throughout the painting process.

Use of Space to Create Interest

Now you can give your attention to the areas surrounding the portrait head; let us call them space areas. They represent the sky, wall, floor, etc. The effect of light and shadow on them makes for additional interest. These space areas overlap and give you the opportunity to use free brushwork, color, and any painting effects which will help you develop the beauty of the painted surface. A wall of the background, for example, may turn into a bay, creating vertical corners; across its planes a shadow may fall, blending these areas.

Related Forms and Areas

When you look at a portrait, remember that you are also looking at a painting. The head resembles the sitter; it is also a painted form. Consider, too, the subordinate elements, such as the pattern on the wall, the checker of the shirt, the weave of the jacket, the ornamental carving of the chair—parts to be painted in detail as aids in summing up the character of the subject. Sometimes these passages are indicated by a change in the brushwork; sometimes by an alteration of color or light and dark, but each will produce a different surface quality.

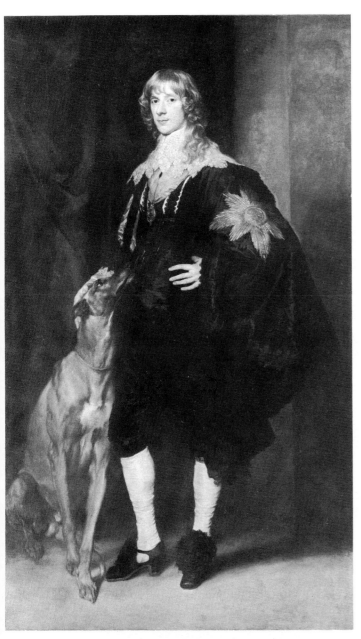

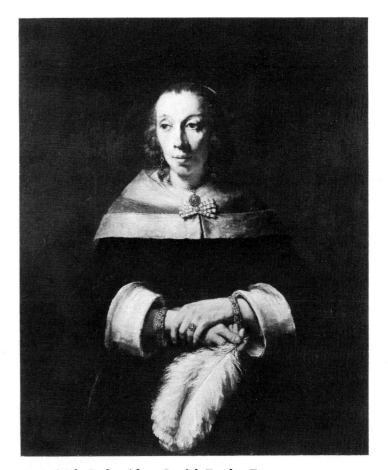

Portrait of a Lady with an Ostrich-Feather Fan
by Rembrandt Van Rijn.

Oil, 39¼" x 32⅝". Connecting shapes, as when one form joins another, suggest a balanced order within the composition. Courtesy, National Gallery of Art, Washington, D.C. Widener Collection.

James Stuart, Duke of Richmond and Lennox
by Sir Anthony Van Dyck.

Oil on canvas, 85" x 50". Give your attention to the areas surrounding the portrait head: the sky, wall, floor, etc. The effect of light and shadow on them makes for additional interest. Collection, The Metropolitan Museum of Art, Gift of Henry G. Marquand, 1889.

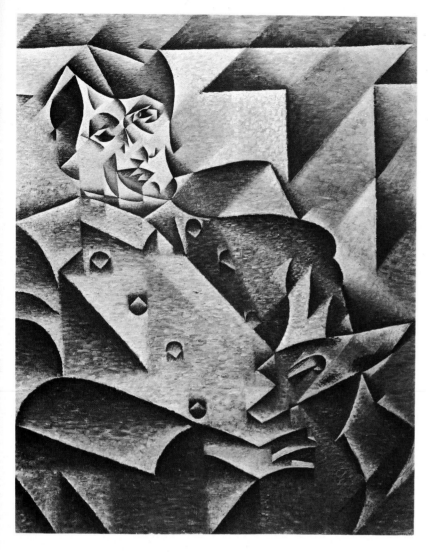

Pablo Picasso by Juan Gris.

Oil on canvas, 37" x 29½". Disconnected shapes suggest diversity. Compare this to the Rembrandt portrait. Collection, The Art Institute of Chicago.

Design refers to the whole picture, not only to the pose but to the totality of elements that make for interest in the painting. It is important that the painter make the surface full and varied, contrasting bright with dull, opaque with transparent, hard-edged with soft-edged, rough with smooth.

Connecting shapes, as when one form joins with another, will suggest a balanced order within your composition, while disconnected shapes suggest diversity. Rembrandt's *Lady with an Ostrich-Feather Fan* is an example of connecting shapes, while Juan Gris' *Portrait of Picasso* is an example of disconnected shapes. Study these variations as shown in the reproductions. Try them and see how they work.

Abstract Pattern

Just as every color has its complement, so does every pattern. When you draw a pattern to indicate the figure of your subject, you inherit an opposite pattern, that of the surrounding area. Naturally, the figure will assume the main interest and the surrounding area will become complementary. But, for the moment, we speak of these areas as abstract patterns. Any pattern, with its complement, will form an optical unity. Patterns or shapes are established on the canvas when you draw and paint. As you work, you refine these patterns, and gradually your portrait will emerge from them. Each one has its special place in the total effect. Arrange them so that they relate well together.

Constructing with Triangulation

You will recall that the relationship of head to hand and hand to hand has been referred to as the triangle of prime interest, since head and hands are dominant in your composition. You may ask "Why the triangle?" As a means of construction, the triangle helps to establish the form of the portrait subject in a strong, simple design, and to integrate its shape into the surrounding area. Of course, it is possible to experiment with shapes other than a triangle, but the triangle remains the most efficient means to circumscribe an area.

Although we have only considered the patterns of the head and the two hands, it is possible that you may want to expose only one

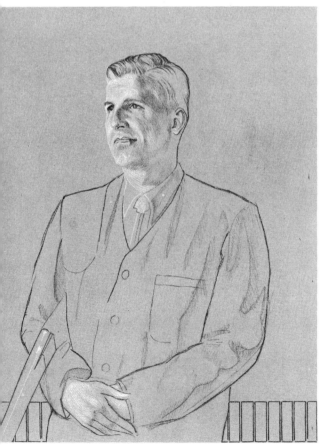

(Above left) *Draw a pattern to indicate the figure of your subject.*

(Above right) *You inherit an opposite pattern, the surrounding area.*

(Left) *Any pattern, with its complement, will form an optical unity.*

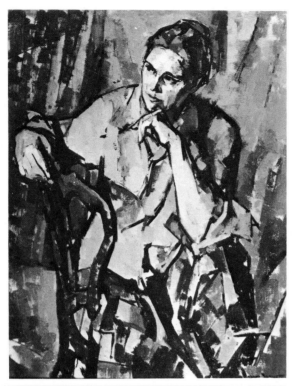

Portrait of Betty (Pink Blouse)
by Herbert P. Barnett.

Oil on canvas, 30" x 24". The triangle helps to establish the form of the portrait subject in a strong, simple design. Collection of the artist.

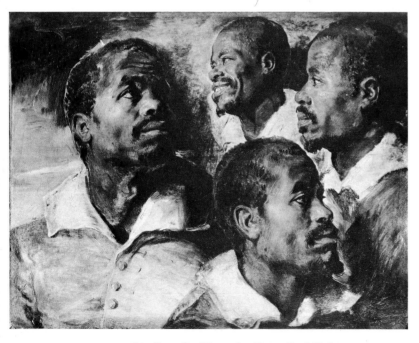

Studies of a Negro by Peter Paul Rubens.

The oil sketch can be worked freely. Because of its size, the small oil sketch is less involved than a large one. Collection, Belgium Royal Museum of Fine Arts, Brussels.

hand to view. How then can you establish the triangle of prime interest? Under these circumstances, you might select an object as the third vertex of the triangle. This third point should be located so that the triangle is drawn across the figure and support is given to the head. Therefore, set this vertex on the chair arm, or on the sleeve or the knee; place it where you feel it will balance the other two points.

The abstract pattern also involves considerations of form and depth. Keep all relationships in order by establishing the action of each triangle of interest properly within its space area. For example, if the head is established within the middleground and the vertex of the triangle is extended to the foreground or pushed into the background, the pattern will be weakened. This triangulation, used creatively, will help you to tighten the abstract pattern, securing the foundation for a strong composition.

Now that you have established the primary points of interest with the help of triangulation, the secondary areas can be employed to repeat or contrast with the main theme.

Finally, as you examine your work, the overall pattern may suggest a figure such as an *A* or the curved form of an *S*. You can now move from the seeming rigidity of the triangulation; with a freehand, sweeping line, you can release the drawing to conform to this new image. Then, too, without adhering to the subject you actually see, it is often effective to strike a bold line through a background area to stir it. Pick up your charcoal and actually draw a line across the area that needs movement. The areas of color or light and dark can now be raised or lowered so that they touch or cross this line. Thus, the eye will be directed by these adjustments after the actual line is erased, without the observer being aware of it. By this means, you can direct his attention wherever you wish.

Oil Color Sketches

That the oil sketch is used so frequently—occasionally completed in detail—indicates the practicality of this method of work: first, to present your idea to the patron; then as a working source or reference. You have previously undertaken studies of your subject in

pencil and charcoal; now arrange the lighting and work out the problems of color in a small sketch.

As a basis for the oil sketch, select the charcoal sketch which was the choice for the pose. Square it into quarters. Now, do the same to the canvas and proceed to transfer the sketch. The process of squaring and transferring is described in Chapter 10, in the section, "Putting the Photograph to Use." Then paint the sketch.

For this purpose, use a stretched canvas or a cardboard panel of sufficient weight to avoid warping. If you use cardboard, cover it with a layer of shellac on both sides. The sketch should be a broad application of color and design. It may also be carried further than a basic impression requires. I have undertaken these preparatory sketches with a limited palette of half a dozen major colors and two or three medium sized bristle brushes. Select your own materials, those with which you feel most familiar.

The monochromatic drawing offers the light and dark pattern, but your concept is carried further with the introduction of color. The oil sketch will be worked freely; the more fully it is developed, the more useful it will be as reference for the final portrait. Because of its size, the small oil sketch is less involved than a large one.

I often provide myself with a *full* scale, roughed-in color sketch. I cover my canvas—the one on which I intend to do the portrait—with a piece of heavy wrapping paper, as this will support the oil paint very well for this temporary purpose. I use as little medium as possible, since paper is absorbent, and work directly. I note my first color impressions in the size I expect the portrait to be. These unrefined impressions will produce a stimulating pattern. For this painting on paper, I recommend a limited palette and bristle brushes.

As a basis for the oil sketch, select the charcoal sketch which was the choice for the pose. Square it into quarters.

Square the canvas into quarters and proceed to transfer the sketch.

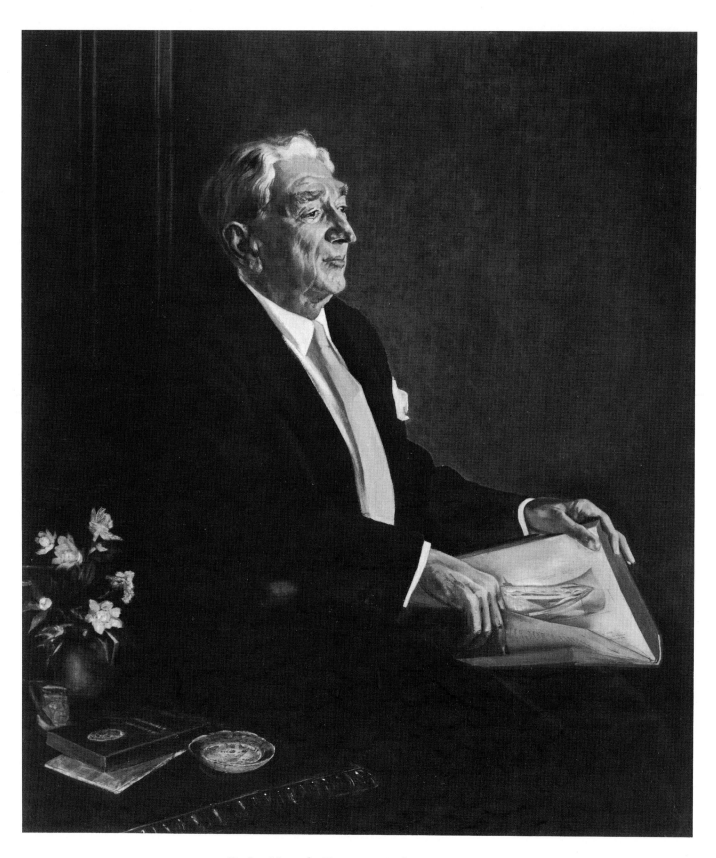

Dr. Leo Mayer by Furman J. Finck.

44" x 35". The planning of a portrait composition can have as many different approaches as there are individuals painting. Collection, Hospital for Joint Diseases and Medical Center, New York.

12 Painting the portrait

A good portrait is a good picture. Planning its composition can have as many different approaches as there are individuals painting.

Transfer the Preliminary Sketch

Work on your preparatory sketches until you have gained what you want from them. Draw the composition full size on paper prior to drawing it on canvas; this large scale work will be an invaluable aid to you. You can now transfer it from the paper by tracing, or you can freely redraw it.

Adding Light and Dark

After you have transferred your drawing to the canvas, examine its pattern for the location of important lights and darks and begin to block them in. A mixture of burnt sienna and white will produce an off-shade of light, useful for the lighted areas. Ivory black, white, and ochre will give a neutral gray of suitable impact that can be made lighter or darker to describe the various values for the supporting darks—all the areas of form and background that are not directly lighted.

As your work develops, you will compose light and dark to achieve form. For example, the face is partially lighted and you see the forehead, as well as the front plane of the nose, cheek, and chin, in a luminous light. Work with these shapes until the head has been developed.

Let us suppose the sitter is holding an open book. Both hand and book are lighted. Treat them as a single compound shape. In placing them on the canvas, relate them well to the total design. When you feel that the lights have been fully developed, you can add the supporting darks.

Maintaining the Character of the Portrait

As the painting is developed, so is the characterization of the sitter, and at the same time the artist is making a statement of his own. You will shade and round some shapes within the pattern, developing them for form. Main areas may be lighted for definition, while unlighted areas may be fused.

As you progress, your thoughts will trans-

Draw the composition full size on the paper prior to drawing in on canvas. This large scale work will be an invaluable aid to you.

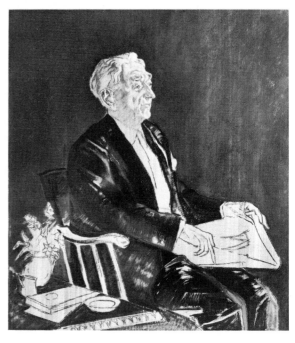

After you have transferred your drawing to the canvas, examine its pattern for the location of important lights and darks and begin to block them in.

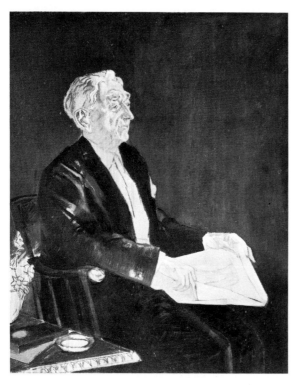

If the sitter is holding an open book, both hand and book are lighted. Treat them as a single compound shape.

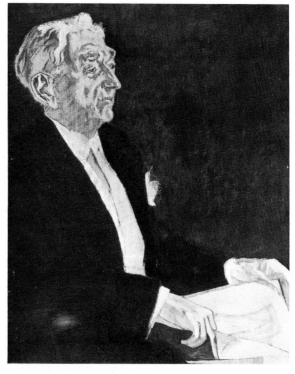

Pay attention to achieving different textures and variety within the surface quality.

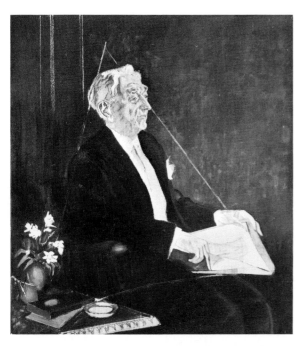

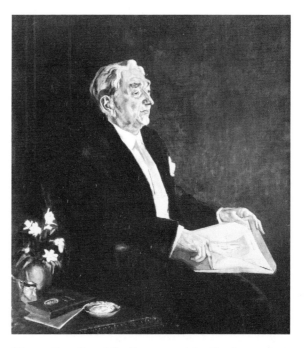

In order to make a picture read well or easily, certain devices are used, such as "directional findings": vertical, horizontal, or diagonal.

These directional findings may take the form of an accent with the brush, a series of light or dark passages, or well rendered detail.

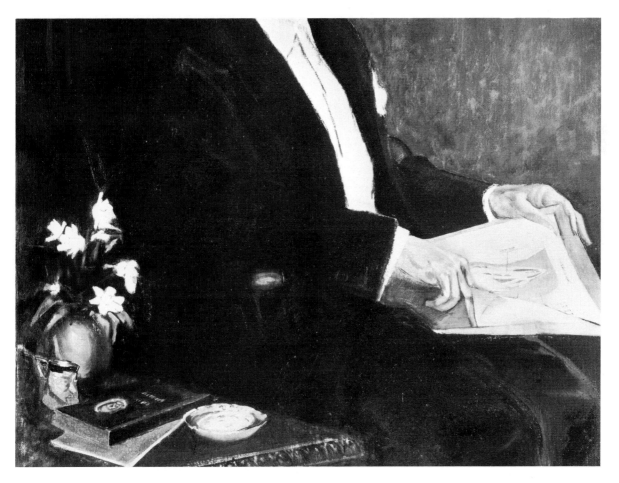

As you work over your canvas, let your eye fall where it will; touch this passage, then turn to another. This way, you avoid unevenness in the growth of your portrait.

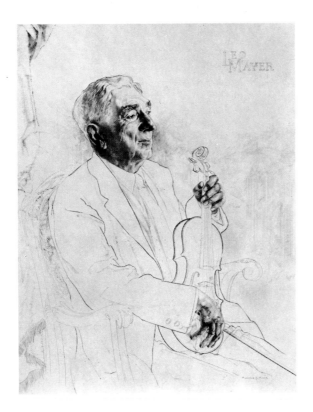

Pencil on gesso-sized board, 26″ x 21″. This is one of the two finished drawings for the portrait shown in this chapter. Courtesy, Portraits, Inc., New York.

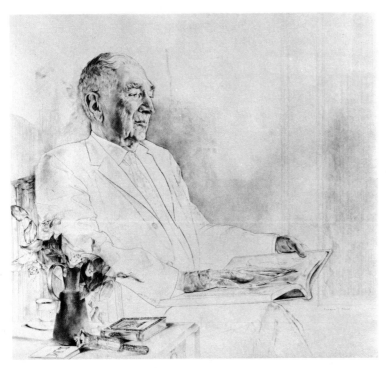

Dr. Leo Mayer by Furman J. Finck.

Pencil on gesso-sized Bambridge board, 24″ x 26″. The other of the two finished drawings sets the mood for the painting and gained the patron's approval. Courtesy, Capricorn Galleries, Bethesda.

fer from speculation on his personal characteristics to the sitter's painted form. What can your brushwork do for you? If you reduce the wrinkle, do you impair the sitter's character? Can you describe the character and retain the brush strokes? You are caught up with the plastic quality of the paint and also in fascination with the character of the sitter. How far can you carry the painting and not lose the character? A painting may be painted well and be a poor likeness; a painting may reveal a good likeness and be poorly painted. In order to be a good portrait, it should be a good painting and represent the sitter as well.

Developing Focal Points

Having carried the composition through to its over-all plan, you now develop the center of interest and the secondary points of interest. A center of interest can be achieved with strong light, with great detail, or with both. In order to make a picture read well or easily, certain devices are used, such as "directional findings": vertical, horizontal, or diagonal. These findings may take the form of an accent with the brush, a series of light or dark passages, or well rendered detail.

These can be used to direct the eye and also to relate and tie in patterns. For example, you may emphasize height by directing the eye from the lower corner across the table, to the hands, up the lapel of the coat to the head, and across and up the paneling to the picture edge. The eye moves more rapidly on a continuous, straight line or form than on a broken one. Curves tend to soften a form. Diagonals can carry the eye up, down, or across. These directional thrusts will lead to and support the centers of interest.

Laying in the Paint

As you begin your painting, apply the paint loosely, in a monotone or muted color, until you have completely covered the canvas. Hold back full strength of color at this time, because it is easier to intensify color than to reduce it.

In the beginning, paint is applied loosely. Treat the shadow areas thinly and transparently, while keeping the lighted areas opaque and pastose. The less medium you use the bet-

ter, just enough to get the desired effect. This treatment of the areas is necessary because the shadows absorb light, while the lights reflect light. Use whatever medium you need to insure a sketchy covering. Do not allow the medium to run, if it blots out the grain of the canvas weave, you are using it too freely. Medium is a lubricant; it serves as a vehicle for the paint. Do not let it replace paint.

Using the mixture of white and burnt sienna for the lights, black, white, and ochre for the darks (as suggested above), block in your subject, give attention to the light and dark masses, their shape, their proportion, and their relationship. Develop the over-all pattern, light and dark.

From time to time, you may want to remove excess paint with a palette knife during this blocking in of your work. Draw the flat of the knife gently across the wet surface and lift whatever paint comes up. This use of the knife may serve to "pull" the painted areas together and, often, the surface is more interesting for what remains.

Treat your composition as if you were on a voyage of exploration. Let your eye fall where it will; touch this passage, then turn to another. Place a note of paint, not too light, not too dark; then locate another likely place and repeat the note. Following this procedure, set one or two dark notes, and, finally, place a light note with care. If you work over the entire sur-

face in this way, you will avoid unevenness in the growth of your portrait.

These notes of color and tone will gradually cover your transferred drawing, and the light and dark values will create a monochromatic study—the foundation of your painting. Try to carry this stage of muted values to the point where you can see the whole composition as an underpainting.

At all times, even if you should stop short of its full development, your painting should have the aspect of a completed statement. No part should be developed ahead of another part; consequently, no part should be completed independently. Do not force your progress; let the work suggest its own natural development.

While you cover your canvas in these muted values, you resolve the many compositional problems that do not involve color, such as arrangement, proportion, character, etc. Undertake your work in orderly steps, a little at a time. Mark progress as you go. A project that starts simply and is carefully planned will end successfully.

Not all passages need to be fully covered with paint. But once you have considered all the areas of your composition and applied basic tones to most of them, you are ready to apply color. Various methods of completing a portrait are described in the demonstration chapters that follow.

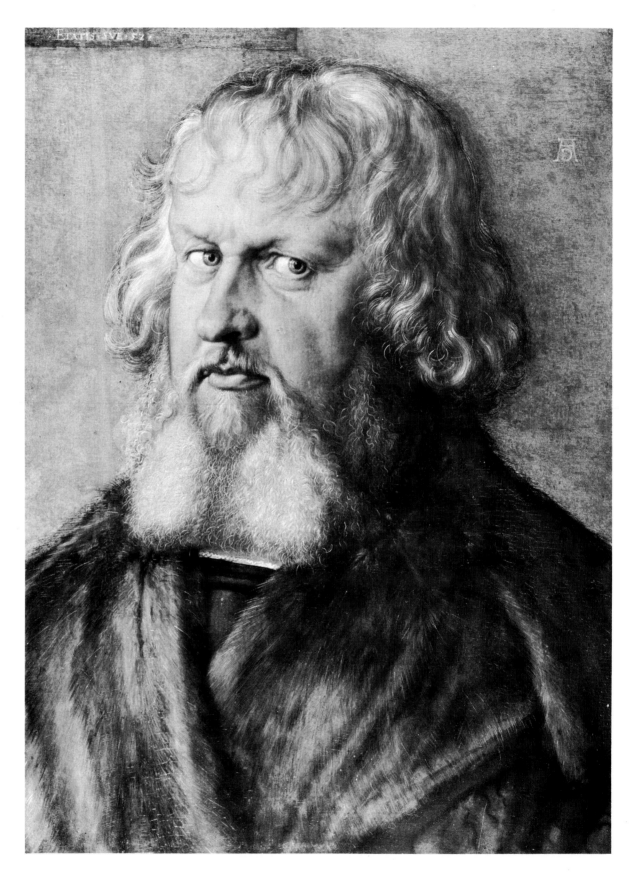

Hieronymus Holzschuher by Albrecht Dürer.

The eyes of the adult male should be rendered with sharp focus and not be enlarged. Collection, Former State Museums of Berlin, Museum Dahlem.

13
Getting
a
likeness

When your portrait is successful you will be told "It is such a good likeness." One will say, "You have caught the twinkle in his eye;" another, "I have seen him take that very pose so often."

Likeness involves every statement you make about the subject. It will develop gradually. In addition to representing his figure and features, you must develop a characterization of his personality.

To insure a good likeness you will want to follow an order of study and procedure involving three main points: (1) achieving correct proportion and placement of facial features; (2) portraying the subject in a characteristic and complimentary pose; (3) employing efficient brushwork in strong design. Keep these three points in mind during the entire painting of the portrait. As you work, check your progress; confirm each proportion. Move slowly; look twice, draw once.

What features does one stress? In what order? Determine what is characteristic of your subject. Does a feature or combination of features impress you? The eyes are the focal point; then the mouth, nose, and ears.

A Note About Flattery

Should you flatter the sitter? Yes, but not at the expense of his personality. When features are idealized at the sacrifice of character the image may be lost rather than strengthened.

What about requests to minimize or accentuate certain features? Do not assume that you are free to alter or modify at will. Painter and subject must come to an understanding to insure accord. Draw a double chin as you see it, then reduce it slightly. Draw a balding head as it appears, then add hair a little at a time. If your subject is plump, emphasize the bony structure in order to overcome the effect of roundness. Reversing this emphasis, if your subject is gaunt and his form noticeably bony, give the taut lines the slightest suggestion of fullness. But be conservative with any adjustments.

Useful Suggestions

If they are prominent, especially in women and children, the eyes may be accentuated to

some degree. The eyes of the adult male should be rendered with sharp focus and not enlarged.

When you sketch in the head, lay in both eyes at the same time. Allow ample space between them, draw them carefully, understate their color. Brown eyes blend with hair, but blue eyes are a field of color. Pale eyes become sharper when contrast is emphasized between pupil and iris, softer when contrast is minimized.

The mouth is secondary in importance only to the eyes. When painting it, retain the form and mobility. Though located at the same time as the eyes, its painting should be kept incomplete until the final statement. This way you will avoid a "set expression."

Consider the nose at the same time you place the eyes and mouth. Because of its position, the rendering of the nose must increase the relationship between eyes and mouth. The nose must be kept compact; if you stress leanness, character will be retained; if largeness is stressed, the effect may be gross and, at best, caricature.

Ears are part of the over-all concept and are secondary to the facial features. On the female portrait, they can be painted somewhat smaller. On other subjects, should they be large or protruding, they must not be altered, but rather understated.

The area extending from ear to ear, over the cheeks and across the nose, known as the *color band,* contains most of the painting referred to as the *color* of the portrait. An emphasis on color in this area, while blocking in your portrait, is helpful and will not disturb the progressive development of your painting.

Enlarging features will not necessarily add character, but sharpening their drawing will generally draw attention to them.

Getting a Likeness: Demonstration

In the demonstration on pages 145 to 149 the model takes a standing position, holding a gun in the crook of his arm. He leans from his right to his left. An upward thrust is suggested by the position of the arms, the folds of the jacket, and the set of the head. It is important, before concentrating on likeness, to realize the character and construction of the head so that the form will always be solid. As he faces toward his right, the front face catches the full light which comes from that direction.

Using the demonstration on these pages, follow the painting for likeness as if you were painting it yourself.

Establishing Features

The drawing is on the canvas. With a bristle brush, establish forehead, cheeks, bridge of nose, jaw, and chin in a medium flesh tone. A darker flesh tone, also applied with a bristle brush, can locate those planes not in direct light: the side and bottom of the nose, the pocket of the eye where its socket joins the nose, the side of the face and neck, and the underside of the chin.

With small bristle and sable brushes dipped into the wet paint, block in the features, placing them for relationship, developing them for proportion and character. Both eyes should be placed in the sockets and appear as a single unit. Now use shadow to shape the features and to give support to the lighted areas.

As you determine the position of the eyes, the length of the nose, and location of the mouth, the small brushes will enable you to develop such critical areas with precision. The brushwork now moves from one feature to another, taking in their relationship, eyes to nose to mouth. What is the prominent feature? Perhaps in the portrait reproduced in this demonstration it is the nose and its pronounced accentuation where the bridge and eyes relate to each other.

Now check the nose for width and length; a light on its tip will help balance these proportions. Next, place the nostril and set the angle of its wing against the cheek. Finally, check the over-all shape.

The jaw is well formed, with a normal proportion to the upper lip. A slight protrusion of the lower lip gives prominence to the area. Loosely sketch—but correctly place—the line separating the lips. Sketch in the lips so that the mouth appears in character and as a unit.

While the shadow cast by the upper lid partially frames the eyes and makes them arch toward the nose, you will note that the brows move in the opposite direction, rising from the

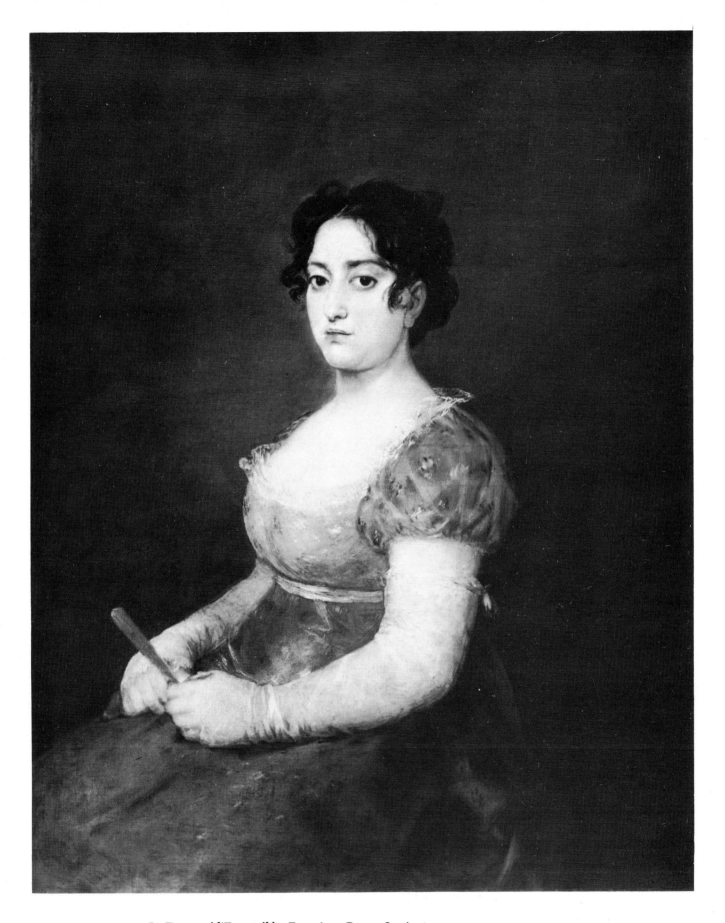

La Femme á l'Eventail by Francisco Goya y Lucientes.

If they are prominent, especially in women and children, the eyes may be accentu-ated to some degree, as Goya has done here. Collection, Musée du Louvre, Paris.

nose and gently dropping off towards the outer corner of the eyes.

In halftones, now place the ear, the dimple in the chin, and the neck. These areas are secondary to the facial features, but must be painted with the same care. As the passages in halftone are made to blend with the frontal plane, their relation is important in establishing the form of the entire study.

Now use a medium value to identify hair and to define its shape. In this study, the note of hair will register with the eyes, but must not be of the same intensity.

Over-all Shape of the Face

Consider the mask of the face. Now that you have set in the principal features, your next concern is this over-all shape enveloping them. The initial application of a medium flesh tone has covered the area with paint; it is now time to rework it in correct value. This reworking is part of the full scale development of your portrait, which includes a review of the features already placed—modifying and refining.

When more precise refinement is desired, especially with the flesh tones, there is nothing better than the fingertip for applying the color. The large sable bright will merge the many small brush strokes and simplify the areas, and the fingertip will add blending of the ut-

most delicacy, giving a final paint surface which will compliment the fairest complexion.

Adjusting as You Go Along

If you merely suggest the features at first, you can make adjustments in the process of refining. As you concentrate, your conception sharpens. Work with economy—do not go too far—until proportion and placement are properly related. Starting at the top and finishing each feature as it is placed on the canvas is working without plan; this can lead to errors remaining unchecked until the end, when it may be too late to adjust them. Avoiding errors at the beginning is better than correcting them at the end. If necessary, it is better to start again with a new canvas than to patch a work that may not be wholly successful.

At first, you may find it difficult to achieve likeness, but it is a skill and you will surely develop it. Eventually you will evolve a successful plan of work and likeness will become a part of that over-all pattern.

As you lay in the paint, check the model constantly, and you will be able to detect any distortion before you have finished. Each stroke, each color will fall into place, shaped and matched like the stones of a mosaic. To quote Boris Blai, artist and teacher, "Put the paint in the right place and you will have a good portrait."

14
Direct oil technique demonstrated

This and the following chapters deal with four technical approaches to painting a portrait all illustrated in the color section. I will demonstrate direct oil technique (alla prima), tempera technique, mixed technique, acrylics (the new polymer pigments).

The first three are traditional; time has given us the proper perspective to evaluate their results. The fourth medium, the new acrylic (polymer) colors, will require time to evaluate them properly.

Direct Oil Technique

Let us begin with the first technique: direct oil painting. (See pages 150 to 152.) This technique is best suited for painters who render their work in a broad, free, direct style, working at the outset for an immediate, finished result. For the sure and skillful artist, this approach is spontaneous, retains the purity of color and the force, effectiveness, and variety of the direct brush stroke. The direct oil technique avoids the temptation to overwork an area. It produces a bold, dramatic authority.

Applying the Tone

First make a charcoal drawing of your subject on the canvas. Spray the drawing with fixative and apply a tone in a neutral gray value—a mixture of black, ochre and green earth (terre vert)—over the entire canvas. This wash should be so thin that it will allow the drawing to show through. It will produce a working texture which accepts all color, and a wet surface which is desirable for the painting that follows.

With a clean cloth, gently wipe away the tone to establish the lighted areas of your drawing, removing whatever of the gray value is not needed. By applying different pressures when wiping, you will obtain different effects. Keep your rubbing cloth clean, and refine the tone continually to develop the lights and darks, establishing a study in monotone, ready for the application of color.

Laying in the Color

Place on your table the following brushes, or their equivalent:

Dr. Henry Allen Moe by Franklin C. Watkins.

Direct oil technique. The alla prima technique is best suited for the sure and skillful artist: it is spontaneous, and retains the purity of color, the force, effectiveness, and variety of the direct brush strokes. Collection, American Philosophical Society.

Bristle: no. 0 round; nos. 2, 4, 8, and 10 long flat; no. 3 filbert, no. 6 long filbert, and no. 20 or no. 24 bright.

Red sable: no. 1 long round; nos. 1, 2, 4, and 16 long flat: nos. 10 and 12 filbert; nos. 5, 6, 7, 12, and 20 bright.

With the no. 10 red sable or the no. 12 filbert, working in a sketchy manner, apply a flesh tint (a mixture of white, alizarin crimson, and yellow ochre) across the surface of the head, face, and neck, especially in the wiped areas. (As you paint, try to retain the effects of the wiping and rubbing.)

Although you are painting for a direct result, do not strive to finish any part. Nor should you concentrate on obtaining a likeness immediately, for if you arrive at one prematurely, it will suffer constant threat of alteration with the addition of each color. In your first loose application of a flesh color with a no. 12 red sable filbert, you simply lay in color for the over-all character in a somewhat blurred form. Before the next stage, this form should be an image of your subject, the first evidence of his character as well as his appearance. Establishing the planes of light and dark will give this image form.

Establishing the Features

Focus on your model and, with a no. 3 bristle filbert, draw in the position and shape of the features in a soft red or red-orange color. Then take the no. 6 bristle long filbert and, in a mixture of white, alizarin, and viridian, hatch in the gray, darkened areas of the head. Now, develop the lighted areas in brighter focus and render them as they exist in contrast to the darkened areas, showing in particular where they turn away from the light.

Turned on its broad side, the filbert brush will create an almond shaped stroke and can be used effectively for modeling the human form. On a convex surface—such as the high point of a cheek, or the turn of the forehead into the temple—the clean filbert is very effective. With its elongated, rounded form carefully pressed, wiped and pressed again on the painted surface at the critical joining of two planes, the filbert can produce the subtlest emphasis of precise form.

The model takes a standing position, holding a gun in the crook of his arm. He leans from his right to his left. An upward thrust is suggested by the position of the arms, the folds of the jacket, and the set of the head. It is important, before concentrating on likeness, to realize the character and construction of the head so that the form will always be solid.

The drawing is on the canvas. With the bristle brush, establish forehead, cheeks, bridge of nose, jaw, and chin in a medium flesh tone. A darker flesh tone, also applied with a bristle brush, can locate those planes not in direct light. With small bristle and sable brushes dipped into the wet paint, block in the features.

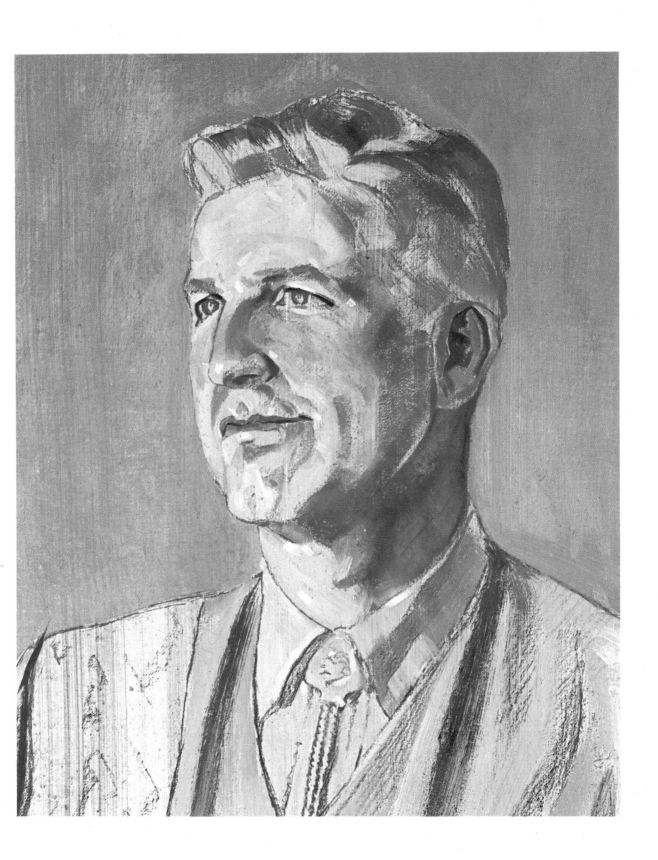

The area extending from ear to ear, over the cheeks and across the nose, known as the color band, contains most of the painting referred to as the color of the portrait. Emphasizing color in this area, while blocking in your portrait, is helpful and will not disturb the progressive development of your painting.

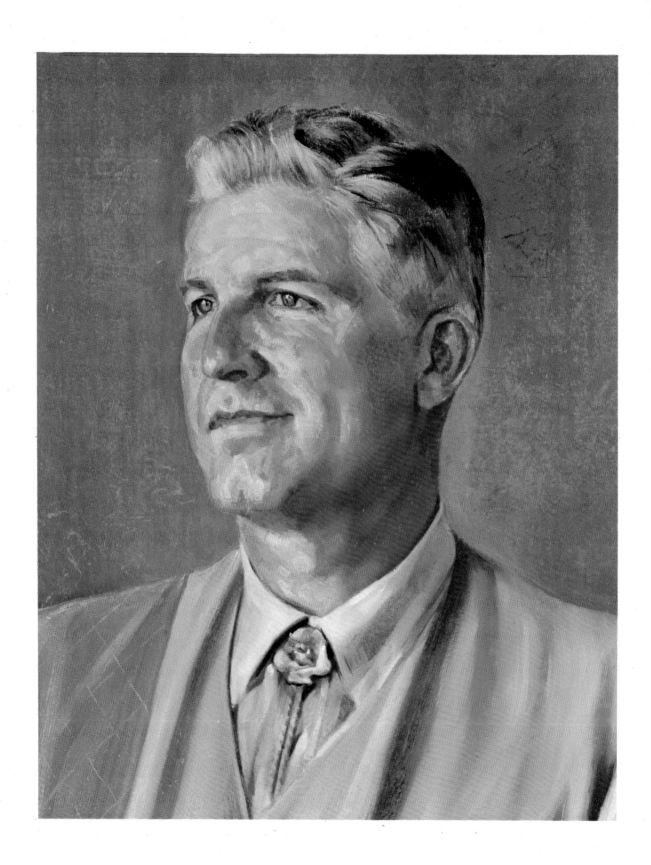

Move your brush from one feature to another, concentrating on their relationship as you work. After you have set in the principal features, your next concern is the over-all shape enveloping them. The initial application of a medium flesh tone has covered the area with paint; it is now time to rework it in correct value.

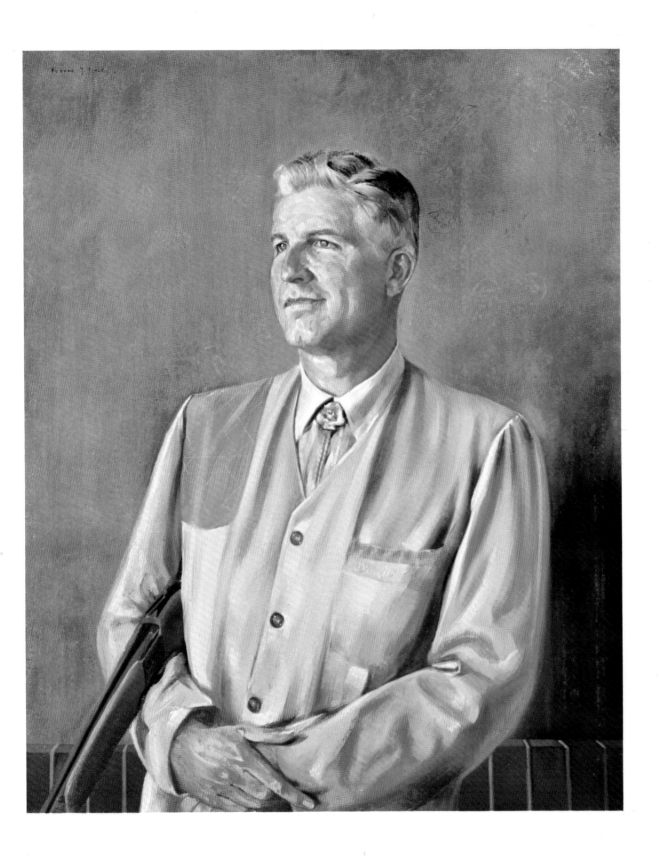

Dr. Karl Jonas by Furman J. Finck.

Oil on linen canvas, 30″ x 25″. When more precise refinement is desired, especially with flesh tones, there is nothing better than the fingertip for applying the color. The large sable bright will merge the many small brush strokes and simplify the areas, and the fingertip will add blending of the utmost delicacy. As you lay in the paint, check the model constantly to avoid any distortion. Courtesy, Dr. and Mrs. Karl Jonas.

First make a charcoal drawing of your subject on the canvas. Spray this drawing with fixative.

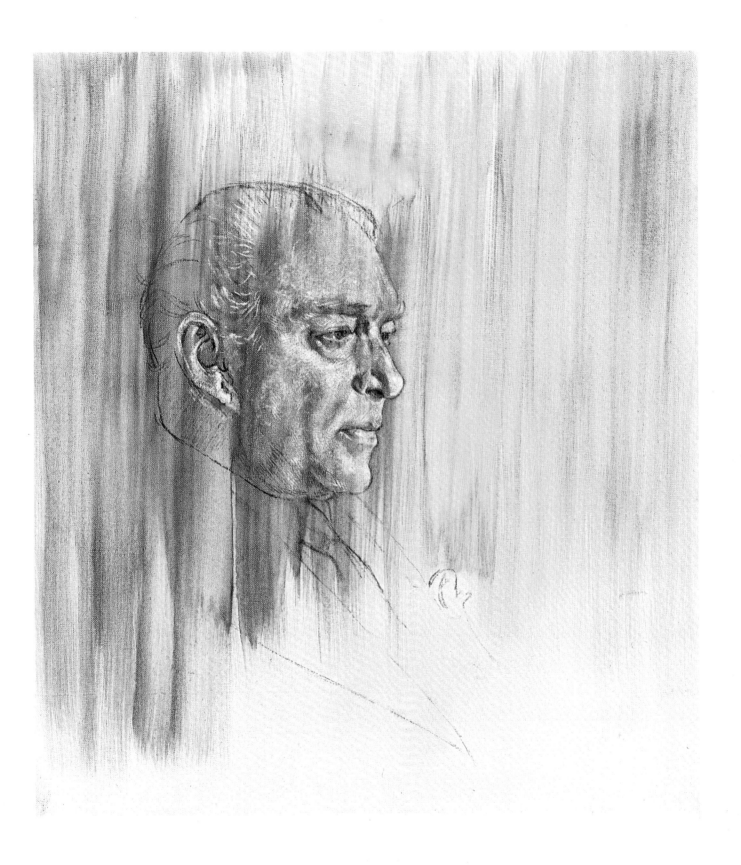

Over the drawing, apply a tone in a neutral gray value—a mixture of black, ochre, and green earth (terre vert)—over the entire canvas. This wash should be so thin that it will allow the drawing to show through, producing a working texture which accepts all color, and a wet surface which is desirable for the painting that follows.

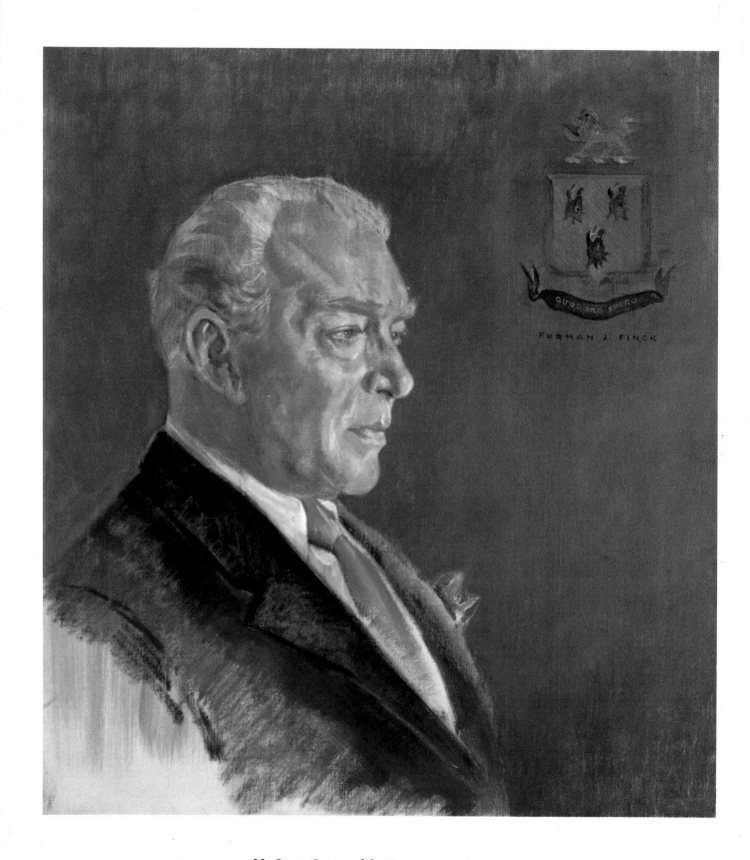

Mr. Staats Cotsworth by Furman J. Finck.

Oil on canvas, 20" x 18". Using oils with a medium of oil and dammar, I completed this painting rapidly in the direct oil technique described in Chapter 14. The satisfaction with this way of painting remains within the pleasure derived from the beauty of the direct brush stroke, the immediate statement, and a fluid and facile technique. Courtesy, Mr. and Mrs. Staats Cotsworth.

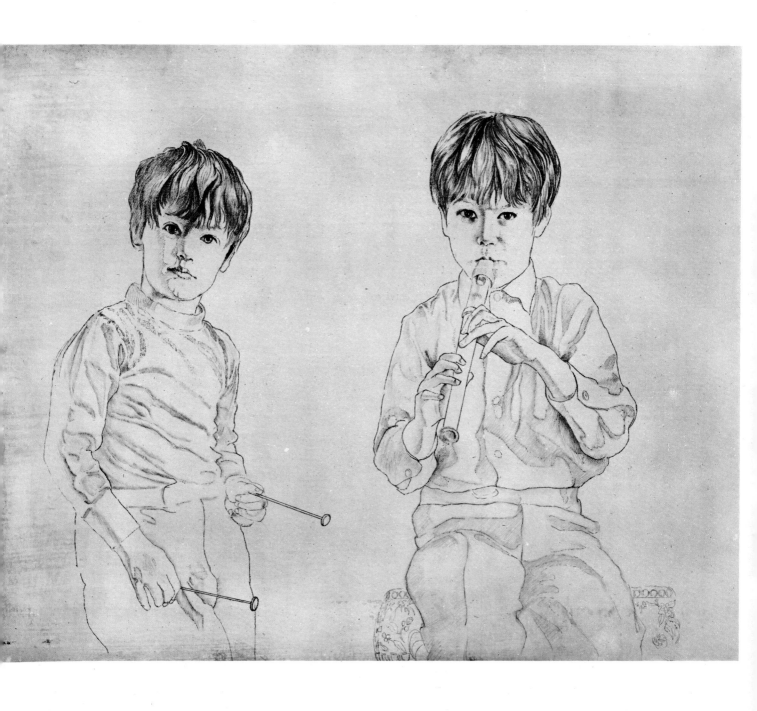

Block in your drawing of the subject carefully in ink, charcoal, or pencil, noting proportion and likeness, and distribution of light and dark. Spray the drawing with fixative so that it will not pick up when worked over; you may also require the underlying drawing for reference.

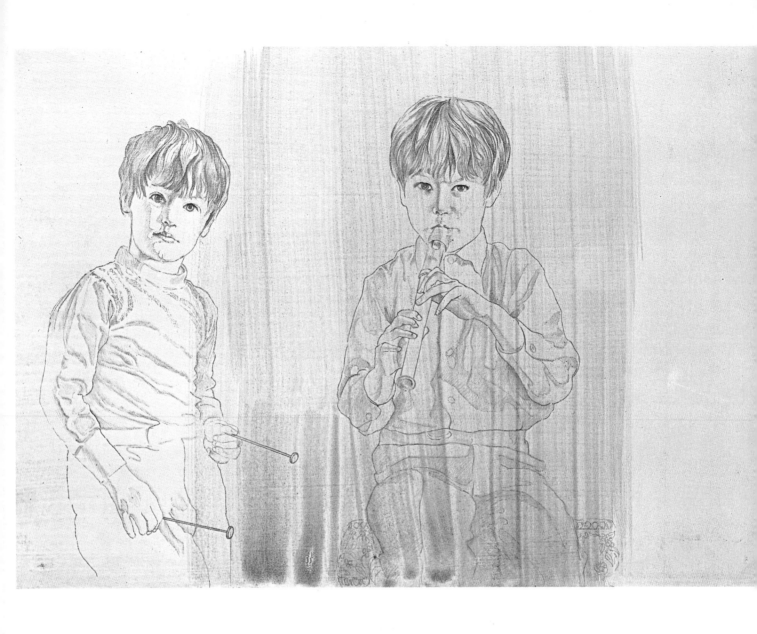

Over the fixed drawing, thinly brush a tone of suitable color across the entire surface to obtain a ground of middle value. I suggest black, caput mortuum, yellow ochre, or green earth; use these either singly or in combination, in greatly reduced strength, mixed with the emulsion medium and applied in a thin, transparent coating. The drawing will show through the tone; into this you develop your painting in lighter and darker shades.

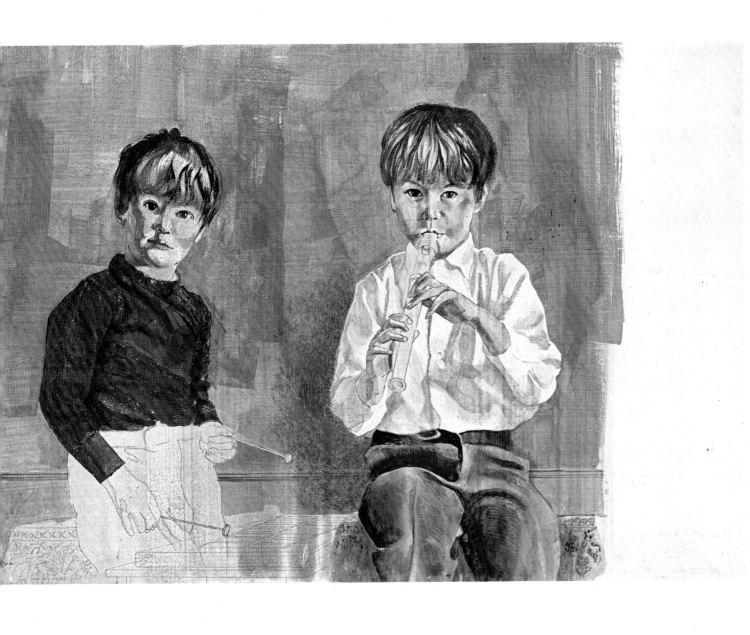

As you apply your brush strokes—some opaque tones, together with some thin, partially covering tones—you will create interesting optical effects as the ground tone shows through. Painting lightly, wet-into-wet, will permit closer and softer intervals of color; painting more dryly will produce opaque tones and more pronounced brush technique.

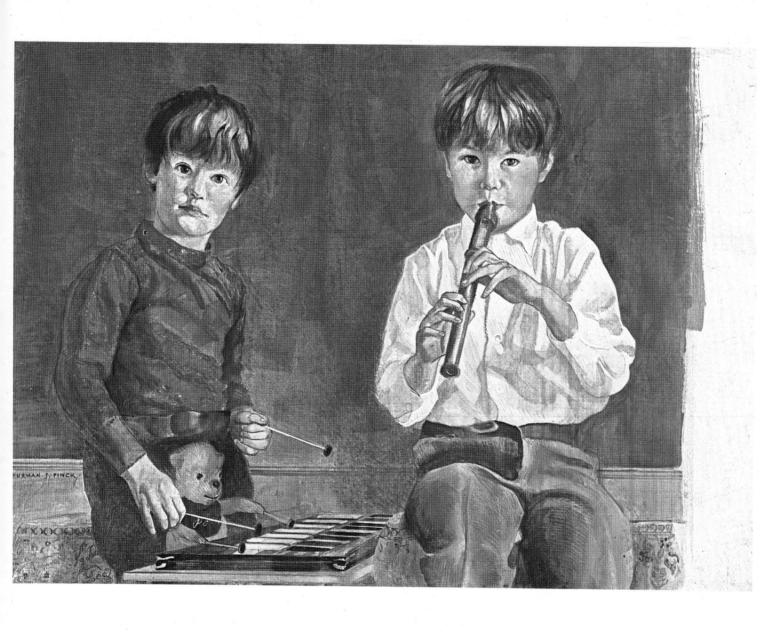

Aaron and Andrew by Furman J. Finck.

Egg tempera on gesso-sized poplar panel, 12″ x 14″. Because it is fast drying, you will find it difficult, if not impossible, to keep large areas of tempera pliable for extended mixing and blending. On the other hand, if you accustom yourself to a short, dry paint, you will enjoy a technique that includes the pleasures of both drawing and painting. Collection, Mr. and Mrs. Jay Julien.

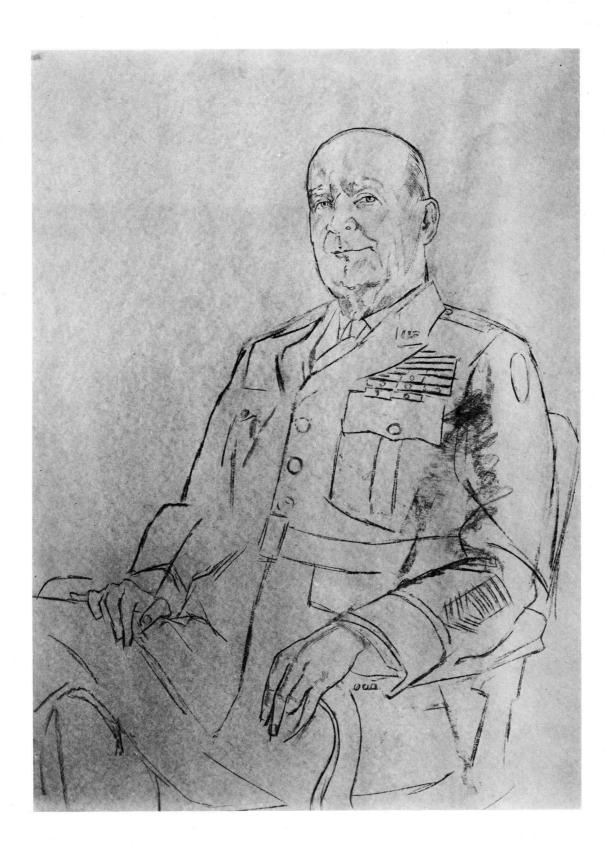

First work the drawing on paper for character, action, and detail, and to resolve the composition. Then you can transfer it or redraw it onto the canvas with certainty. For this drawing, use ink, charcoal, or pencil, because they will not chemically effect the overpainting. When you are satisfied with the drawing, fix it with a spray of dammar varnish.

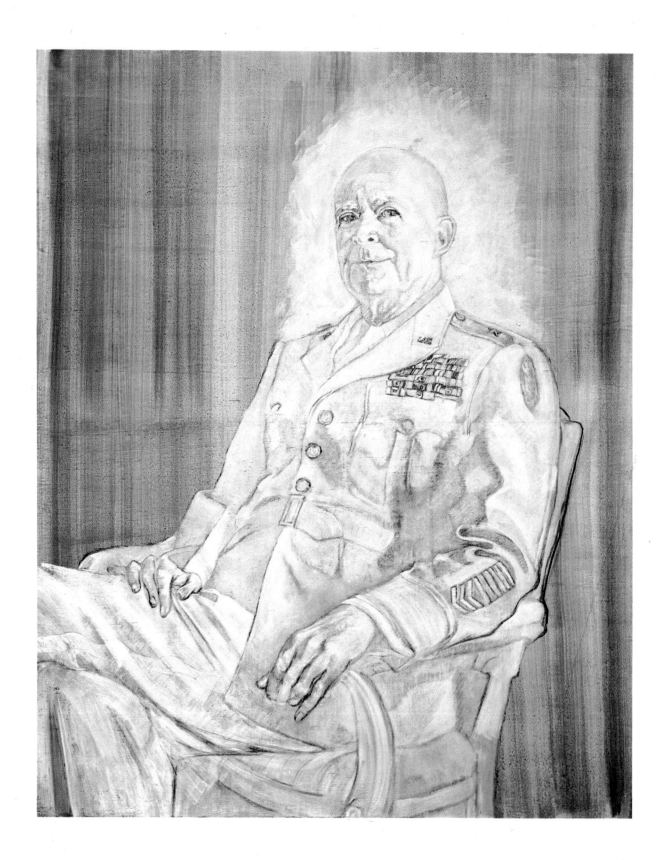

Tone the canvas with black, caput mortuum, yellow ochre, oxide of chrome, in powdered form, either singly or in combination, mixed with the tempera emulsion medium and applied in a thin, transparent coating. Study the distribution of light. The lights will be painted in a more complete coverage, the shadows in a less complete coverage. When completed, this tempera underpainting will cover the entire canvas in some degree of white.

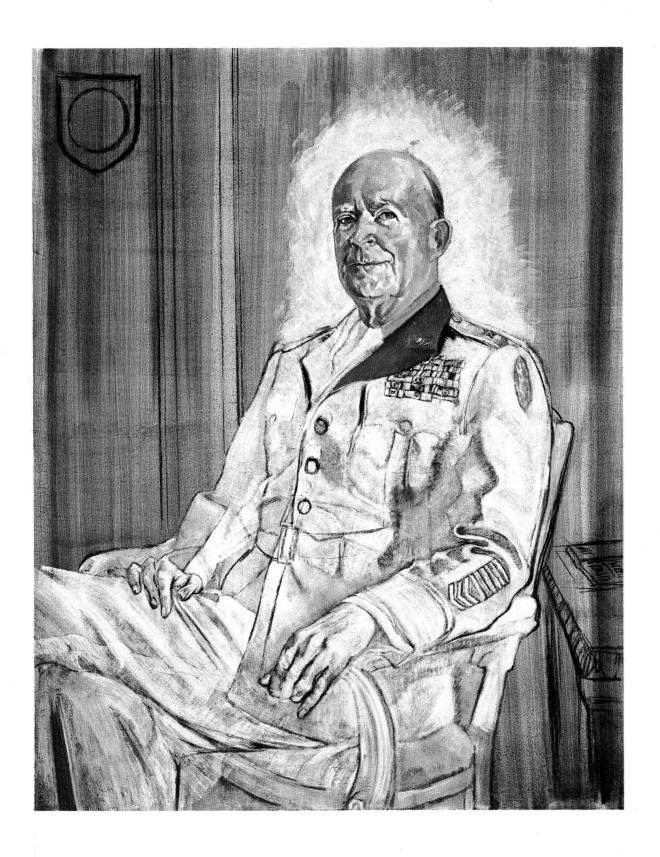

Begin the oil overpainting. Color is brilliant over white tempera; it is possible to increase this power when tempera is scumbled into the color and the colors then repainted over the tempera.

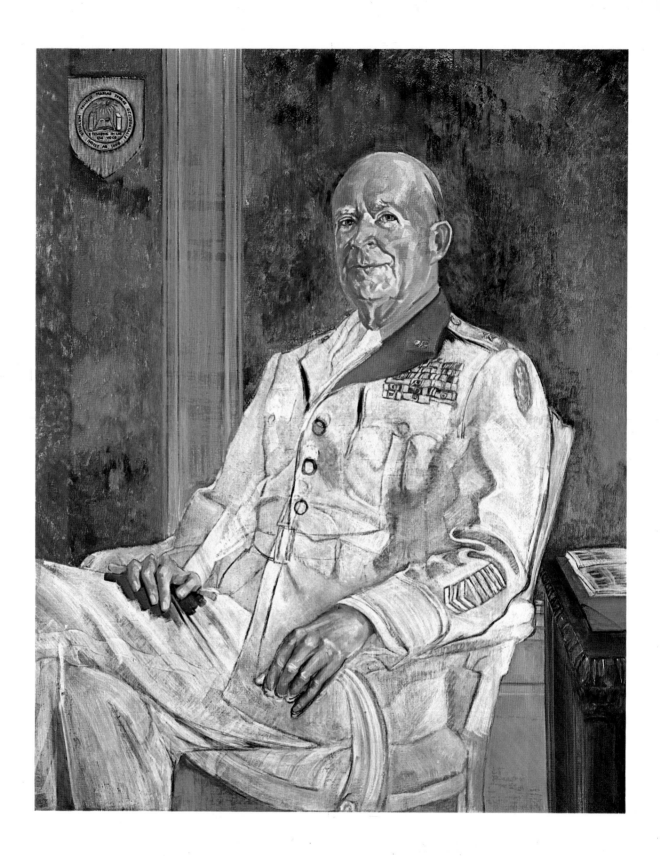

As you paint, take full advantage of all form and definition provided by the under-painting. Strongly lighted areas can be strengthened and reset with the tempera white scumbled into the finished wet oil pigment. Backgrounds can also be brushed in with the bristle long flat. The no. 20 or no. 24 broad bristle bright should then be drawn over the wet background area in a vertical direction from top to bottom. This will set the background so that it stays behind the head.

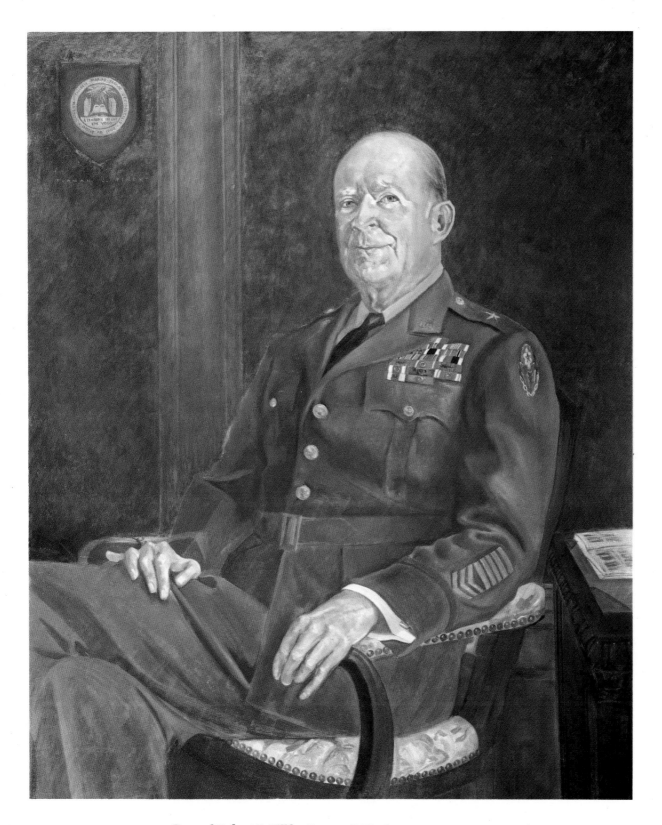

General Robert J. Gill by Furman J. Finck.

Mixed technique, 42″ x 34″. Because your portrait is firmly set in the tempera under-painting, many of the secondary passages in the overpainting may be left simply as transparent tints. This is particularly true in the darkened passages, which should retain some transparency. This may also occur at times when you want to reserve some areas in the underpainting against those more thoroughly covered. Collection, Western Maryland College.

The working drawing was completed on Fabriano paper.

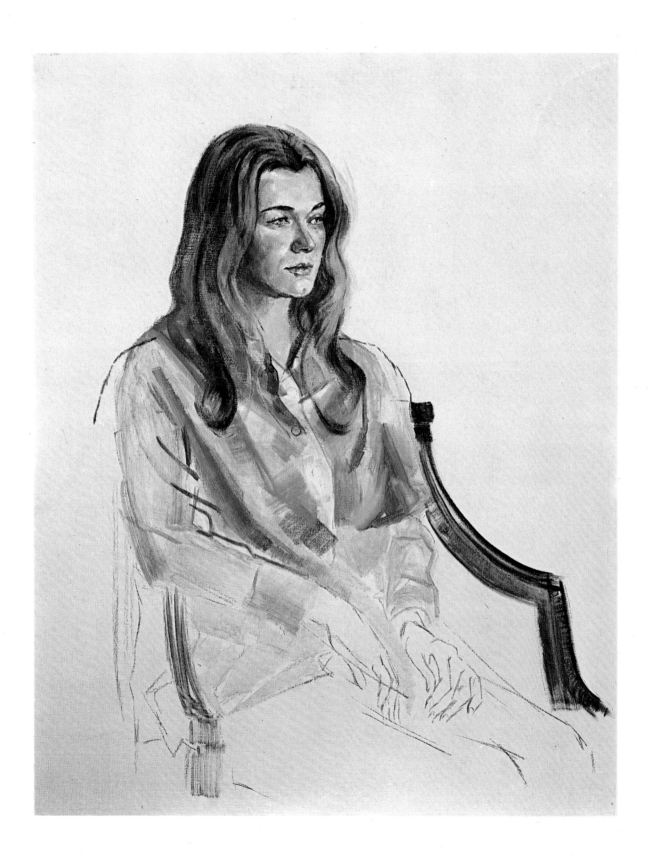

The head is blocked in and refined with free strokes and a light touch, allowing the grain of the canvas—and actually some bare canvas—to break through in such casually painted passages as the hair, the brow line, and the corner of the jaw. The blouse is indicated in flat strokes of very thin paint, which are almost in the nature of a watercolor wash. The darker accents on the blouse suggest drybrush. Thus far, the background is untouched and the rest of the figure is not yet developed.

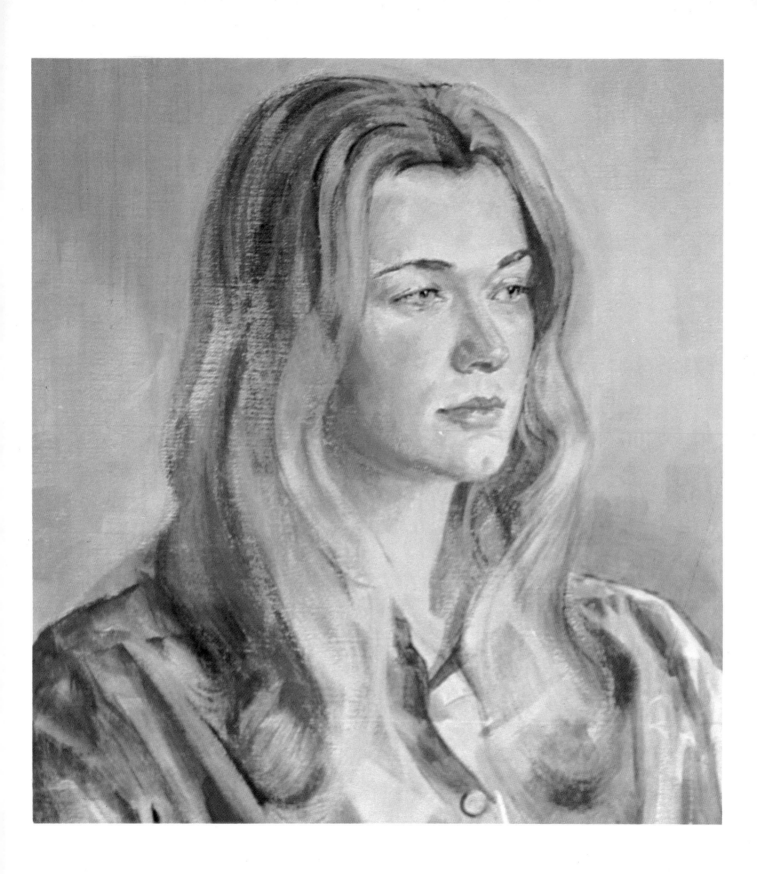

This detail shows thin applications of paint, the canvas texture breaking through.

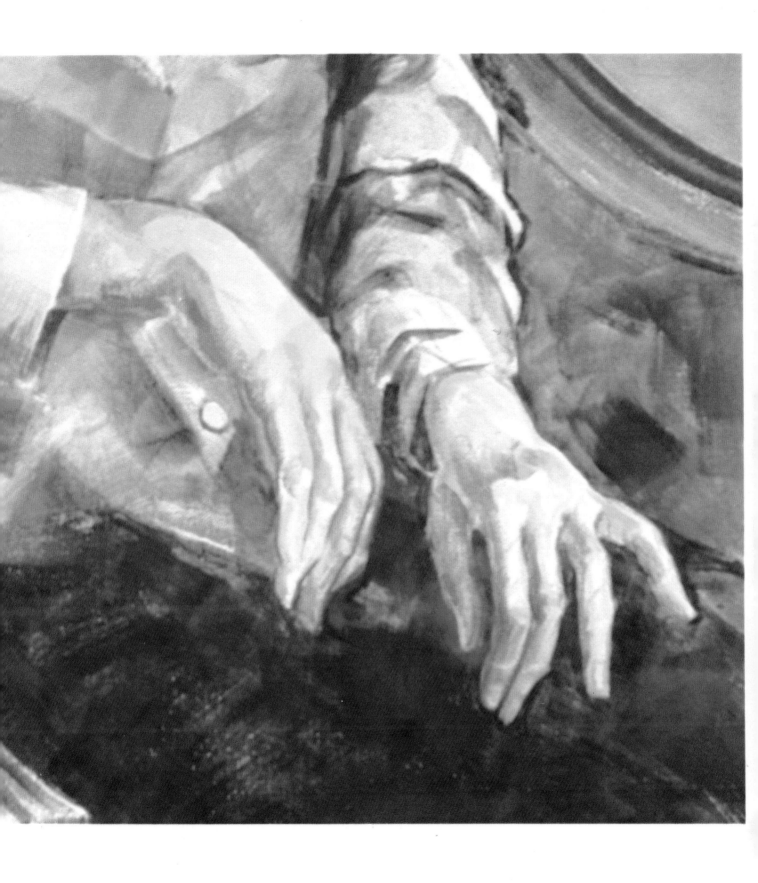

Detail of hands shows how warm and cool colors are overlayed rather than blended.

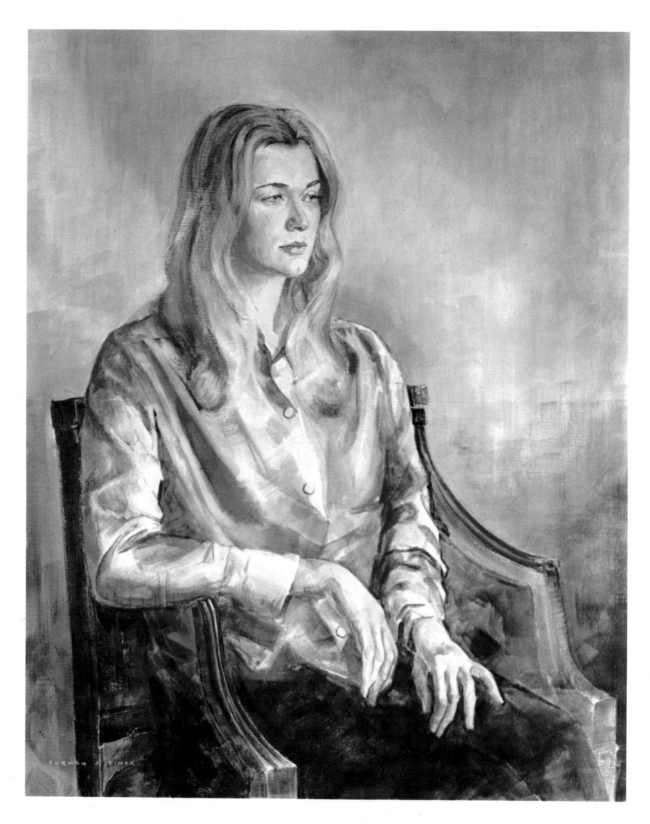

Alice by Furman J. Finck.

Polymer colors, 32" x 26". Further refinements complete the head, which is softened with delicate applications of paint that integrate color and texture. The rest of the blouse is painted in, still quite thinly, with the shadow planes of the folds more firmly stated. The hands are developed in a technique similar to the head, with thin washes and strokes of translucent color placed one over the other. Courtesy, Mr. and Mrs. Douglas B. Kitchel.

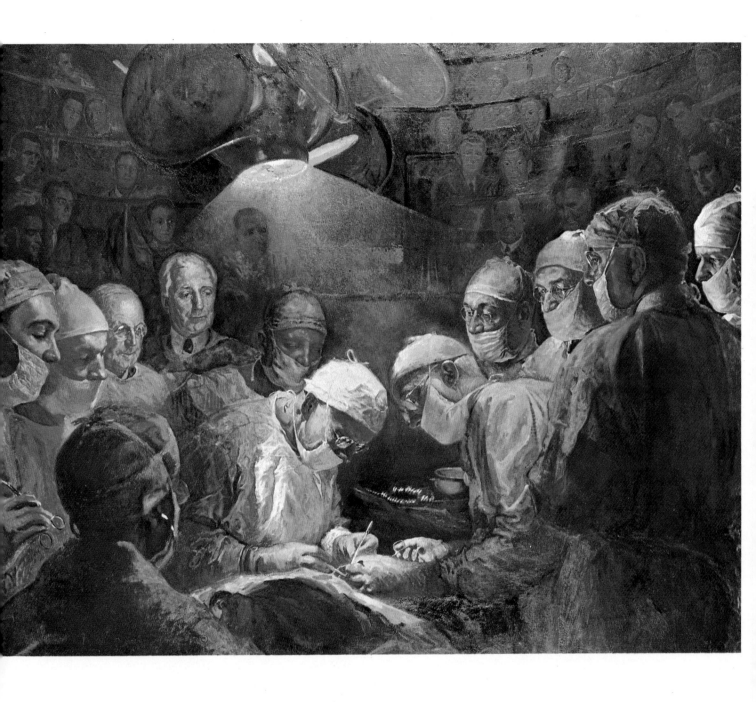

Babcock Surgical Clinic by Furman J. Finck.

Mixed technique on linen canvas, 5′ x 7′. After many preliminary sketches and nota-tions, this is the final painting that emerged. Glazing over the oil painting enhanced the sharp and brilliant effect of the color scheme, and pastose applications of paint add luster and texture to the over-all surface of the canvas. Courtesy, Temple Uni-versity Health Center.

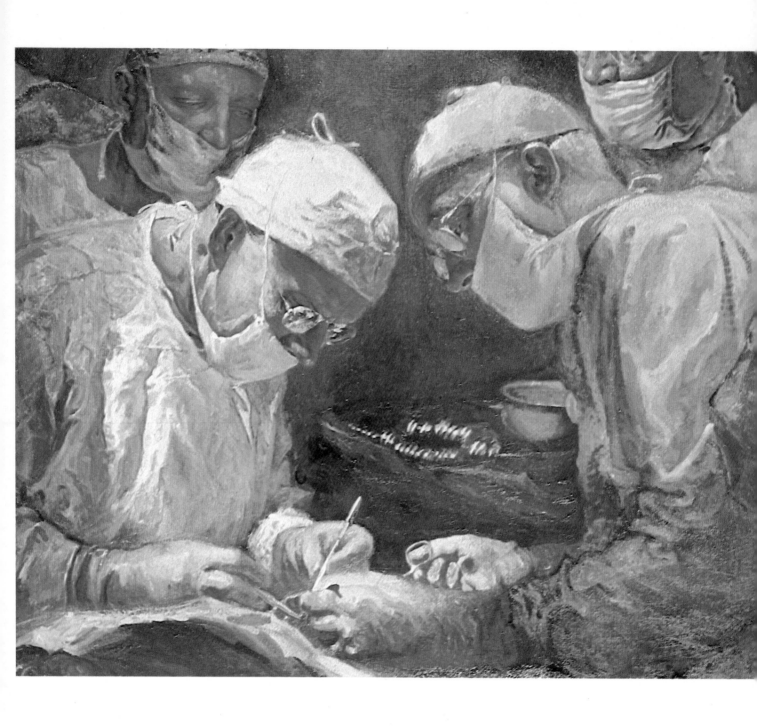

Detail of Babcock Surgical Clinic. Dr. Babcock and his assistant—two heads and four hands—are the center of interest.

Laying in the Background

A color can now be scumbled into the background. This should be a muted color so that it does not compete with the portrait. The no. 8 or no. 10 bristle long flat, or the no. 20 or no. 24 broad bristle bright are best for spreading the background.

Building Up the Color

You are now ready to use the no. 12 and no. 20 red sable bright to develop the planes of the face in the light and dark areas. In the process of painting, the areas of light are emphasized and carefully built up, while the areas in the dark are simply suggested. Up to this point, you have scumbled a flesh color into the wet, gray tone, and into the flesh color you have noted the features and established the planes of light and dark describing anatomical form and surrounding areas. Your next step will be to identify one color tone against another, spreading them on the canvas in a broad fashion, working for a simple, total effect. These bright brushes make a flat stroke with distinct edges. Their strokes, placed one against the other with an occasional accent of edge, lend interesting blocklike character to the painted form.

When you have completed certain color passages with the no. 12 red sable bright, and wish to soften these areas, wipe the no. 20 red sable bright clean. Then moisten it in the medium and press it now and then across the strokes of the no. 12 to achieve softer effects. This treatment will unify and give emphasis to the painted form.

The nos. 2 and 4 bristle long flat are useful for laying in the shape and form of features, hair, collar, shoulders, and sleeves. Nos. 1, 2, 4, and 16 red sable long flat enable you to make refinements on a smaller scale. The red sables always follow the bristle brushes when you want refinement, since a blending of the brush strokes softens and unifies the passages. This is especially recommended when you paint the face.

Over the drawing of the eyes, nostrils, mouth, and ears, you now need color accents: a suggestion of blue, gray, or brown in the pupil; red on the lips and in the concha of the ear, and pink for the nostrils. A small red sable (no. 4 long flat) contains enough spring to soften these colors and to model the features, and a no. 3 bristle filbert adds the stouter spring of a bristle brush, if the paint needs to be worked over or removed.

The clean cloth continues to be useful for blotting or picking off excess paint. The palette knife, because of its metal blade, renders an enamel-like finish and produces possible special effects when you lift and scrape the paint surface. Paint retains its greatest luminosity when it is not too heavily applied. Use the fingertip for surfacing the paint or for merging two colors.

As you progress, move about the entire painting and keep your interest alive in every part of it. Although the painted eye will usually remain a focal point, do not finish it immediately. Satisfy yourself with a suggestion of the eye, allowing some of the charcoal drawing and selective color notes to frame it, then suggest all of the features in the same way. Indicate the eye first and immediately set it against the dark of its upper lid. This lid will contain some red, while its lacrimal papilla will be pink. Into the wet paint of the upper lid, an accent of ochre and pink will mark the eye socket. Into the forehead, in a mixture of burnt sienna and viridian and, with a no. 2 bristle long flat, paint in the eyebrow, wet-into-wet. As it joins the bridge of the nose, the eye form is caught in a pocket of dark. This dark is a luminous shadow which can be approximated with a mixture of alizarin crimson, viridian, cadmium red light, and white.

Establishing the Head

Indicate the hairline and the forehead with a no. 20 red sable bright. Within this framework, the zygomatic prominence of the cheek can be placed, thus framing and supporting the eye. In this area, apply a slight glaze of pink on the cheek—a mixture of alizarin crimson and cadmium red light—which can be pulled quickly into the wet layer already established there. Although the no. 20 red sable bright is a wide brush, it can be used on its corners for fine work when it is kept pointed. By the increase or decrease of pressure, it can be made to assume shapes and to cover areas in many ways.

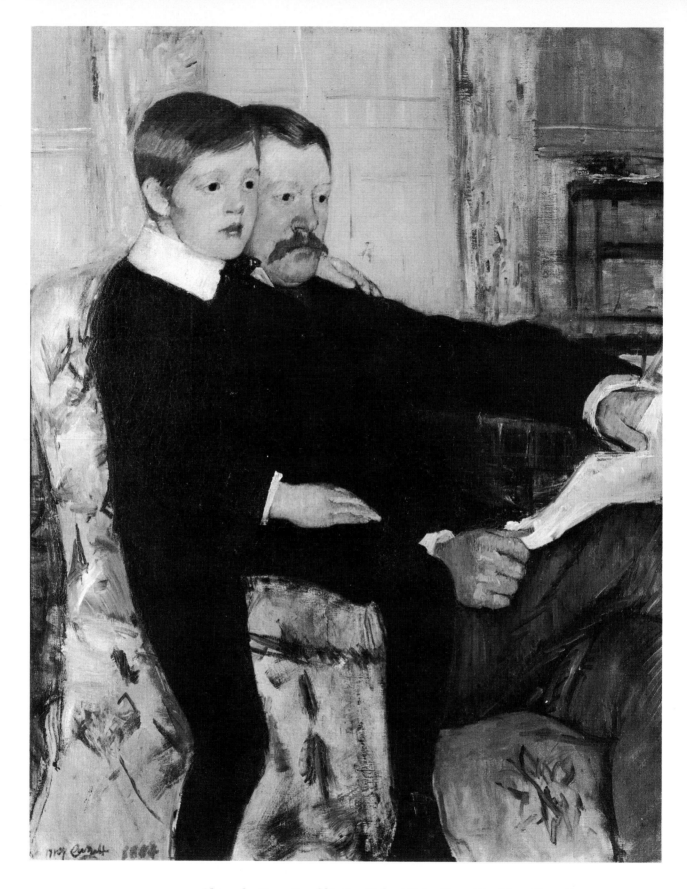

Alexander Cassatt and his Son Robert Kelso Cassatt by Mary Cassatt.

Direct oil technique. This technique is best suited for painters who render their work in a broad, free, direct style—like Mary Cassatt, for instance—the artist who works at the outset for an immediate, finished result. The Wilstach Collection, Philadelphia Museum of Art, Gift of Mrs. William Coxe Wright.

Establishing the Nose

Develop the area between the eyes, locate the bridge of the nose, establish the length of the nose, and place the nostrils. Then indicate a light note across the cheek, just below the eye, another down the prominence of the nose to its tip, and another across the philtrum—between lip and nose—and finally another on the projection of the chin. These notes can be brushed in to meet and support the painting of the eyes, nose, and mouth. For this painting I suggest nos. 5, 6, and 7 red sable brights.

There is a dark area where the lesser alar cartilage (or outer wing portion of the nose) touches the cheek. This dark is picked up and carried across the underside of the nose, locating and framing the nostril. It can be brushed in sketchily with a gray tone of alizarin crimson, viridian, and white, made warmer by an addition of yellow ochre. Do not develop this passage fully, but establish it correctly so that it relates to the brow, and so that the observer will readily view the brow and then the mouth, in this order, accounting for the nose which lies between them. Because the bridge of the nose extends the prominence of the forehead down the face, this projection creates a decided plane on each side of the nose. Starting in the brow, a dark or halflight relates directly to those similar notes on the temple, cheek, ear, and in the undercut of the chin, and all can be suggested with the same cool gray tone. These areas represent the contrasting focal planes which give support to the lighted areas of forehead, bridge of nose, cheek, and chin.

An important feature, the nose must be carefully painted, but must not, on any occasion be overstated. In fact, you should make it your practice to understate it.

Establishing the Mouth

Now suggest the mouth. Cadmium red light, alizarin crimson, and white will produce the red required for the lips; darker for the upper lip, lighter for the lower. At each of its outer ends, the upper lip turns into a pocket of warm gray, a mixture of alizarin crimson, viridian, ochre, and white. The lower lip becomes light in the corresponding areas and establishing

these lights—wet paint into wet—will lend fullness to the lower cheek in the region of the jaw. The projecting lower lip creates a slight dark underneath it which animates and completes the form. It is similar to the warm gray at the side of the upper lip and can be brushed in when you paint the lower lip, as a means of defining its underside.

Refining the Eyes

With the features now established, you can begin to work them for the emphasis you desire. The iris of the eye is a small area, but critical and prominent. It appears somewhat shaded by the upper eyelid, which partially covers it. Paint in the white of the eye, which is an off-white shade; then paint in the iris against that white. Now take one of the clean, small red sables (nos. 1 or 4 long flat) and blend over the edge where the iris meets the white. In a wet, luminous gray glaze (alizarin crimson, viridian, and white), draw the no. 4 red sable long flat across the eye, under the upper lid to mark the lid's overhang and subsequent shading. The corresponding underlid will contain the lighted flesh color which will just touch, but not cover, the iris. On the underside of this lower lid, and moving to the outside corner of the eye, a dark will complete the placement of the eyelid. Paint these notes delicately, wet-into-wet. You can use the nos. 10 or 12 red sable filbert to blend all the wet paint, indicating the gentle forms of the surrounding structure and thus setting the eye.

Take a bit of white and spade it into a drop or two of medium with the palette knife, until the paint becomes like soft butter. Pick it up on the point of the no. 1 red sable long round, or on the point of its handle. With this point, touch the painted eye where the highlight is and *do not touch it again.*

Refining the Nose

You are ready to consider refining the nose. The high ridge or prominence extending from the brow ends in a highlight on the tip of the nose; this highlight should always be an emphatic note. The sides of the nose join the brow, rising from a pocket of dark or halflight of the medial areas of the eye sockets; then

extend to the lesser alar cartilages or outer wings of the nostrils, and conclude with a note of dark on the underside. These side planes of the nose will catch a dark when the direction of the light creates a shadow there. But the light on the zygomatic prominence of the cheek will often bleach out the strength of this dark, so that you indicate the dark in the brow, in the pocket of the eye, and again in the region of the nostril, while just suggesting it elsewhere.

Again, use the small bristle brushes, nos. 2 and 4 long flat, to model these nasal features, and use the red sables, nos. 1, 4, and 16 long flat, to blend them. The large no. 20 red sable bright can prove useful if you gently employ it to unify further a small passage containing the multiple refinements of the smaller brushes; you can, in fact, pull it across whole finished sections—such as the eye in its socket or the nose on the face, where both light and dark colors are involved—to set the colors without smearing them. Finally, with the no. 2 bristle long flat, set the pink nostril again, over the finished surface.

Refining Mouth and Ear

Like the eye, the mouth has a liquid quality. It is softer and must not be rendered with the same sharp focus. Now take a no. 0 bristle round, containing the pink-red in a somewhat dry impasto (thickly applied), and draw it lightly into the wet surface of the earlier notations of the mouth. Give the brush a spiral half turn and, as the color drops unevenly, the surface of the lip will take on a feeling of fullness. Do not define the outer edges of the mouth sharply. Now you can redefine the warm gray halftone representing the undercut of the lower lip, forming it to meet the red of the lip. Refine surrounding flesh areas and, with the blender, no. 20 red sable bright, or no. 10 filbert, finish the mouth.

The ear, with its multiple form, will offer an extra field of color. Like the treatment of the nose, the ear should remain underdeveloped. It offers an opportunity for drawing, but do not overstate the drawing. The ear is secondary to the mask of the face.

Examine Your Painting

Consider your portrait as far as you have gone and now point up color, light and dark, and expression. Consider a lock of hair as it falls over the face, the side of a cheek against the hair, a light on the chin, or a dark on its undercut. Examine all of the features together.

Indicate the side of the cheek, the outside of the ear, and the jaw in articulate brush strokes. The strength of these three features is also the strength of the portrait. Note here the change of the plane from direct to indirect light. If a warm light bathes your subject, these supporting areas out of the direct light will be shown in indirect, cool halflight. Some areas behind the ear, or in the undercut of the chin, or where the collar meets the neck, may form a rapid change of direction of the plane, or a shutting off of the light, and will require a pronounced dark. A mixture of alizarin crimson and burnt sienna, or cobalt blue and burnt sienna, are good combinations for these pronounced darks. Under some conditions, these darks may pick up considerable reflected light. Although you should account for this reflected light, hold it to a minimum so that the darks are not destroyed.

As you examine your study, the bristle brushes are an aid in your brush drawing, while the sables are effective for refined surfaces. Using bristle and sable brushes together will enable you to increase your range of surface variety.

Continue the cycle of development by examining, composing, expanding, and also by reducing and eliminating, constantly refining, leaving the placement of the highest lights and the richest darks and other bold, dramatic accents until the very end. Keep the composition flexible in all areas; even when finished, each part should be capable of still further development.

Some Further Considerations

Colors in portraiture should be muted. In almost every instance, a color serves you better when mixed. As you require a more brilliant flesh tint, blend cadmium red light, cadmium yellow light, and white. This tint will blend and work easily with the less brilliant tint

Mr. Nicolas H. Finck by Furman J. Finck.

Oil on canvas, 20″ x 18″. Direct oil technique. When paint is applied dryly, you will not be able to extend the brushing beyond short strokes; but within the pastose effects, color retains a jewel-like brilliance. Collection, Mr. and Mrs. Furman J. Finck.

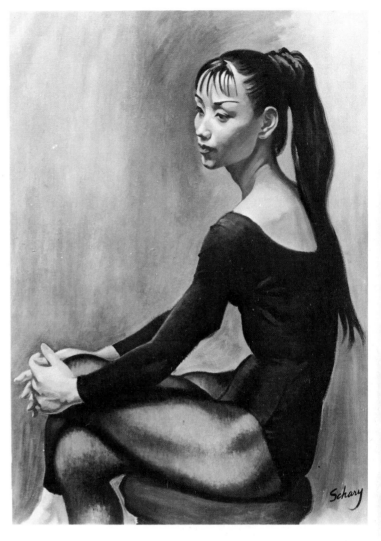

Akiko by Saul Schary.

Oil on canvas, 40″ x 30″. Direct oil technique. A feeling of facility is enjoyed when working wet paint; here nature lends support to many beautiful, subtle blendings. Blending will unify a passage and bring it close to the living form, while preserving all of the technical subtleties and refinements. Courtesy of the artist.

Mr. Leroy Clark by Furman J. Finck.

Oil on canvas, 20" x 18". Painting in the direct oil technique without using medium produces a more concentrated color that has a weight and power which generally contributes strength to the painted composition. Courtesy, Mr. Leroy Clark.

already indicated as the flesh color. You can leave certain areas in a minor key in order to accentuate those portions of the picture which should catch the eye. This lends variety. In general, avoid mixing too many colors to obtain a blend, because color strength will be dissipated by the mixing.

In the treatment of the shadowed areas on the figure, burnt sienna—a luminous, warm brown—can be used effectively in darkening the flesh tones as they turn away from the light. If you find this tone too warm, try viridian, a green capable of delicate tints, which can soften a passage that should be neutral. Black, used in small amounts, will reduce a color passage, producing that necessary off shade of gray to quiet its color.

When you paint the areas of the face and neck, it is good practice to allow them to extend just over their boundaries. Then, employ the brush with the background color to reclaim correct drawing and proportion, pushing the background color into the wet paint which has extended beyond the boundaries to reinstate the edges, wet-into-wet. This practice will give you a more critical focus on the portrait against a good, supporting background.

In contrast to this, the painting of the hair is, in turn, pushed *across* the background to describe its outer edge. The hairline is softened and blended to describe its meeting with the forehead.

Carefully study the edges; some will require sharpening and others will be softened. To soften an edge, gently draw a clean no. 12 red sable bright over this edge while the paint is wet.

Do not use too much paint. Only enough paint needs to be applied to cover the fully lighted focal areas. The warm gray tone of the original wash, still visible in places, may lend rest to the eye and complement the few well chosen accents in these secondary passages. Then, too, the wet toned wash gives rise to many subtleties, a contrast to those more thoroughly developed passages in which you have done the interpreting. Understatement is always desirable. Not every passage should receive equal emphasis. There is special interest for the viewer when something is left to his imagination.

Thus far, we have spoken of applying paint

and *building up* a surface. It is possible, and good practice, to *scrape away* some surfaces. For variety, for luminous and transparent effects, and to pull together a passage, gently scrape that surface with the palette knife and lift off the excess paint.

Using an oil-varnish medium permits you to dilute and extend the paint and to apply it more rapidly. It also increases the possibility of interesting technical accidents and allows for an infinite variety of color blending. As you add medium, your mix will assume a different weight and workability. As the medium thins the color, it separates the particles of paint. Find the proportion which fits your need, always using as little as possible but as much as you need to achieve the effects you desire. Be on guard against too free an application of medium; it should not dominate the paint surface on your canvas. This portrait, size 20″ x 18″, is painted on "Winton" single prime linen canvas. Winsor & Newton colors with medium of oil and dammar were used.

A feeling of facility is enjoyed when working wet paint; here nature lends support to many beautiful, subtle blendings. Blending will unify a passage and bring it close to the living form, while preserving all of the technical subtleties and refinements. Both a wet brush and a dry brush are useful for blending and will deliver slightly different effects, depending on the degree of facility required.

The satisfaction with this way of painting derives from the beauty of the direct brush stroke, the immediate statement, and a fluid and facile technique.

Direct Oil Technique Without Use of Medium

Painting directly on the canvas without the aid of a medium will appeal to those painters who prefer the crispness of a stiff, dry tube paint. When paint is used in this way, bristle brushes are recommended, for they will accept the handling required to spread the paint.

When paint is applied dryly, you will not be able to extend the brushing beyond short strokes; but within the dry, pastose effects, color will retain a jewel-like brilliance. This method of painting lends itself to a short stroke technique similar to that employed by the Impressionists. Some examples of Monet and Pissarro contain such dryness and brilliance, the richness of one color built upon another, each stroke so evident that one may identify the undiluted color.

This more concentrated color has a weight and power that generally contributes strength to the painted composition. Furthermore, the absence of medium and the vigorous brush technique of this method diminishes the tendency of the paint to crack.

When subtle shades of color, luminous flesh tints, optical grays, etc., are required, it is a good plan to mix them on the palette with the palette knife so that attaining some of the refinements of color will not be left entirely to the brush.

The stiffness of the undiluted paint does *not* provide a fast working surface, but does allow for bolder usage, some unique effects, and greater control. One color can be drawn across another without necessarily blending them; the effect suggests a dry-brush technique in which the brush stroke catches only the ridges of the grain of the canvas, allowing tones of previously painted areas to come through.

In order to obtain the best results, lay in a composition of a simple pattern and strong design. This painting practice is, in fact, so direct that it has its own richness and should not require varnish.

I suggest bristle bright brushes for much of this painting. The bristle filbert, because of its shape, will be useful for finishing all anatomical areas and the long flat and long round will serve well for drawing. The large nos. 20 and 24 bristle brights can be used for blending and unifying in much the same way as the no. 20 red sable bright is used for glazing.

Painting without the aid of medium is technically sound, provided the impasto is vigorously manipulated and not applied too thickly.

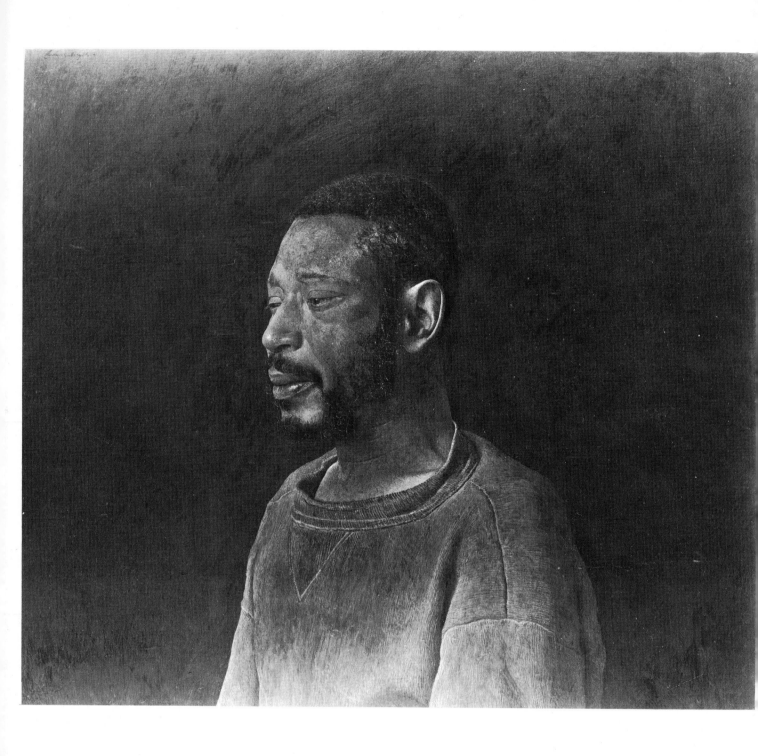

Mr. Willard Snowden by Andrew N. Wyeth.

Tempera, 25¹/₂″ x 29¹/₄″. In painting with tempera, plan for precision of touch and correct density of color so that each stroke of paint may match its surrounding strokes and may require no further blending. Courtesy, Amanda K. Berls and The Metropolitan Museum of Art.

15
Tempera technique demonstrated

Tempera is a painting medium which combines pigment with egg or casein. Both are natural emulsions; the egg is the fatter (or oilier); the casein is the leaner.

To make the egg emulsion, break a whole egg, yolk and white, into a *new*, clean eight-ounce bottle. This egg will equal two parts of the whole emulsion. To this, add one part cold-pressed linseed oil and one part dammar varnish. This equals four parts. To this, add four parts of water. Shake well. Measure the parts carefully. If the emulsion seems rich and the tempera paint does not adhere readily to the canvas, add water to the emulsion, a little at a time, until this condition is overcome.

To make the casein emulsion, dissolve water-soluble casein in water hot to the touch, one part to fifteen parts water. Add one half teaspoonful ammonium carbonate. Stir this mixture over a low flame and the ammonium carbonate will froth and disappear as a gas. If the casein does not dissolve within a minute or so, replace it over the flame and renew the stirring. Twenty-five percent dammar varnish may be added as the emulsion cools. Store in a clean bottle.

Both of these emulsions are recommended; make your own choice.

Working With Tempera

The tempera finish has a mat, chalky appearance, with colors the shades of pastel, which retain their brightness and have a high degree of permanence. Painters of the early Italian school, such as Raphael and Botticelli, used the tempera technique, as did Orozco and Rivera, of the more recent Mexican school.

Tempera is a quick-drying paint that allows for a minimum of blending; the effect of its chemistry on color and surface suggests hatching or drawing rather than blending. Unlike slow-drying oil paint, each stroke of tempera dries quickly and tends to remain intact, distinct. However, a tempera brush stroke, even though it is isolated when applied to the picture, will readily incorporate with other brush strokes as the painted surface dries. Thus, when you paint in tempera, you must relate each tint as carefully as you can on first painting. Plan for precision of touch and correct density of color so that each stroke of paint

may match with its surrounding strokes and may require no further blending.

Tempera dries opaque. It is not good practice to use more medium than necessary—whether egg or casein—as it is a strong binder and can crack and peel. It is advisable to work on a solid backing; I suggest a panel or canvas-covered panel. The sizing for the panel or canvas-covered panel should be no richer in oil content than the tempera emulsion used, since the principle of working fat over lean must always be observed.

Tempera lends itself to small, precise rendering. There is a crispness in tempera and, since the paint lends itself to refined handling, its application should be precise.

For my pigment, I spade powdered color into the emulsion medium (egg or casein). Should any of these mixes become dry on the palette while I am painting, I add emulsion and respade the drying color to renew it.

First Steps

Before you set out to paint, take out the following brushes:

> Bristles, nos. 2, 4, 8, 9, and 10 bright
> Bristles, no. 0 round
> Bristles, no. 9 short filbert
> Red sable, no. 1 long round
> Red sables, no. 10 and 12 filbert type
> Red sable, no. 20 bright

Block in your drawing of the subject carefully in ink, charcoal, or pencil, noting proportion and likeness, and distribution of light and dark. The drawing should be sprayed with fixative so that it will not pick up when worked over; you may also require the underlying drawing for reference.

Bristle brushes are most effective for spreading the initial surfaces. Over the fixed drawing, thinly brush a tone of suitable color across the entire surface to obtain a ground of middle value. (I suggest black, caput mortuum, yellow ochre, or green earth; use these either singly or in combination, in greatly reduced strength, mixed with the emulsion medium and applied in a thin, transparent coating.) The drawing will show through the tone; into this you develop your painting in lighter and darker shades. As you apply your brush strokes—

some opaque tones, together with some thin, partially covering tones—you will create interesting optical effects as the ground tone shows through.

As in oils, painting lightly, wet-into-wet, will permit closer and softer intervals of color; painting more dryly will produce opaque tones and more pronounced brush technique. Paint applied too thickly will crack, especially if it is in a very wet state when applied. Until you obtain some familiarity with this medium, a cautious approach is recommended.

Tempera color dries lighter than it seems while wet; it will reflect surface light, and produces a soft, flat finish. In comparison to oils, tempera is much brighter, but lacks depth and comparable transparency in the darker tones.

Because it is fast drying, you will find it difficult, if not impossible, to keep large areas of tempera pliable for extended mixing and blending. On the other hand, if you will accustom yourself to a short, dry paint, you will enjoy a technique that includes the pleasures of both drawing and painting.

Continuing the Portrait in Tempera

Scumble your drawing with a flesh color: a mixture of white, alizarin crimson, and yellow ochre. For scumbling a flesh tone in the key light areas, in dry impasto, use nos. 4 and 8 bristle brights. Turned on their sides, these same brushes will allow you to hatch a gray-green—a mixture of white, black, alizarin, and viridian—into the halflights, at the side of the head, the temple, the cheek, and under the nose and chin. Again, the bristle brights allow you to simplify your work when blocking in. Laying a broad stroke, they will hold the paint and allow you to control it, without dropping too much paint at a time. The character of the stroke is flat and these brushes can be varied to create passages of shallow or deep form, to hold or lose an edge.

After developing the area with its initial color, make refinements over the flesh scumble, heightening the lights and refining the halflights. The nos. 9 and 10 red sable filberts, used on the broad side, are excellent for developing anatomical form. Turned to the narrow side for the halflights, these filberts will enable you to render refined, hatched passages, and pre-

Mr. Hambleton Shepperd by Staats Cotsworth.

Casein and egg tempera on Masonite. The tempera finish has a matte, chalky appearance, with colors the shades of pastel, which retain their brightness and have a high degree of permanence. Courtesy, Mrs. Hambleton Shepperd.

cise drawing. Once you have initially covered the surface, use the smaller brushes—first the bristle, then the sable—to place the accents, to build and develop the form.

You can obtain many finished surfaces by hatching or other linear modeling. An old no. 10 or no. 12 red sable of the filbert type, or a no. 9 short bristle filbert—whose worn hairs have become sprung and slightly separated—is excellent for this purpose. Dip just the brush tip into the paint and, as you draw it across the surface, the brush will release a stroke containing four or five ribbons of paint, evenly divided, with a space between each. Then, re-dipped and drawn over this former stroke in a slightly different direction the brush will produce the ribbons of a new stroke which will mesh with those of the former stroke. Pulled back and forth across a surface, this brush gradually refines, gradually builds and, at all times, reveals the undersurfaces through the spaces between the ribbons of paint.

With the undersurfaces of the painting showing through, you can develop the painting's form and evolve a luminous surface at the same time. You build a strong fabric of paint using this technique. Each brush stroke, producing a few descriptive threads which model a form, combines with other brush strokes, pulling in different directions to create a multiple webbing similar to the threads in a tapestry. Go over the surface with a palette knife at intervals, lifting off any ridges or granules of dry pigment. Paint reaches its most expressive power when its thickness is just enough to cover.

If you would like to try a transparent wash, apply a more liquid mixture. The enamel-like beauty of the tempera surface is produced by the application of several semi-solid washes. Be careful in the way you place them, because washes used too freely will dissolve the under-layers. The luminous surfaces, so effectively used by the Florentines, are the result of tempera applied in transparent films. Both small and large red sable brushes to lay the wash, and a clean fingertip or a clean bristle brush to spread it, will evenly distribute any excess of paint medium. This has an important effect on the permanence of the painting as well: a surface that dries uniformly will not be likely to crack.

Using the Brushes Effectively

I would use much the same order of brush-work when painting with tempera as I de-scribed in the direct oil technique. In order to blend and glaze, keep in mind that your work should be confined to smaller areas at a time, due to the rapid drying process of tempera.

After the face has been blocked in with simple mass tones of light and dark, I would proceed in the following manner. From nos. 2, 4, 8, 9, and 10 bristle brights, I would select three or four, according to the size of the por-trait, adding the no. 0 bristle round, the no. 9 short bristle filbert, and red sables no. 1 long round, nos. 10 or 12 filbert type, and no. 20 bright. (The demonstration portrait being of small size, the smaller brushes listed here were used more frequently.)

Over the simple mass tones, previously es-tablished in a not-too-wet flesh tone, apply a mixture of white, ochre, alizarin, and viridian across the forehead, the bridge of the nose, the zygomatic prominence of the cheek, and the prominence of the chin. With small nos. 2 and 4 bristle brights, work into this wet tone, cor-rect the drawing, modify the color, and build the form, leaving a pattern of block-like strokes.

With the no. 0 bristle round and the no. 1 red sable long round, line the eyes, nostrils, the separation of the lips, the location of the ears, and the undercut of the chin. The temple, the side of the nose from nostril to bridge, and the side of the cheek will take halflights of gray—white, alizarin, and viridian; a no. 4 bristle bright, properly handled, will shape and place these halflights. Use the smaller brushes, no. 0 bristle round and no. 2 bristle bright, for modeling the smaller forms and for precision work.

At regular intervals, following the develop-ment of anatomical form and subsequent strengthening of color, I would employ the no. 10 or no. 12 red sable filbert type or the no. 9 short bristle filbert—brushes whose hairs have become worn and sprung—in the cross-hatching technique, to pull together the areas and to simplify the form.

For finishing the forehead, use nos. 2 and 9 bristle brights, the no. 9 short bristle filbert, the no. 12 red sable filbert type, and the no. 20 red sable bright. With the no. 9 bristle bright and the no. 9 short bristle filbert, model and

round the forehead in a wet flesh tone. With the no. 2 bristle bright, place the subtle indentations, the highlights, and the transparent grays. The nos. 10 and 12 red sable filbert type and no. 20 red sable bright, used dry, or used wet with a little medium, if pulled over the freshly painted form in a caressing manner, should solidify the area. Into this you can redefine passages with a long, flat sable, rendering in detail. Do not over-model the forms.

The cheek usually contains a maximum of color and variety of form. Select nos. 2, 4, and 8 bristle brights; the no. 9 short bristle filbert; the no. 10 or no. 12 red sable filbert type; and the no. 20 red sable bright. With the bristle brights nos. 4 and 8, block in the form of the cheek in a wet flesh tone. As it turns from the lower eyelid and crosses the zygomatic prominence, the cheek picks up a light equal to that on any other facial prominence. As it turns to the front of the face, it gains color. This is usually the strongest area of color on the face. As it turns to the side and joins the temple, it will pick up a gray transparency or halflight. Pull the no. 4 across the cheek, directing it in curved strokes to describe the rounded form. The no. 8, pulled immediately across these strokes, will simplify, but not destroy their effect. Follow this with the no. 10 or no. 12 red sable filbert type. The rounded form of the filbert tip and the softness of the sable hair will bring the painted surface very close to the living form. Finally, the clean fingertip, pressed into these delicate areas, will produce transparencies equal to and sometimes finer than those of the brush.

Reworking and Refining in Tempera

Although it might seem that these descriptions are final, tempera allows for considerable working and reworking. If you are careful, alternating wet and dry brush strokes, you can repeat any combination of brushed surfaces until you are finally satisfied with the results.

Tempera has greater covering power and more body than watercolor. Impressionist effects can be approximated by placing semi-transparent tints over one another while they are wet. Tempera permits infinite refinements, each layer of paint enriching the one before it, the surface constantly renewing itself. This procedure encourages an appreciation of the form. Attaining form will require concise and refined technique. Since the glaze is semi-transparent, the form seems to emerge and rise to the surface.

The double portrait in this demonstration, measuring 12″ x 14″, is painted on a gesso-sized panel of poplar core with poplar veneer. The gesso size contains equal parts by volume of powdered zinc white (oxide of zinc), gypsum, and cologne glue. The consistency should be that of light cream; if necessary, add more of the glue water until the sizing spreads readily and not too thickly. To prevent the warping of the panel, it is advisable to size it equally on both sides. Apply a coat at a time to each side, being sure to alternate the sides between coats. This panel received four layers of gesso size, horizontal, then vertical, first one way, then the other, repeating the process until the four layers were completed, allowing for drying time between each layer. Finally, this white, gesso size was sanded with fine silicon carbide paper.

The panel containing the portrait of Andrew and Aaron (pages 153 to 156) received a tone of green earth. For the overpainting, powdered colors were spaded into egg emulsion with a palette knife; the egg emulsion was used as the medium.

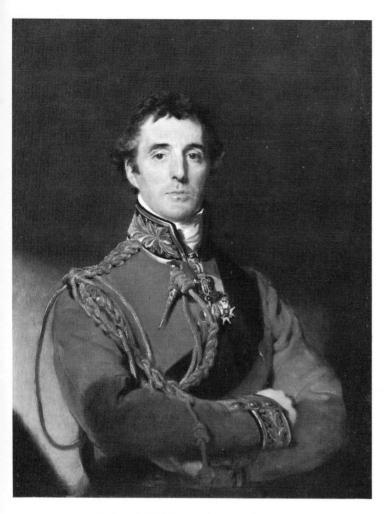

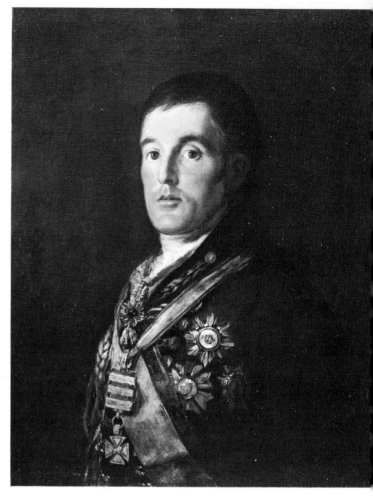

Duke of Wellington by Sir Thomas Lawrence.

Notice how this portrait of the Duke differs from the one by Goya. Each artist puts something of himself into his work. Collection, Apsley House, administered by the Victoria and Albert Museum, London.

Duke of Wellington by Francisco Goya y Lucientes.

Although a portrait of the same man, one can see the individual interpretation given to the Duke of Wellington by Goya. Compare this to the portrait by Lawrence. Collection, The National Gallery, London.

16
Mixed technique demonstrated

Painting, as practiced by the German and Flemish artists of the fifteenth and sixteenth centuries, became known to the Italians, and techniques then practiced in the Italian school were examined by northern artists. It is generally thought that oil was first successfully used for painting in the fifteenth century, when some German artists found tempera not to their liking. Varnish was laid over tempera and oil color over varnish. Tempera was then scumbled into the oil color to heighten the effects.

The work of Dürer, the Van Eyck brothers, and Van der Weyden, for example, clearly show the Italian tempera base. Members of the Venetian school, including Bellini, Titian, El Greco, Tintoretto, etc., employed this interrelating of tempera and oil that became known in Europe as the mixed technique.

For those who are attracted by the brilliance of color achieved with tempera, but who prefer the pliability of oil, the mixed technique may be the ideal combination. This technique combines an underpainting of tempera (an emulsion based paint) with an overpainting of oil (an oil based paint). Either casein or egg emulsion may be used for the underpainting.

As you observe the object you are painting, its form and color become apparent as a result of the light reflected from it. The mixed technique, with its white tempera underpainting and oil color overpainting, is physically structured to reproduce in paint this form and color as revealed by light. The lean, brilliant nature of tempera allows the superimposed oil color to show to its fullest advantage.

Drawing

First work the drawing on paper for character, action, and detail, and to resolve the composition. Then you can transfer it or redraw it onto the canvas with certainty. For this drawing, use ink, charcoal, or pencil, because they will not chemically affect the overpainting. Do not use any form of crayon—lithographic or other wax pencil—since the grease content will bleed through, penetrating each covering layer of paint.

When you are satisfied with the drawing, fix it with a spray of dammar varnish.

Toning the Canvas

It is desirable to tone the canvas. As opposed to painting on a white canvas, where you are always working from light to dark, the toned canvas offers you a middle range, allowing you to work lighter than the tone and also deeper than the tone, as desired. The toned canvas provides an automatic harmony. It lends color, and many accidental effects are obtained while the painting is in progress.

The mixed technique permits a deliberate stage by stage approach to painting. Using this technique on a toned canvas allows you to concentrate on one aspect of the work at a time: the drawing (planning, composing, outlining); the underpainting (working for form and likeness); and the overpainting (application of color, bringing form to life).

You may get a likeness in drawing and lose it in painting, since the dimensions of drawing and painting are different. With the midstep of underpainting, you fix the likeness in tempera and it can always be found again under the overpainting.

To tone the canvas, I suggest you use black, caput mortuum, yellow ochre, oxide of chrome, in powdered form, either singly or in combination, mixed with the tempera emulsion medium and applied in a thin, transparent coating. If the tone is applied thinly it can be applied *over* the drawing and the drawing will show through. But if the tone is brushed on opaquely, it should be applied first and the drawing placed over the tone.

Just which color you select to tone the ground should depend on the nature of the portrait and the character of the sitter. If the subject poses in a brightly colored costume and is of ruddy skin, the caput mortuum in full strength may be used. If the subject is a child of delicate coloring, use the caput mortuum thinned so much that it streaks when applied, so that it resembles the grain of wood. If the subject is a female whose skin is pale but luminous, black may be applied thinly to create a tone of off-white. If the portrait is in an outdoor setting, ochre or terre vert may suggest foliage and other natural colors. The color should be muted to allow for an increase of color in the overpainting which follows. This ground color acts as a middle tone.

Brushes for Tempera Underpainting

For your tempera underpainting put out the following brushes or their equivalent:

Bristles, nos. 2, 4, and 9, long flat
Bristles, nos. 2, 8, and 10, bright
Bristle, no. 9 short filbert
Bristle, no. 6 long filbert
Bristle, no. 2 extra long filbert
Red sables, nos. 10 and 12 filbert type

As mentioned in the tempera demonstration, nos. 10 and 12 red sable filbert type or no. 9 short bristle filbert (in each case, brushes whose hairs have been worn or sprung and are slightly separated) will serve to build these undersurfaces in the crosshatch technique. The bristles are useful for the more vigorous placement of the tempera white, the sables for refining the surfaces.

Tempera Underpainting

Now you are ready to study the distribution of the light and shadow, placing these areas in a varied and interesting pattern. The tone of the canvas will act as your dark on which you will build the lights in tempera white. The lights will be painted in a more complete coverage, the shadows in a less complete coverage. Decide which areas are important when you compose them. As you paint, focus on each area, relating to its surrounding areas and to the whole. When completed, your underpainting will cover the entire canvas in some degree of white, with the toned ground allowed to show through as you desire.

For tempera white, use dry, powdered lead white mixed with an emulsion—egg or casein—in a fluffy consistency, loose enough for easy application. Although no physical harm results from a wet stroke which completely drowns the grain of the canvas, such continued application may weaken and eventually crack the surface. A more pastose application will deposit drier paint strokes with intervals of space between each, without completely covering the underlying tone. This loose handling of the tempera white is good, physically as well as esthetically, creating optical effects which often may be useful in your final painting.

Over your fixed drawing, with the nos. 4 and 9 bristle long flat in a scumbling stroke, cover all of the lighted areas, using a loose tempera impasto, leaving paint just on the peaks of the canvas grain. After you have done this—and before building further on these lighted areas —examine their total effect as they relate to the yet unpainted passages. This observation provides the first opportunity for you to examine your work as a painting.

Before developing any part, make certain that all parts fit well together in the total composition. On your second round of study, you may feel the need to reshape or join some of these parts toward a simpler design.

In principle, you pack the lighted areas until they are almost opaque, building continuously in a series of fine layers. Do not hasten this process by applying the white heavily. The strength in the underpainting is produced by progressively developing a surface, the result of many fine coats of underpainting; no one coat covers completely. At first, the lights are painted in loosely. When you have arranged these, go back for the second round of work, gradually moving in on the unpainted areas. In the third round of work, some lights are carried into the deepest darks to lend luminosity. As you build and model on the scumbled, lighted areas, you will find the no. 9 short bristle filbert brush useful.

When each part fits, you are ready to analyze and develop its possibilities, identifying human features, a space area, a fold of cloth, employing for this work the nos. 2, 8, and 10 bristle brights.

The bristle brushes can be scrubbed or drawn over the forms. The dry nature of the tempera impasto will make it adhere to the brush, separating from the bristles through sometimes more, sometimes less vigorous handling, as the situation may require. This gives you easy control against the uneven release of the tempera white to the canvas. For drawing and refining details, use the no. 6 bristle long flat, the no. 2 bristle extra long filbert, and the no. 2 bristle long flat, with a slightly wetter mix.

Develop the lighted areas fully. Build these surfaces gradually, working over them many times, modeling for form with the bristle brushes and the dry impasto, refining with the

sable brushes and a more liquid impasto. The nos. 10 and 12 red sable filbert types have been previously mentioned for the hatching technique; now you may add any other red sables as you refine the tempera passages in a more liquid application. Take care that the tempera is wet when you employ the sables; do not subject them to vigorous brushing.

If you wish to redraw into the tempera with ink, charcoal, or pencil, you are free to do so, hatching the grays and, by contrast, pointing up the lights.

Develop All Areas in Direct Light

As you have developed your underpainting, you have been advised to build fully the lighted areas and to establish the halflight or shadowed areas less emphatically. From this you may have concluded that since an area is dark, it need not be fully built in the tempera underpainting. To clarify this point, I suggest you thoroughly underpaint the area of the hair in full light, if your subject has dark hair. If your subject is wearing a purple velvet gown, a fully explored underpainting is required to attain the richness of the purple velvet, since the color will not retain its strength on a sketchy foundation. All color is more active in full light. The dark occurring in the absence of light reduces all contrasts and brings values closer together.

Completing the Underpainting

Correct all proportion and refine all detail so that your painting is complete in monochrome, a white tempera over a canvas tone. You may redraw and repaint in tempera, altering and revising already completed areas. Tempera is porous and any overpainting in tempera acts to renew the painting surface. If there are any passages in the completed underpainting that contain no white tempera—and the canvas tone is still uncovered—use a large bristle brush to scumble some white over these areas. The *entire* canvas surface must finally have some degree of tempera covering. If you develop the tempera underpainting to its fullest possibilities, you should indicate every aspect of the portrait except for the color.

As you continue to work, your portrait

should reach full development for proportion, form, likeness, and arrangement in the tempera underpainting. When you are satisfied with the results, the underpainting can then be brushed or sprayed, *very thinly,* with a coating of dammar varnish over the entire canvas. The underpainting should remain mat —not too much varnish—otherwise the overpainting will adhere poorly.

Brushes for Overpainting in Oil

In the oil overpainting, you will use both bristle and sable brushes, working one against the other, the bristles for defining, the sables for refining. For your overpainting your list should include:

Bristle, no. 0 round
Bristle, no. 1 long round (Da Vinci)
Bristle, no. 1 filbert
Bristle, no. 2 extra long filbert
Bristles, nos. 2, 8, and 10 bright
Bristles, nos. 4 and 9 bright
Bristle, no. 10 long flat
Bristle, no. 20 or 24 bright
Red sable, no. 00 pointed rigger
Red sable, no. 1 long round
Red sables, nos. 9 and 10 filbert
Red sables, nos. 12 and 20 bright
Red sables, nos. 1, 2, and 6 long flat

This list of brushes may seem large, but if you are amply supplied with brushes in a variety of shapes and sizes, your work will progress rapidly and your painting will always be concise and clear.

The bristles, both long flat and bright, can be used to establish some wet painted surfaces that will be refined with sables. When unpainted areas are to be covered, bristle brushes will do a more satisfactory job. When blending or glazing in wet areas, use the sables.

Oil Overpainting

The oil colors can be used both to paint over the underpainting or simply to tint it, but they should not be used more heavily than is necessary to cover fully. When the oil color has been applied and the painted surface is not exactly what you wanted, you can reapply tempera into the wet oil paint, refreshing the painting surface. A brisk stroke is necessary, which will force the mix of tempera into the oil paint. You can paint oil over tempera, but tempera must not be painted *over* the oil but, rather, *into* it. This method of painting should appeal to those who like the richness of texture and the accidental effects of a multiple-built paint surface. Color is brilliant over white tempera; it is possible to increase this power when tempera is scumbled into the color and the color then repainted over the tempera.

Mixed White for Oil Painting

For those who like the feel of "body" and covering power in paint, I recommend using "mixed white," equal parts of white tempera paint and white oil paint spaded together. (For best results, whites should always be lead.) This mixed white can be thinned with the tempera emulsion for a leaner mix, or with the oil-dammar medium for a richer mix, and will be a good white to use with the oil colors. Also, it may be applied more heavily than the tempera white and with it you can achieve more surface variety in the overpainting.

Color for Glazing

For glazing or refining an overpainting, where you may desire exact transparencies on finished detail, I suggest a loose oil paint, the consistency of warm butter. To oil paint from the tube, I add 20% of dammar-oil medium which is spaded into the color, making it a very loose but not runny paint. Apply this loose color—and the tones you make with it—using sable brushes.

Developing the Portrait

As you paint, take full advantage of all form and definition provided by the underpainting. When a layer of overpainting obliterates a detail, immediately reestablish the detail before you lose it. If this is unsuccessful, wipe out the overpainting and the detail will be there in the underpainting.

With the no. 20 red sable bright, paint a flesh color tint across the forehead, nose, cheek, and chin in the lighted areas. With nos. 4 and 9

bristle brights in a more pastose pigment, model with correct tones directly into the tint and more carefully describe these areas. The no. 4 bristle bright can be used to place a series of semi-opaque strokes with the pastose paint. Manipulate these covering strokes; that is, place them with the direction emphasized, shaped, softened, sharpened, pulled one across another, so that from the several strokes a form evolves. Then, immediately, with the no. 9 bristle bright, wetted in a color which is a refinement of the original flesh tint, blend the form and reset the tint.

Strongly lighted areas can be strengthened and reset with the tempera white scumbled into the finished wet oil pigment, using a no. 2, 8, or 10 bristle bright. This scumbled tempera will pick up the oil color and blend with it. Then, if it seems too light and strong by comparison, you can glaze it, blot it with a clean cloth, and finally press and work it with your fingertip until it takes its place. Painting tempera into oil, wet-into-wet, creates a fusion of tones in softer intervals than pure tempera will produce. Also, it gives more varied effects than oil alone or tempera alone will produce.

Dip the no. 20 red sable bright into the medium; then, pull the wet hairs across the underpainting of the brow and eye on the fully lighted side of the head. Into this wet field, with a small bristle bright, and a no. 1 sable long round, set the contrasting notes for the eye: pink for the lacrimal papilla; alizarin for the upper lid; a mixture of burnt sienna, viridian, and white for the brow; a flesh tint for the upper and lower lids; and an off-shade of white (towards blue) for the sclera or white of the eye; blue, brown, or hazel for the iris; and a mixture of alizarin and black for the pupil. Work with middle to small sized brushes: bristles to lay the color, sables to blend. Relate and blend this section of the eye with that of the forehead, the side of the nose and cheek—areas already indicated.

Into this wet field of freshly painted eye, lid, and brow, press a clean no. 9 or no. 10 red sable filbert, being careful not to rub the painted surface. This operation will set the colors and lift off any excess paint. You can make corrections, apply other colors, and repeat this operation, but always with a clean sable.

When you want critical lights, use small bristles or sables in tempera: the bristles to press and blend the light, the sables to deposit the light as a superficial highlight upon the painted surface. For precise refinements, add the no. 0 bristle round and the no. 00 sable pointed rigger.

If you have been working a warm flesh color in the lighted areas, the halflights and shadows will require a cool color: a mixture of ochre, viridian, alizarin, black, and white.

To indicate the depth of color value, locate the several dark tones in the halflights across the side of the head, down the cheek, and over the ear. These areas, out of the direct light, have not been heavily underpainted, but contain a scumble or a comparatively light covering of tempera. Continue to build them this way in the overpainting, taking advantage of the porous surface of the underpainting. These negative areas bolster the positive, lighted areas and must be kept simple so that they do not compete. You can sense a luminosity in them as a result of this multiple lightweight building in low-keyed colors.

As your work grows, the refining takes more time. Use the sable filberts and the no. 12 and no. 20 sable brights frequently to improve and simplify the passages.

Study the important junction of light and dark, where the planes of the head turn out of the direct light into the halflight. With the medium to large sized bristle brights and the no. 12 or no. 20 red sable bright, you will be able to treat this significant turn in simple mass. The filberts will give you the kind of stroke you need to define, to firm, or to soften the edges.

The value made from the mixture of ochre, viridian, alizarin, black, and white will locate a halflight in the space between the eye and the bridge of the nose, and down the side of the nose. In addition, this mixture covers the side of the head out of the direct light, the undercut of the chin, and the dark side of the neck.

Set the other eye, the nostril, mouth, and ears. Fill in the facial areas: the cheeks, bridge of nose, space surrounding the mouth, the jaw, and the neck. The no. 4 bristle bright will work easily in and about the features, enabling you to place brush strokes of approximately local

color. Build on these strokes in a pastose paint, not too wet, modeling for solid form. At intervals, you can employ a sable of similar variety—no. 1, 2, or 6 long flat—in a glaze which will soften and blend the modeled forms.

Moving away from the lighted face for the moment, look again at the surrounding half-lights. With a no. 9 bristle long flat, strengthen and develop an adjacent form and this will give support to the lighted areas. You will begin to relate your painting of individual parts to the whole design.

At this time you can use the no. 10 or no. 12 red sable filbert type with the sprung bristles, in the hatching technique, across both light and dark areas in order to draw them together. Pull this brush in a slightly curved fashion and your form will become round.

Some Additional Suggestions

Avoid the temptation to glaze the underpainting immediately for finished results. If you overpaint too thinly, as though you were tinting, particularly in the prime areas, your final result will lack the pigmented richness and volume that this technique offers. You should not look upon the underpainting as precious; let it free you for the full development of the overpainting.

Darker complexions require deeper, richer color combinations. Lights are pronounced, transitions from light to dark more vibrant. Here the painter should increase his use of color and, in general, strengthen his statement. Various ethnic characteristics, as well as gradations in skin tones, will influence the artist's use of his materials.

No matter how much detail it contains, clothing should be treated as a simple mass area. Apply the paint in these areas with a no. 9 bristle bright or a no. 9 bristle long flat. The no. 20 red sable bright, gently drawn across the painted clothing, will set the area so that it keeps its place without conflicting with the portrait head.

Backgrounds can also be brushed in with the no. 9 bristle bright or with the no. 9 bristle long flat. The no. 20 or no. 24 broad bristle bright should then be drawn over the wet background area in a vertical direction, from top to bottom. This will set the background so that it stays behind the head.

Highlights on eyeglass frames, cufflinks, jewelry, shirts, collars, handkerchiefs, etc., may be treated with touches of tempera. All accents must be technically conservative.

Because your portrait is firmly set in the tempera underpainting, many of the secondary passages in the overpainting may be left simply as transparent tints. This is particularly true in the darkened passages, which should retain some transparency. This may also occur at times when you want to reserve some areas in the underpainting against those more thoroughly covered.

The nos. 10 and 12 red sable filbert type, used dry or semi-wet, can be drawn across whole areas of the portrait to refine and unite the structure. These brushes, which have often been employed for cross-hatching, can now be gently drawn across finished areas in much the same way. If they are kept clean for their brushing, they will serve to blend the delicate color values and transparencies in a succession of beautifully modeled forms, lending vigor to the final results.

The portrait on pages 157 to 161, size 42" x 34", is painted on a gesso ground which I prepared (two parts powdered zinc white, two parts gypsum, two parts cologne glue, to which I added, a few drops at a time, one part linseed oil) to a consistency of light cream. A stretched canvas of Utrecht linen, type 73D, on which I had previously placed a sizing of cologne glue, received two coats of gesso (one horizontal, one vertical). This white gesso ground was sanded, and toned with a caput mortuum red diluted with egg tempera.

The underpainting was applied with powdered lead white in egg tempera. For the overpainting, F. Weber Co. oil colors were used.

17
Acrylic technique demonstrated

The new synthetic colors are finding favor among contemporary painters and a brief consideration of their qualities and character should be of interest to you. Although these colors have been given various names—acrylic, polymer, acrylic polymer, acrylic co-polymer, acrylic-vinyl copolymer, etc.—they are generally referred to simply as acrylics, which is what I shall call them from this point on.

Until these synthetic materials were manufactured, only natural binders (casein, egg, oil, gum arabic, dammar, etc.) were used to make paint. Acrylic emulsions are, therefore, the first binders to be artificially produced. Instead of combining dry pigment with oil, casein, gum, etc., the manufacturer of acrylics combines dry pigment with a liquid plastic, called an acrylic emulsion. Like linseed oil and other traditional materials, this emulsion is essentially a glue, which binds pigment to a painting surface.

Since its manufacture can be precisely controlled, acrylic emulsions can be formulated with a wide variety of film characteristics. There are many possible chemical combinations to work with and the manufacturer can thus control the hardness and flexibility of the paint film, as well as the handling characteristics of the wet paint. The manufacturers have, accordingly, varied their formulas and they do not recommend that the product of one company be mixed with that of another. Various brands may not always be compatible because of differences in chemical composition.

It must be mentioned here that acrylics must not be used in temperatures lower than 50° F.; the particles of the emulsion will "freeze" or harden below this temperature and will not coalesce to form a proper paint film.

Unlike egg or casein which, when thoroughly dry, will easily dissolve from the hairs of the brushes in warm water and soap, the acrylic emulsion will not so easily dissolve. It is therefore necessary to keep constant watch on your brushes to know that they are kept wet throughout the working period and washed immediately afterward. If the painting period is extensive, the brushes may be washed during work, whenever they become caked with paint.

When acrylic color begins to set and a skin forms over the mix, remove all of that color and replace with a fresh supply from the tube.

Most acrylics are water based; that is, you can thin them with water as you work, although they become thoroughly insoluble when they dry.

Painting Surfaces

For the best results, acrylic colors should be used on a specially prepared surface whose character is similar to the paint itself. This means that water based acrylic paints belong on a water based ground (like gesso) and oleo based acrylic paints work best on an oleo based ground (like the white lead priming used for oil painting). Although oleo based paints will adhere to a water based ground, some richness of finish will be sacrificed; the finish may be less glossy—which many artists actually prefer. Under no condition, however, should water based paints be applied to an oily surface, like the white lead in oil normally used to prepare canvas; the result would be poor adhesion.

The various acrylic manufacturers make a gesso which they recommend be used as a foundation for acrylics and oil paint. This gesso is applied directly to the raw canvas, panel, or to any other suitable surface. It is usually a mixture of acrylic emulsion and titanium white. It is rather thick and may be thinned with water, according to directions given. When dry, the gesso has a slight tooth and may be sanded if a totally smooth surface is wanted. Some artists add marble dust or fine sand to obtain certain textural effects. Toned grounds can also be made by adding a small amount of acrylic color—mixed directly into the gesso—before the ground is applied to the canvas or panel.

This gesso may be applied thickly in one coat as it comes from the can or jar; or it can be thinned and applied in successive coats. Several thin coats will produce a smoother surface. The gesso can usually be brushed directly onto the support without any preparatory sizing, and will act as its own sealer.

You can make your own gesso simply by mixing titanium white (either acrylic tube paint or powdered pigment) and the acrylic emulsion to the proper consistency. This mixture should be easily brushable—that is, not too thick.

Acrylic Mediums

The use of one medium or another is a personal matter for you, the artist, to decide. The manufacturer offers you liquid acrylic emulsion to thin your paint, acrylic gel to thicken it, acrylic modeling paste to thicken it even more, and acrylic varnish to protect the finished painting.

It is possible to use the colors (which come in tubes, jars, and squeeze bottles) without adding any emulsion, simply thinning the water based colors with water, and thinning the oleo based acrylics with turpentine or a similar vehicle.

Well diluted with water, aqueous acrylic colors will produce effects similar to watercolor, although, unlike watercolor, the passages cannot be reworked once they have dried. Used undiluted, aqueous acrylics handle more like gouache or oil paint. Diluted with turpentine or a similar thinner, oleo acrylics produce glaze effects similar to oil paint, but do not rework easily once dried. Reduce the quantity of turpentine, and oleo acrylics produce an impasto similar to oil paint.

Aqueous acrylic medium (pure acrylic emulsion) is usually available in two liquid forms: glossy and mat. Both are whitish liquids—the consistency of cream—which dry clear. The glossy medium dries to a luminous, shiny surface, like oil paint which contains a high percentage of oil or resin. The mat medium dries to a surface with no shine, more like gouache, casein, or pastel.

By adding pure medium to tube paint, without adding water, you can produce a thick liquid paint with fluid brushing qualities. The more medium you add, the more transparent the paint becomes, making acrylic an excellent material for techniques that involve glazing and scumbling one color over another. By adding water and medium to the tube paint, you produce a thinner liquid than paint diluted with medium alone. Whether you choose glossy or mat medium—used straight or in combination with water—is merely a matter of personal preference.

Similar mediums are available for oleo acrylics. The medium can be used alone to produce a fairly thick, though fluid paint consistency, or in combination with turpentine for thinner paint.

The acrylic gel is clear and contains the same ingredients as the liquid emulsion, with the addition of a thickening agent. Mixed with acrylic colors, this gel adds body and produces impasto effects similar to oil paint. By adding this gel to the paint mix, you will slow the drying process and thus lengthen the time during which the paint remains workable. If this longer drying time appeals to you, it is possible to slow the drying process even further by adding a few drops of glycol (with or without gel) to the paint as you work.

In addition to the gel, there is acrylic modeling paste (sometimes called paste extender). This paste combines acrylic emulsion and marble dust and is used for creating pastose (very thick) effects. Combined with paint, this modeling paste slows drying time, extending the time during which the paints can be worked.

Some manufacturers recommend that liquid medium (glossy or mat, depending upon preference) be applied over the completed painting as a protective varnish. Other manufacturers do not recommend that medium be used as varnish, but make glossy and mat varnishes for this purpose.

Just as some form of oil is common to all oil paints, acrylic emulsion (such as Rhoplex, manufactured by Rohm and Haas) is the foundation for all acrylic painting materials. Such an emulsion is used for grinding the paint, and for making gel, medium, modeling paste, varnish. If you buy liquid Rhoplex, you can even make your own paint by adding powdered pigment, although it is not really worth the effort.

Handling Qualities

Acrylic paints, as yet, do not have the brushability of oil paint. Acrylics dry too quickly for protracted brushing, but they handle well in quick, direct painting, and should appeal to the painter who seeks rapid, spontaneous effects. Compared with oil paints—where slow drying allows extensive blending for soft diffused effects—acrylic colors require a brisk, direct attack. As a result, acrylic paintings are often characterized by clean strokes of clear, bright color.

Since acrylics have different characteristics from oil or watercolor, it will be necessary for you to adjust to this rapid drying and develop your technique to *profit* by this quality. Acrylics are new and with them you should attempt to develop a new approach.

You will find that acrylics are best for large areas of flat color and for crisp, decisive strokes. Subtle gradations cannot be produced by blending—as with oils—but *are* possible if you rely on scumbling effects; dry-brush effects; graded washes, similar to watercolor; and the cross-hatching and stippling techniques of the tempera painter.

Rich color effects are also possible if you build multiple glazes on top of one another, taking advantage of the rapid drying time of acrylic, which permits you to apply glaze after glaze in a single day—impossible with slow drying oil paints. Equally rich broken color effects can be produced by scumbling, dry-brushing, hatching, and stippling one semiopaque color over another, again exploiting the rapid drying time between layers of paint.

Acrylic also permits textural effects impossible in other media. Gel, for example, can be used for impasto *glazes,* while the modeling paste can be used to build impasto as thick as bas relief; both these techniques are impractical with traditional media.

Knives and Brushes

Any palette knives or brushes you have employed for oil painting may also be used for painting with acrylics. The knives can be used to manipulate the colors, the gel, and the modeling paste. Bristle brushes can be used for sketching, for covering areas, and for bold strokes. The sables are suitable for refining.

Brushes of nylon bristle are also recommended. Nylon bristles have a different feel from the natural bristle. They resemble fine wire; they do not have the curve of the natural bristle, but are straight. Furthermore, nylon brushes are not as full bristled in their construction; the bristles do not mat (lock together) and the paint does not pack at the fer-

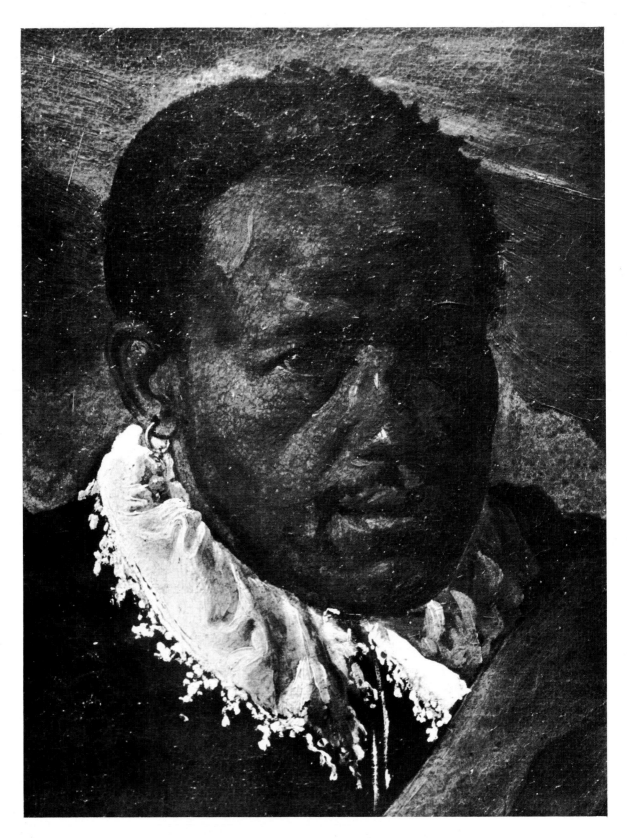

Wise Man (Detail from the Adoration of the Magi)
by Diego Rodriguez de Silva y Velasquez.

What features does one stress? In what order? Determine what is characteristic of your subject. Does a feature or combination of features impress you? The eyes are the focal point; then the mouth, nose, and ears. Collection, Prado Museum, Madrid.

rule. You may find it necessary to work with them awhile to get used to them.

Brushes must be kept wet as you work and should be cleaned immediately when you have finished. Paint drying on the bristles will ruin the brush. It is, therefore, advisable to keep all brushes immersed in water while you are painting and to wash them immediately (with mild soap and water) after each work period.

Colors

Acrylic paints are made in a wide assortment of colors. Like oil paints, some are transparent, some semi-transparent, and some opaque. Some of the colors available in oils are not used in acrylics for chemical reasons, but others are substituted. Since acrylic emulsions are alkaline, those colors which are not alkali proof have been replaced.

In addition to the cadmium yellows, oranges, and reds, there are Hansa yellows, yellow ochre, raw sienna, yellow and red oxides, and naphthol red, replacing alizarin crimson. Phthalocyanine blues and greens (dye colors of recent origin) are prominent in the cool side of the palette, but more traditional blues and greens are also available. Browns include the traditional earth colors, plus some newer man-made hues. The powerful titanium white and Mars black are standard. Generally speaking, these paints dry in bright, high color, and it is worthwhile to develop a technique that exploits their features.

With acrylics as with all other painting materials, the artist's procedure is just as personal—and the possibilities are just as diverse. Once you have learned the technical characteristics of the medium, you will find a way to fit them to your needs.

In this book, the two portraits painted in acrylics are the painting of Hans Obst on page 65 and the portrait of Alice, the demonstration portrait on pages 162 to 166.

The portrait of Hans Obst was painted on Fredrix no. 190 single prime A linen canvas with Weber Artists' Polymer Paint, and the palette of colors included phthalocyanine green, cobalt blue, brown earth, Mars black, Permalba, yellow ochre, cadmium yellow, cadmium red light, alizarin crimson. Aqua gel was the only medium used, as I wanted the full feel of oil paint. The finished work was varnished with Weber Univar spray gloss varnish.

For the portrait of Alice, I used Liquitex Acrylic Polymer Emulsion Artists' Colors (Permanent Pigments) on Fredericks' #111 Double Primed Acrylic linen canvas. My palette included: phthalocyanine green, cobalt blue, burnt sienna, Mars black, yellow oxide, cadmium yellow light, and naphthol ITR crimson. I used Liquitex Acrylic Polymer emulsion and the Liquitex emulsion gel with water as a thinner. The finished work was varnished with Permanent Pigments Soluvar gloss varnish.

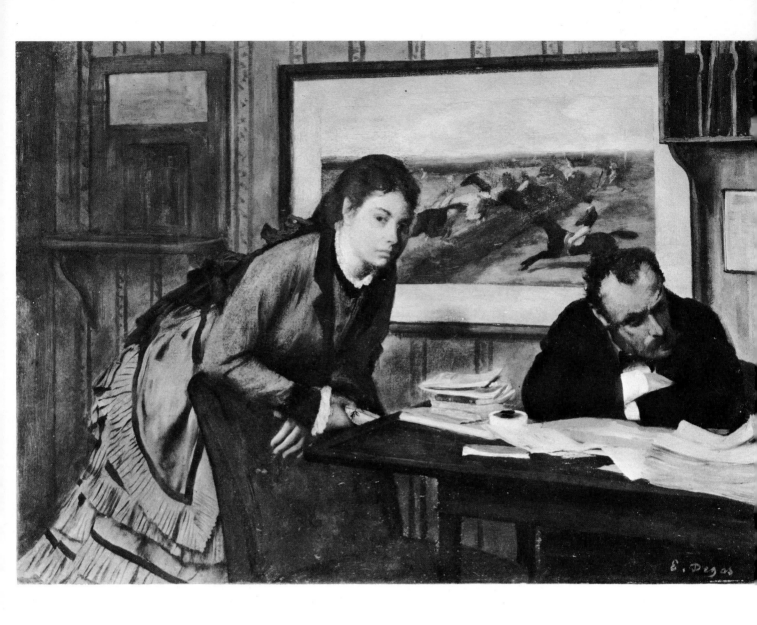

Sulking by Edgar Degas.

If, in composing a double or multiple portrait, you should paint your subjects so that they face away from each other, you should then locate a central or focal interest within the secondary area between the heads, as Degas has done here. Collection, The Metropolitan Museum of Art, Bequest of Mrs. H. O. Havemeyer, 1929. The H. O. Havemeyer Collection.

18
Multiple portrait demonstrated

When a painting contains more than one portrait, the heads of those portrayed will complement each other when they are turned toward each other, or the figures will complement each other if they incline toward one another. Heads facing away from each other seem to look out of the composition, pulling the eye of the observer in opposing directions which can disturb optical unity. If, in composing a double or multiple portrait, you should paint your subjects so that they face away from each other, you should then locate a central or focal interest within the secondary area between the heads. This will establish a visual force that will draw the heads together.

The dual or multiple portrait requires the establishment of more than one main interest within the design. The organization of your material becomes more complex and considerable exploratory preparation will be necessary.

Initial Plan

When I was asked to do an on-scene portrait of Dr. W. Wayne Babcock and his clinic, I did not immediately conceive the size and complexity of the work ahead. Beforehand, I learned what I could about the clinic and about surgery—reading, looking, asking questions. During my visits to the operating room, I made many drawings from which an oil sketch for the large painting was developed. Several of the doctors posed in groups so that I could see them together. This helped me to determine their comparative heights. Others posed singly and they were incorporated into the group. As the design grew, it was necessary to make some changes to improve the composition and some of the doctors were moved into different positions.

The composition began by establishing in drawings on a sketch pad Dr. Babcock and his assistant—two heads and four hands—as the center of interest. A rectangle in the proportion of five by six, based on the proportion of the oil sketch, was drawn on paper as a preliminary plan. This rectangle, about 10" x 12" in size, was then quartered as an aid to the laying out of the composition. I cut out the figures of Dr. Babcock and his assistant and placed them on the plan, moved them about,

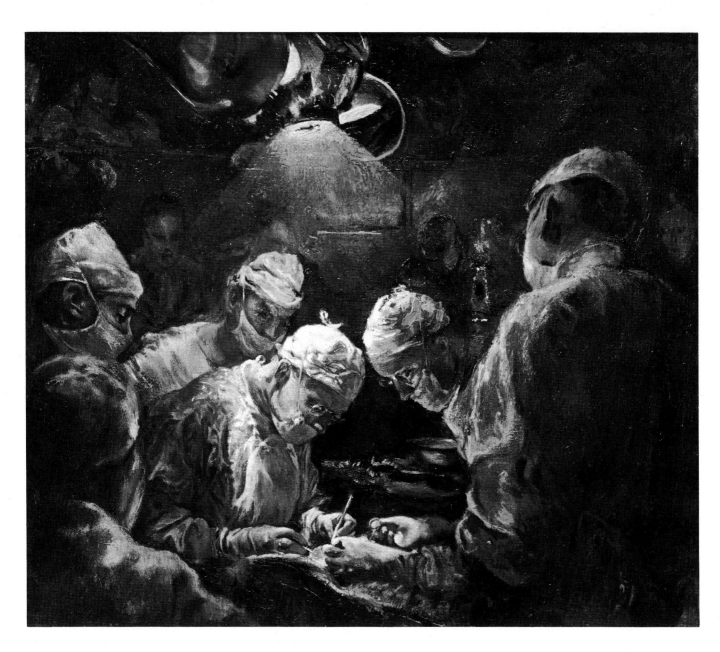

The Babcock Surgical Clinic

Mixed technique on poplar panel, 9″ x 11″. During my visits to the operating room, I made many drawings from which the oil sketch above was developed. The sketch was subsequently enlarged. The early pen sketch at the left, was drawn on an index card. Courtesy, Mrs. W. Wayne Babcock.

arranged them where they looked well. The composition was planned to include the interior of the amphitheatre and it was necessary to consider the parts of the picture which did not show in the sketch. The figure of the anaesthetist, the largest head, occupied the foreground, apart from the central group in the middleground. The interns and medical students in the gallery made up the background.

Over-all Pattern

The plan was already quartered and the patterns of the two central figures tentatively set. Behind Dr. Babcock, and to your left as you face the composition, the group of observing doctors contains five heads. To your right, and behind the assistant surgeon, the group contains four heads. This difference allows the necessary space for the projection of Dr. Babcock's head, across the vertical median to your right, while the field of operation—framed by the four central hands—is situated just to the left. Although it is not on center, Dr. Babcock's head becomes the optical center by means of the support it receives from the surrounding area.

The main theme divides into three groups. The first contains the central group: two heads and four hands. The second group, to your left as you view the picture, contains five heads, and the third group, to your right, four heads. Because the two central heads fall into a diagonal pattern, it seemed desirable to support this emphasis. Therefore, I set two diagonals, from the lower left corner to the upper right, and from the upper left corner to the lower right. A line of interest established itself, running from the immediate field of operation through the narrow space between the heads of the two central figures.

I set a counter direction in motion by placing the light off center to the left, and cornering its reflected beams on the sterile cloth to the right, to effect a visual balance. The spread of light and the description of lighted heads creates a diamond shape in the central area, cutting across the original diagonals and reversing their action. This repeat of the diagonals not only establishes the diamond shape, but fractures the area and is, in turn, quartered by the original diagonals.

Working Toward a Final Arrangement

With this preparatory work behind, I divided the groups into areas, then subdivided them for light and dark. I drew the left hand group, roughly shaped, to scale on paper, then cut it out. The right hand group followed, then the foreground and background areas. These shapes were fitted into an abstract pattern and worked on until they looked good together. As they were wanted, I added accents to indicate the plasma stand, surgical tray, railings, and fixtures to establish the environment and to add to the total interest.

Dr. Babcock and Dr. Coombs

Conté pencil on gesso-sized Bambridge board, 28″ x 32″. The composition began by establishing in drawings on a sketch pad Dr. Babcock and his assistant—two heads and four hands—as the center of interest. Collection, Dr. Henry Clay Fleming.

Drs. Rosemond, Burnett, Steel, Parkinson, and Preston

Conté pencil on gesso-sized Bambridge board, 28" x 35". The second group, to your left as you view the picture, contains five heads. Collection of the artist.

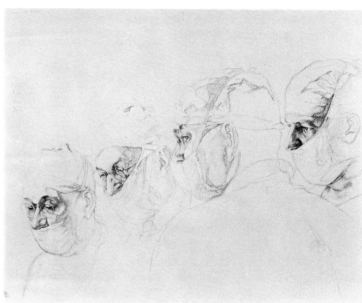

Drs. Leedom, Astley, Hess, and Bacon

Conté pencil on gesso-sized Bambridge board, 28" x 36". The third group, situated at the right as you view the picture, contains four heads. Collection of the artist.

The Babcock Surgical Clinic

Higgins brown ink on rice paper, 24" x 32". After having placed the three groups into approximate positions, I added accents to establish the environment and add to the total interest. Collection of the artist.

The Babcock Surgical Clinic

Oil on toned canvas, 10" x 14". With this step-by-step working of each phase of my composition, I accumulated a number of sketches and drawings which I hung in my studio for review. Referring to all work so far completed, I undertook oil sketches to resolve problems involved with the arrangement of color, such as this study of Dr. Babcock's hands. Courtesy, Mrs. W. Wayne Babcock.

Making the Sketches

At this point in planning my composition of the Babcock clinic, I had decided on the placement of each doctor, his position, how the light should reflect upon him, the color of his gown. Each one posed for me, assuming the stance that fitted the sketch of him. Painted separately, I later incorporated them into the group, working from these individual studies. I put one of the surgical gowns on a life-sized mannequin and set it into the position each doctor assumed. This allowed me all the time I needed to study the many wrinkles characterizing an unpressed sterile gown.

With this step-by-step working of each phase of my composition, I accumulated a number of sketches and drawings which I hung in my studio for review. Referring to all work so far completed, I undertook oil sketches to resolve problems involved with the arrangement of color.

The preliminary plan was now scaled into half-inch divisions, vertically and horizontally. I later expanded these divisions eight times to meet the dimensions of the large canvas. I covered the canvas with a large piece of brown wrapping paper, placed the large scale on it, and transferred all key points of the preliminary plan to meet the new size. This transfer allowed me, for the first time, to evaluate the plan in the size it would finally appear.

Final Plan

As I viewed the enlargement of the plan, now a map for the picture, I was not fully satisfied with what I had obtained. Consequently, I made other drawings of the various figures on wrapping paper to this scale, in which I developed a firmer line. These drawings were then cut out and suspended on a cord over the place of the figure they represented in the composition. They could be raised or lowered, moved about and reset. This device allowed me to alter and recompose these forms into new proportions until I felt that they were right. This planning was the rehearsal for the painting which followed.

Dr. William N. Parkinson

Mixed technique on poplar panel, 10″ x 8″. Courtesy, Dr. William N. Parkinson.

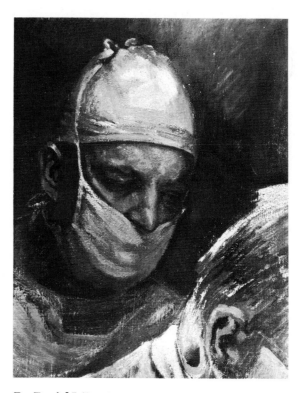

Dr. Daniel J. Preston

Mixed technique on poplar panel, 10″ x 8″. Courtesy, Dr. Daniel J. Preston.

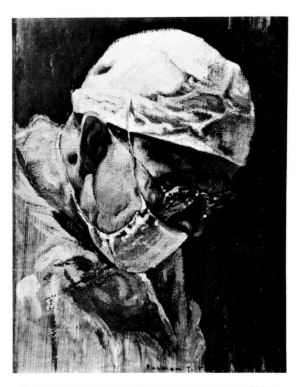

Dr. W. Wayne Babcock

Mixed technique on poplar panel, 10″ x 8″. Courtesy, Mrs. W. Wayne Babcock.

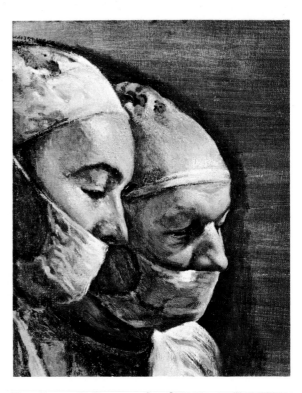

Drs. George P. Rosemond and W. Emory Burnett

Mixed technique on poplar panel, 10″ x 9″. Courtesy, Dr. George P. Rosemond.

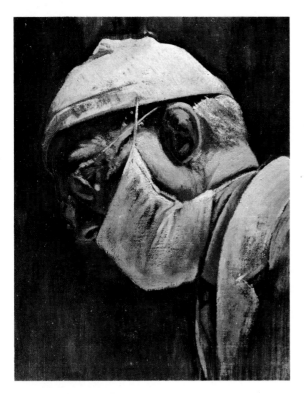

Dr. James N. Coombs

Mixed technique on poplar panel, 10″ x 8″. Courtesy, Dr. James N. Coombs.

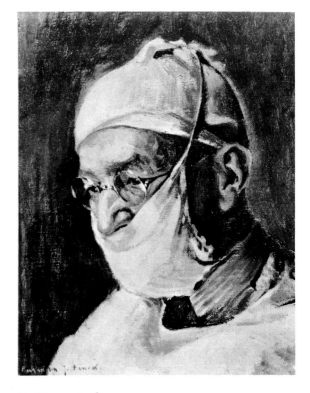

Dr. Mason Astley

Mixed technique on poplar panel, 10″ x 8″. Courtesy, Dr. Roy Astley.

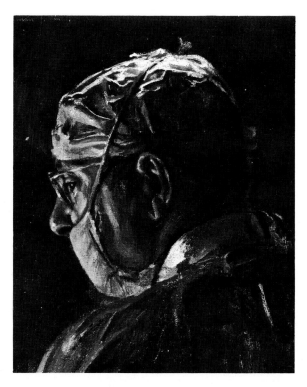

Dr. Valentine M. Hess

Mixed technique on poplar panel, 10" x 8". Courtesy, Dr. Valentine M. Hess.

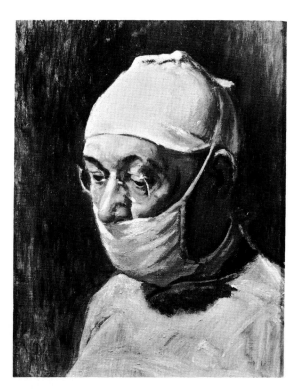

Dr. John Leedom

Mixed technique on poplar panel, 10" x 8".

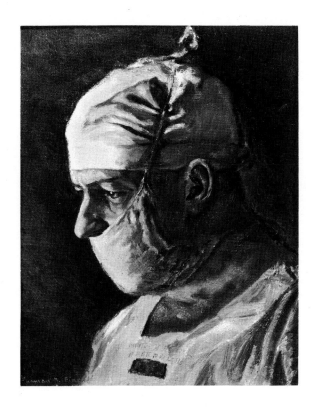

Dr. Harry E. Bacon

Mixed technique on poplar panel, 10" x 8".

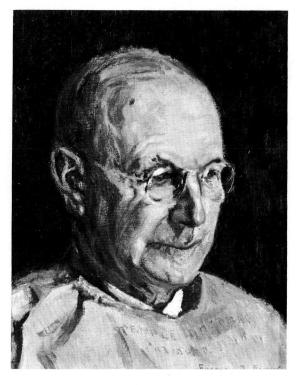

Dr. William A. Steel

Mixed technique on poplar panel, 10" x 8". Courtesy, Mrs. William A. Steel.

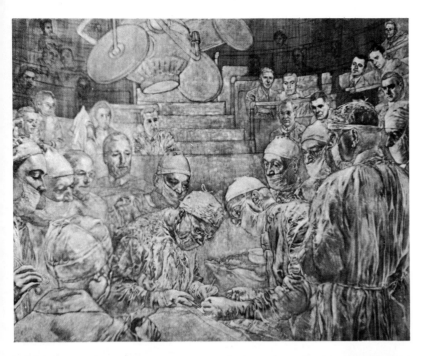

The Babcock Surgical Clinic (Left)

Mixed technique on canvas, 5′ x 7′. Here the tempera underpainting shows throughout the main area, and, above, the red caput mortuum ground is seen, as well as the drawing in charcoal and the grid for the transfer of the original drawings to the canvas. Courtesy, Temple University Health Sciences Center.

The Babcock Surgical Clinic (Below)

Mixed technique on canvas, 5′ x 7′. Here the painting is shown nearing completion, complete except for the application of the final glazes. Courtesy, Temple University Health Sciences Center.

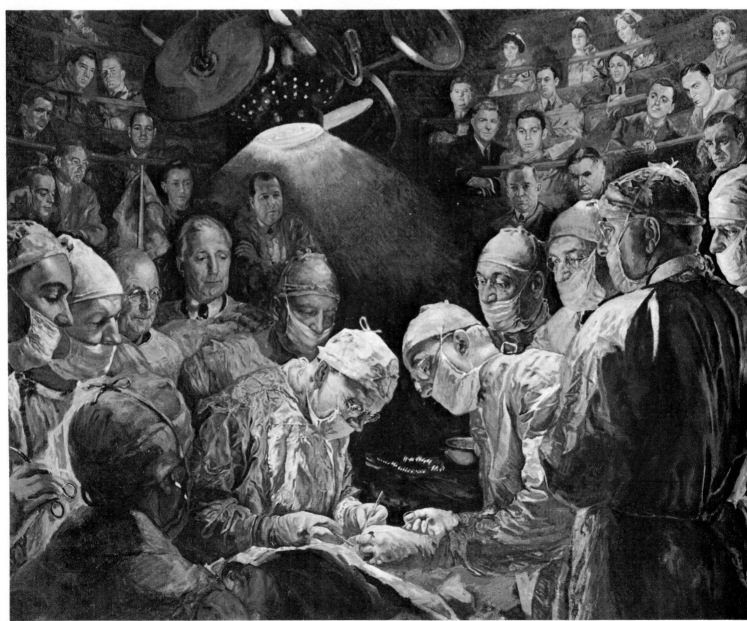

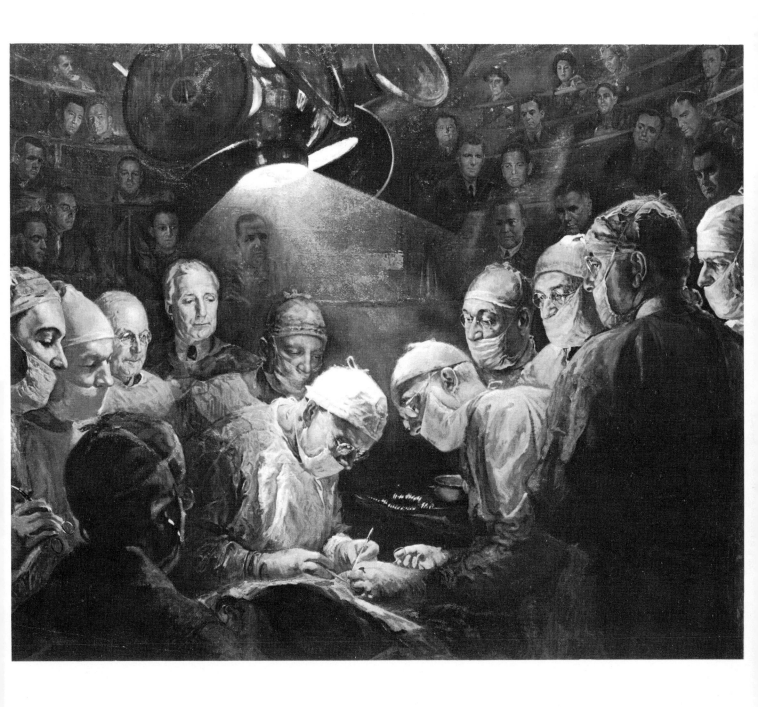

The Babcock Surgical Clinic by Furman J. Finck.

Mixed technique on linen canvas, 5' x 7'. Here is the painting in its final state, after the glazes have been added. For all of the painting in this project I used Winsor & Newton colors. A full color reproduction of this painting is shown on page 167. Courtesy, Temple University Health Sciences Center.

Index

Edited by Susan E. Meyer
Designed by James Craig
Composed in ten point Melior by York Typesetting Co., Inc.
Printed and bound in Japan by Toppan Printing Company Ltd.
Printed and bound in Japan by Dai Nippon Printing Company